ADVANCE PRAISE FOR

Cyberspaces of Their Own

"Rhiannon Bury has spent time getting to know the people in these fan communities, their patterns of interactions, their social dynamics and their tastes and interests. She writes with the vividness and precision of an insider but with a strong intuitive sense of what she needs to explain if she is going to make these interactions accessible to non-participants. This book's real strength is its focus on the social dimensions of fandom—the codes of politeness, the bonds of friendship, the kinds of trust and the anxiety about flaming which reflect the particular qualities of these women's interactions with each other."

Henry Jenkins, Professor and Director,
Comparative Media Studies, Massachusetts Institute of Technology

"There is little doubt that this book is important to the study of global techno-mediated cultures. Rhiannon Bury clearly articulates the relationship between 'virtual' community and television viewers to provide readers with an insight into how different technologies and their users/consumers/audiences criss-cross in the forming of online and offline global realities through socio-cultural meaning-making practices."

Radhika Gajjala, Associate Professor, School of Communication Studies,
Bowling Green State University

Cyberspaces of Their Own

Digital Formations

Steve Jones
General Editor

Vol. 25

PETER LANG
New York • Washington, D.C./Baltimore • Bern
Frankfurt am Main • Berlin • Brussels • Vienna • Oxford

Rhiannon Bury

Cyberspaces of Their Own

FEMALE FANDOMS ONLINE

PETER LANG
New York • Washington, D.C./Baltimore • Bern
Frankfurt am Main • Berlin • Brussels • Vienna • Oxford

Library of Congress Cataloging-in-Publication Data

Bury, Rhiannon.
Cyberspaces of their own: female fandoms online / Rhiannon Bury.
p. cm. — (Digital formations; v. 25)
Includes bibliographical references and index.
1. Internet and women. 2. Electronic discussion groups.
3. Science fiction television programs—Electronic discussion groups. 4. Fans (Persons).
5. Science fiction fans. 6. Subculture. I. Title. II. Series.
HQ1178.B87 004.693—dc22 2004007400
ISBN 0-8204-7118-6
ISSN 1526-3169

Bibliographic information published by **Die Deutsche Bibliothek**.
Die Deutsche Bibliothek lists this publication in the "Deutsche
Nationalbibliografie"; detailed bibliographic data is available
on the Internet at http://dnb.ddb.de/.

Cover image by Luis Marmelo

The paper in this book meets the guidelines for permanence and durability
of the Committee on Production Guidelines for Book Longevity
of the Council of Library Resources.

© 2005 Peter Lang Publishing, Inc., New York
275 Seventh Avenue, 28th Floor, New York, NY 10001
www.peterlangusa.com

Printed in the United States of America

⌣ Contents

❧ Acknowledgments

The journey that is this book has taken almost ten years to complete, and there are numerous people without whom it would not have taken the path that it did. First, I am indebted to those members of the David Duchovny Estrogen Brigades who agreed to participate in this project and offered me their time, their insights, their trust and the pleasure of their company for a year: Beth, TC Carstensen, Lara Eakins, Katie Fritz, Inez Gowsell, Sue Johnston, Julia Kosatka, Melanie Lightbody, Julianne Lee, Susan Lyseng, Kellie Matthews, Polly Moller, Jennifer Roth, Nancy Simmons, Sarah Stegall, Elissa Teeple, Melinda Young and Vasna Zago. Then there are those members of the Militant RayK Separatists who were kind enough to plough through my survey of almost 50 questions and then invite me into their collective home for the summer of 2002: Debbie Baker, Crysothemis, "Drucilla" (for an encore performance!), Kelly Funk, Stephanie Grant, Beth Haddrell, Val King, Cynthia Lockington, Kit Mason, Anne Milliken, Audra Morrison, Karen Sieradski and Meg Wittenmyer. A very big thanks to Colleen, Carla Coupe, Karen Byerly, Nicole K Drake, Rowan Fairchild, Bonnie Gibbons, Otsoko Guretxea, Liaison and Viridian5 for giving me permission to use their MRKS contributions from the data collection period. I also want to thank those participants who took the time to read over some of the chapters and provide feedback. I want to single out Audra, Kellie and Sarah for being there (virtually speaking) over the years whenever I had questions or needed clarifications, and Jennifer, who went beyond the call of duty to provide a beta *par excellence*, Mike, those DS DVDs were a godsend, thank you!

On the academic front, I am most grateful to my thesis supervisor, Bob Morgan, for opening my "high-culture" eyes to the pleasures of popular television and shepherding me past the missteps and false starts of those early drafts. Your close, careful readings taught me to lead in the dance with the data. A very special thanks also goes to Kari Dehli and Monica Heller for their constructive criticism and encouragement as members of my committee.

I am grateful to Gail Currie and Mireille Majoor for helping me wrangle my thoughts into a focused book prospectus. And then there is Steve Jones, without question the most generous, supportive and modest senior male scholar I have ever met. I cannot thank you enough for seriously considering the book proposal that arrived one day in your overcrowded inbox from an unknown scholar and deciding it merited a place in *Digital Formations*. Praise must be bestowed upon my editor at Peter Lang, Damon Zucca, for his patience, guidance and good humor throughout the process from contract to publication. Many thanks as well to Sophie Appel and the other folks in Production. The credit for the layout goes to the creative and meticulous Neil McDermid. Mike Lee, a kindred B5 fan, kindly allowed me to use the number 9 from his Vorlon font as the dingbat in the headings.

Some of the ideas and paragraphs in this book have appeared in an earlier form in *Convergence: The Journal of Research into New Media Technologies* (1998) and in *The Post-Subcultures Reader* (2003) edited by David Muggleton and Rupert Weinzierl. A version of Chapter 3 based exclusively on the DDEBRP data appears in the *Electronic Journal of Communication* (2004). Earlier versions of the first section (DDEB data) of Chapter 5 appear in *Feminist (Re)Visions of the Subject* (2001) edited by Gail Currie and Celia Rothenberg, and in *Resources for Feminist Research* (1999). A shorter version of the second section of Chapter 5 (MRKS data) appears in *Refractory, A Journal of Entertainment Media* (2004). I am grateful for permission to reprint a shorter version of Chapter 1 that appeared in *Popular Communication*, *1*(4, 2003).

Lee "Arithtotle" Easton, scholar and friend, what would I ("Plata") have done without your wise counsel dating back to our days of cramming for comps? The queer text of Chapter 2 would lack clarity if not for your critical eye. To my mother, Nancy. You bestowed upon me your unconditional love, and the greatest and most difficult gift a parent can give—the freedom to let me find my own way.

Last but certainly not least, I extend my love and gratitude to my partner and personal technical support provider, Luis Marmelo. You may be the world's most unromantic man and stubborn as hell, but your sharp mind, sense of humor and generosity of spirit are what count in the long haul.

☙ Preface

The story of how I came to do research with female fans could begin with the night that I came across the home page of the original David Duchovny Estrogen Brigade in 1995. But it really begins in 1990 with the purchase of my first television set. At that time I still lived by the high/low culture binary: unlike the dupes of mass culture, *I* did not lower myself to watch mindless, profit-driven entertainment pumped out by the culture industries. My television was reserved for educational, informational and aesthetic viewing (the latter involving video rentals of art house films). That all changed when I met my life-partner-to-be. Luis would arrive at my apartment after work, flick on the TV and watch *Star Trek: The Next Generation*. I was at a loss to understand how an intelligent person could watch such junk. I felt it my duty to take on the role of critic, pointing out plot and character development weaknesses. Not surprisingly, this led to a number of arguments, but my partner refused to turn off the television. As time passed, I found myself *enjoying* the show and looking forward to new episodes. A range of shows crept into our routines: the highbrow (*Homicide: Life on the Street*), the lowbrow (*Beverley Hills 90210*) and the show that in 1994 was fast becoming a cult favorite—*The X-Files*. In short, I was beginning to experience the complexities of everyday viewing processes that I was theorizing in grad school.

My theoretical paradigm shifted from Marxist to poststructuralist. Rather than a blunt ideological instrument of inculcation, I came to understand the power of television to be semiotic. Moreover, I realized that in the case of *The X-Files*, I was no longer a *bystander* but a *fan* (Jenkins, 1992). I never missed an episode and often viewed those I had taped several times. Moreover, I enjoyed discussing the show with both my partner and other friends. Conversations with female friends sometimes included "gossip" about David Duchovny's good looks and academic background (he had been a PhD candidate at Yale). Once we got internet access at home through the university, I went online in search of fan sites with my text-based browser, Lynx. My first reaction to the discovery of an electronic mailing list

called the David Duchovny Estrogen Brigade was to laugh, imagining a group of silly teenagers obsessing over the actor who played FBI Agent Fox Mulder. I may have been a fan but I was most certainly *not* a "fangirl"! Once I read over the FAQ on the mailing list, though, I realized that its members also refused this negative categorization:

```
We talk about our lives/work/SO [Significant Others]
/kids/life in general - not to mention other actors we
find talented (and not just in the looks department and
not just male ones either…So, as you can see, we're not
nuts. :-) We just have lots to talk about.
```

My curiosity piqued, I put together a questionnaire to send to list members with another doctoral candidate, Lee Easton. It was Lee who encouraged me to take the next step and turn this "side dish" into the academic main course.

I spent one year online with some of the DDEB members investigating processes of identification, community-making and production of social space in the realm of the virtual. In 2001, a year after I defended my dissertation, I decided to pursue these themes as part of another case study on online female fandom. This time I chose to focus on the popular practice of writing fiction based on media characters. I could have approached the DDEBs, for a number of the participants wrote such stories, but I ended up following one member to her new fandom dedicated to the Canadian television series *Due South*. Specifically, she was a member of a private list of women who read and wrote a genre of fanfiction known as *slash* in which male characters presented as heterosexual in the primary text are rewritten as having an intimate emotional and sexual relationship with one another. As I started sifting through four months of data, it became clear that there was a larger story to tell about female fandom.

What you are about to read in the pages that follow is the story (the synopsis of which can be sung to the tune of the *Brady Bunch* theme song) of some lovely ladies who were hanging out in cyberspace. Till they realized that expressing desire for male actors, or between male characters, was considered out of place. Rejecting this heteronormative, patriarchal standard, the ladies formed cyberspaces of their own, spaces in which their friendships, slash fiction and wit could all be honed. And that's how they became members of the David Duchovny Estrogen Brigades and the Militant RayK Separatists, and how I came to write this book.

☝ Introduction

Shooting the Breeze in the Virtual Kitchen

In the fall of 2002, the alternative rock music station in Toronto, Canada, ran an ad campaign for its website, claiming that the internet[1] was "no longer just for pervs and hackers." Their site, it claimed, finally gave music fans a reason to go online. While newsgroup statistics, past and present, do confirm that pornography and illegal software download sites are among the most popular,[2] media fans have always had a strong online presence. Bruce Sterling (1993) notes that one of the first electronic mailing lists created on the ARPANET in the 1970s, and indeed one of the most popular, was "SF-LOVERS" for science fiction fans. Nancy Baym (2000) notes that rec.arts.tv.soaps is one of the oldest Usenet newsgroups. My search of Usenet groups through Google indicated that the bulk of fan-related newsgroups is located in the alt. section, with 1180 clustered under alt.fan, 719 under alt.music and 340 under alt.tv.[3] No other subject area has comparable numbers of groups. Moreover, visits to websites that serve as clearinghouses of fan resources reveal that every popular media text or artist is the topic of several to several hundred discussion forums, including mailing lists, message boards and live chats. It would appear that the *oral culture* that John Fiske (1989) contends surrounds and makes media texts meaningful has a vibrant online component. Being a fan, however, often involves more than talking about one's favorite show, band or movie. Many fans are also active producers of their own texts, creators of artwork, fanfiction (written as one word) and music ("filk") (Jenkins, 1992). The internet has become a site of publication and distribution that both overlaps with and provides an alternative to fan conventions and fanzines.

But a funny thing happened on the way to the online fan forum in that first push into cyberspace ten years ago. As quickly as they arrived, groups of female fans turned their backs on the public spaces of interaction such as Usenet. The user surveys from The Georgia Institute of Technology offer an explanation: in 1994, 94 percent of users were male, the majority of whom worked as computer

professionals.[4] Facing varying degrees of harassment and denigration on the male-dominated forums, many female fans chose to stake out and colonize cyberspaces of their own in the form of private mailing lists.[5] The first such list appears to have been qllc, Quantum Leap Ladies Club,[6] founded in October 1991 (MacDonald, 1998). In late 1992, seven female "Trekkies" set up the Star Fleet Ladies Auxiliary and Embroidery/Baking Society. By June 1993, there were 21 members and the requests for membership came in steadily from other female fans, reaching a total of 48 members at its peak. Around the same time, Kellie Matthews, one of the original members of SFLA, helped set up a women-only list dedicated to the actor who played the role of Captain Jean-Luc Picard in *Star Trek: The Next Generation*. As with the SFLA, the name of the list—The Patrick Stewart Estrogen Brigade—was tongue-in-cheek, playing with the stereotype of female fans obsessed with an actor (personal communication, February 27, 2003). In September 1993, shortly after the first broadcast of *The X-Files*, Kellie, along with another SFLA member, Julia Kosatka, formed The David Duchovny Estrogen Brigade (DDEB). Julia commented that she "liked the idea of trying to replicate what we had over in the SFLA... plus [David Duchovny] is, well, shall we say, 'interesting' to discuss :-)." Others heard about the creation of the DDEB through the announcement on alt.tv.x-files or friends on other email lists. Some were invited to join by Kellie or Julia. Requests to join this list named after the male star of the series quickly reached 50, and in January 1994, the DDEB2 was set up, with DDEB3 quickly following. Despite continued requests, a decision was made to not take any more members or form any more DDEBs. A precedent had been established, however, and other women-only fan lists began to spring up. In addition to the dozens of "estrogen brigades" that now exist, there are lists with names such as Highlander Lust List Limited (HLLL or the HeLLLions), set up in 1995 by original PSEB member Diane Taurins.

Since 2000, internet surveys have confirmed that gender parity among male and female users has been reached.[7] Demographics alone may suggest equally distributed numbers of men and women across fandom, but my admittedly limited web searches indicate more of the same. For instance, forums dedicated to blockbuster trilogies like *The Matrix* and *Lord of the Rings*, popular with both genders, appear to be dominated by male fans. Message boards on websites (not Usenet groups) dedicated to actors like Keanu Reeves ("Neo") and Orlando Bloom ("Legolas") are dominated by female fans. Other examples of women-centered spaces are those dedicated to fanfiction. In particular, relationship-centred fiction involving both

male/female pairings of characters (*het*) as well as male/male or female/female pairings (*slash*) is primarily written and read by women. Sheer numbers do ensure that female fans today have more options than private lists.

As a distinct subculture of a burgeoning online media fandom, women-only and women-centered fandoms are ripe for scholarly investigation. More importantly, and for reasons that will become clear in the pages that follow, it is a subculture that casts in relief three key issues at the heart of social uses of internet: identity, community and space. This book presents two ethnographic case studies of female fan forums: the women-only David Duchovny Estrogen Brigades, and the women-centered Militant RayK Separatists (MRKS), whose members are readers and writers of male/male slash based on the main characters, Benton Fraser (Paul Gross) and Stanley Ray Kowalski (Callum Keith Rennie), of the Canadian television series, *Due South*. Before I discuss the methodology and the case studies in more detail, I would like to outline the theoretical framework.

Theory On (the) Line

That Was Then, This Is Now

According to the "first wave" of cybertheorists and commentators, women-only, or even women-centered cyberspaces should never have formed. Computer-mediated communication (CMC) was supposed to circumvent and, indeed, render irrelevant physical markers of race, gender, sexuality, ability and age that can impede face-to-face communication and the formation of community. Howard Rheingold (1993a) proclaimed that we would be unable to "form prejudices about others before we read what they have to say…In cyberspace, everyone is in the dark" (p. 66). As a result, "aggregated networks of relationships and commitments…make any community possible" (p. 59).

Particularly resonant was what I call the "dream of disembodiment," inspired by William Gibson's cyberpunk trilogy. Beginning with *Neuromancer* (1984) characters "jack in" to their computers, the body nothing but "meat" to be discarded. According to Douglas Rushkoff, when one enters cyberspace, a term coined by Gibson, "one forsakes both body and place and becomes a thing of words alone" (quoted in S. G. Jones, 1997, p. 15). Mark Dery (1994) dressed the same claim in postmodern jargon: "The upside of incorporeal interaction is a technologically enabled, postmulticultural vision of identity disengaged from gender, ethnicity, and other problematic constructions," allowing users to "float free of biological

and sociocultural determinants" (pp. 3–4). Finally, computer-mediated communication was understood as taking place in a virtual locus. Michael Benedikt (1992) was one of the first theorists to think about the geography of cyberspace, albeit in the utopian framework *du jour*: "the common man [sic][8] and the information worker—cowboy or infocrat—can search, manipulate, create or control information directly; he can be entertained or trained, seek solitude or company, win or lose power" (p. 123). Similarly, Sherry Turkle (1995) lauded cyberspace as an ideal public space in which participants could "retribalize." Finally, Howard Rheingold (1993a) talked about the neighborhood pubs, coffee shops and salons he "frequented" in reference to his experiences as a participant of the WELL (Whole Earth 'Lectronic Link), a San Francisco-based bulletin board system (BBS) in its pre-internet days.

Ten years later, much rain has fallen on the disembodiment parade. One of the earliest critics, A. R. Stone (1992), states unequivocally that "forgetting about the body is an old Cartesian trick, one that has unpleasant consequences for those bodies whose speech is silenced by the acts of our forgetting" (p. 113). Anne Balsamo (1996) identifies the cyberpunk narrative as masculinist, failing to "eradicate body-based systems of differentiation and domination" (p. 128). Critical discussions of identity and its workings in cyberspace have become too numerous to list. Suffice it to say at this juncture that gender has received the most critical attention.[9] A body of work has also formed on race and ethnicity, sexuality, and class, at least in terms of access and digital divide.[10] In *An Introduction to Cybercultures*, Daniel Bell (2001) sums up many of the main issues and arguments that have emerged around social identities. In short, bodies and body-based identities matter a great deal in cyberspace.

The notion of virtual or online community has weathered the test of time far better than disembodied identity. Certainly we have moved beyond what John Hartley (1992b) has called the "hooray/boo" binary in which online communities are either seen as new and improved versions of "real life" (RL) communities or pale imitations of the real thing. Nancy Baym understood rec.arts.tv.soaps as a community of practice, whose activities involved both the interpretation of various soaps as well as the establishment of interpersonal relationships among the participants. An in-depth attempt to get at the complexities of virtual communities is the edited collection by Marc Smith and Peter Kollock (1999). Contributors Barry Wellman and Milena Gulia, for example, do a direct comparison of online and offline communities, taking a sociological approach by identifying established factors

CMC = computer mediated communications

that contribute to the building of community networks. They also vigorously challenge the assumed mutual exclusivity of these two types of communities.

Not surprisingly, discussions of community often include references to space and/or place. Jan Fernback (1999) makes the connection explicit, arguing that while we may have technologically transcended space, the identification with it is so deeply entrenched that spatial metaphors for CMC are unlikely to disappear any time soon. Finally, focus on and interest in cyberspace as a new public sphere has remained undiminished, although critical work has emerged that briskly challenges the utopian notion that ICTs will revolutionize/revitalize political society and the democratic process.[11]

My uses and understandings of identity, community and space both overlap with and diverge from those I have referenced above. I draw on an interrelated set of social theories that fall under the broad categories of poststructuralism, post-Marxism, feminism, and queer. This book broadly fits into the "genre of scholarship" known as *cultural studies*. Jonathan Sterne (1999), whose terminology I have used, characterizes cultural studies as encompassing "the political character of knowledge production, an orientation toward the analysis of context, a commitment to theory, and a theory of articulation" (p. 261). Let me begin with the commitment to theory and work back through the list for the remainder of the chapter.

Body Matters

Rather than dismiss the "dream of disembodiment" as outdated, I wish to historicize it in order to come to a more complex understanding of the body in cyberspace. After all, to celebrate the body's supposed absence is to understand it as a form of vessel that in "real life" necessarily houses yet restricts an essential self. The dream, in other words, is but a technologically enhanced version of the mind/body division, which dates back to the Greek philosophers. Sadie Plant (1997) quotes Socrates as stating that

> it seems that so long as we are alive, we shall continue closest to knowledge if we avoid as much as we can all contact with the body, except when they are absolutely necessary; and instead of allowing ourselves to become infected with its nature, purify ourselves from it until God himself gives us deliverance. (p. 178)

Socrates envisioned the purification process as an exclusively *male* preoccupation—women, it seemed, did not have souls and were nature incarnate. The desire for freedom from the body is thus a masculine quest that involves at some level a desire for freedom from the feminine; hence Anne Balsamo's position on the cyberpunk narrative as masculinist. As Judith Butler (1990) puts it, "the ontological distinction between soul (consciousness, mind) and body invariably supports relations of political and psychic subordination and hierarchy" (p. 12).

The futility of the quest to leave the body behind is foregrounded by Michel Foucault (1979), who argues that "the soul is the effect and instrument of a *political anatomy* (emphasis mine); the soul is the prison of the body" (p. 30). While he may appear to be inverting the binary, the reference to "political anatomy" indicates that the body cannot be understood in terms of materiality alone. Donna Haraway expands on this understanding: "biology is not the body itself but a discourse...a logos [which] is literally the gathering into knowledge" (quoted in Penley & Ross, 1991, p. 5). The key concept in this quotation is *discourse*, much used in social theory but not often defined. Norman Fairclough (1993), following Foucault, sees it as "a practice not just of representing the world, but of signifying the world, constituting and constructing the world in meaning" (p. 64). Consequently, we have no access to the material world and no means of making sense of it other than through systems of signification, including language. The effect of this theoretical move is to inexorably weld material bodies to discourse and thereby to systems of power and knowledge. Neither "subservient to power or raised up against it," discourse is seen by Foucault (1990) as both "an instrument and an effect of power" as well as "a hindrance or point of resistance" (p. 102). When aligned with power,

> true discourse, liberated by the nature of its form from desire and power, is incapable of recognising the will to truth which pervades it; and the will to truth, having imposed itself upon us for so long, is such that the truth it seeks to reveal cannot fail to mask it. (1972, p. 219)

Discourses are "true" in the sense that they are involved with the production of knowledge that has the *effect* of being true.

The body is one of those discursive effects. Alison Caddick (1992) describes bodies as

discursive or textual entities generally, the conventional products of particular historical circumstances...Once bodies come to be seen as a matter of coding or as texts, the relative opacity they enjoyed under modernity is circumvented. (p. 118)

A poststucturalist understanding of the body as a product of discourse rather than as a physical entity has vast implications for CMC. While we may be without the benefit of vision in textual cyberspace, there is no reason to assume that true discourses, or *regimes de savoir* (regimes of knowledge), as Foucault (1980a) would later call them, are not operating and producing bodies albeit without what Plant calls their "formal organization" (p. 177). Judith Butler's theory of performativity (1990) and Stuart Hall's of articulation (1986) are critical to understanding the processes by which the body and its identities are (re)produced through online interaction.

Performing Gender On (the) Line

Butler aptly describes the body as a boundary concept. It is neither biology nor patriarchy but "the institution of a compulsory and naturalized heterosexuality" (p. 23) that is responsible for the differentiation between masculine and feminine bodies. "The act of differentiating the two oppositional moments...results in a consolidation of each term, the respective internal coherence of sex, gender, and desire" (p. 23). She argues that this coherence is achieved through *gender performance*, "a repeated stylization of the body, a set of repeated acts within a highly rigid regulatory frame that congeal over time to produce the appearance of substance, of a natural sort of being" (p. 33). For Butler, "identifying with a gender under contemporary regimes of power involves identifying with a set of norms" (p. 126). Moreover, this system of differentiation is hierarchical: femininity is devalued and seen as deviant in relation to the norm of masculinity, as is homosexuality to heterosexuality. Butler emphasizes gender and sexuality "for the simple reason that 'persons' only become intelligible through becoming gendered in conformity with recognizable standards of gender intelligibility" (p. 16). Yet, performativity can, and certainly needs to be extended to encompass race, ethnicity and class, where whiteness and upper/middle class-ness function as norms. Ruth Frankenberg (1993) identifies three aspects of the first:

First, whiteness is a location of structural advantage, of race privilege. Second, it is a "standpoint," a place from which white people look at ourselves, at others, and at society.

Third, "whiteness" refers to a set of cultural practices that are usually unmarked and unnamed. (p. 1)

The same can be said of an upper-class or middle-class identity. Butler's claim that gender is an effect rather than the cause of "words, actions and gestures" (p. 136) suggests that gender performance is not just about ways of walking but ways of *talking*. It is not only what I do that makes me recognizable as a woman but what I say and how I say it. In an online context, the body continues to signify gender intelligibility *linguistically*. Language in this sense is the linchpin that connects bodies to their online identities. That said, I do not wish to underestimate the power of what Steve Pile and Nigel Thrift (1995) refer to as "visual practices" which "fix the subject into the authorized map of power and meaning" (p. 45). When one is unable to get a visual "lock" on other interactants' bodies in cyberspace, a certain "gap" between body and subject opens up. My own online experience and that of my research participants suggests that gender mis-recognition is commonplace. For example, I was addressed as "sir" (despite using my real name) in the context of a mailing list argument. I had made statements of bald disagreement and did not attend to the face needs of the other person, a style of interaction associated with men (Herring, 1996; Holmes, 1995). Similarly, the DDEB research participants' experiences of harassment were directly linked to whether or not they were identified as female.

> I believe my name is unique enough that males [and females perhaps] are not sure whether it is masculine or feminine. (**Bel**)
>
> I think the hyphenation of my last name scares [potential harassers] off. :-) (**Drucilla**)
>
> When I used to participate on IRC I got hit on a lot when guys figured out that I was a female. (**Megan**)
>
> I've never had a problem with any guys - of course, the fact that my name is fairly non-gender-specific may have something to do with that. (**Ash**)
>
> I consider the constant pestering by online Romeos to be harrassment [sic]. I swear I used to get talk requests once a day while I had a decidely [sic] feminine name on my account. (**Hollis**)

What is telling about these examples of mis-recognition is that they conform to gender norms: If a biological female is not identified as such by male interactants, she is assumed to be male and treated as "one of the guys."

In addition to minor gender confusion, textual cyberspace facilitates gender role playing. Multi-User Domains (MUDs) were designed specifically for this purpose, the first ones being modeled on the popular 1970s role-playing game, Dungeons and Dragons. Sherry Turkle (1995) describes MUDs as providing spaces "for anonymous social interaction in which you can play a role as close to or as far away from your real self as you choose" (p. 183). To equate role playing or masquerade with performing a gender identity that produces an intelligible gender core, however, is to misunderstand the project of postmodernity:

> For if I were to argue that genders are performative, that would mean that I thought that one woke in the morning, perused the closet or some more open space [cyberspace?] for the gender of choice, donned that gender for the day, and then restored the garment to its place at night. *Such a willful and instrumental subject, one who decides on its gender, is clearly not its gender from the start and fails to realize that its existence is already decided by gender.* Certainly, such a theory would restore a figure of a choosing subject—humanist—at the center of a project whose emphasis on construction seems to be quite opposed to such a notion. (Butler, 1993, p. x, italics mine, underline in the original)

Attempting to produce a set of behaviors and a speech style associated with masculinity or femininity still conforms to gender norms. As Plant has noted, "real life" transsexuals "are judged solely on their ability to simulate an already caricatured conception of what it is to be a proper human being. To be a proper human being is to have a proper sex" (p. 211).

Whether taking place in "real life" or in cyberspace, however, gender performance is an uncertain process:

> This "being a man" and this "being a woman" are internally unstable affairs. They are always beset by ambivalence precisely because there is a cost in every identification, the loss of some other set of identifications, the forcible approximation of a norm one never chooses, a norm which chooses us, but which we occupy, reverse, resignify to the extent that the norm fails to determine us completely. (Butler, 1990, pp. 126–7)

In spite of this assertion, the only performances that Butler identifies as potentially subversive or *parodic* are those which involve "the replication of heterosexual constructs in non-heterosexual frames" (p. 31), specifically drag and butch/femme

performances. Consequently, Butler has been criticized for failing to accord agency in any meaningful way to social subjects.[12]

A theory of articulation can be used to reorient the theory of gender performance so as to allow for more ambivalence and uncertainty as well as to emphasize the linguistic component of performance:

> It carries that sense of language-ing, of expressing, etc. But we also speak of an "articulated" lorry (truck): a lorry where the front (cab) and back (trailer) can, but need not necessarily, be connected to one another. The two parts are connected to each other, but through a specific linkage, that can be broken. An articulation is thus the form of the connection that can make a unity of two different elements, under certain conditions…[A] theory of articulation is both a way of understanding how ideological elements come, under certain conditions, to cohere together into a discourse, and a way of asking how they do or do not become articulated, at specific conjunctures, to certain political subjects. (S. Hall, 1986, p. 53)

Thus discourses can be thought of as *offering* subject positions, which may or may not be taken up or refused in what John Frow (1986) calls "the very act of producing significations" (p. 75). Wendy Holloway suggests that the same positions are articulated differently among subjects or even *within* the same subject because people have "investments, something between an emotional commitment and a vested interest, in the relative power (satisfaction, reward, payoff) which…[the offered] position promises (but does not necessarily fulfil)" (quoted in De Lauretis, 1987, p. 17). The social subjects produced through this process of identification are better thought of not as coherent, stable rational selves *a là* Descartes but as sites of *interdiscursive collision*.[13] The amount of room that one has to resist, subvert or refuse true discourses, it should be noted, is not evenly distributed among social groups and individuals and is also contingent on historical moment and location.

Performance and articulation are critical to understanding an online media fan subculture that defines itself and is defined by others through the female body. Names for women-only fan lists such as The Star Fleet Ladies Auxiliary and Embroidery/Baking Society and the [name of actor] Estrogen Brigade make direct references to female hormones, a normative female organization and normative feminine activities. In making these identifications, the members both recognize and refuse that which Dale Spender (1985) calls the *plus male/minus male* dichotomy, whereby those practices associated with femininity are measured against those associated with masculinity and found to be lacking. The SFLA FAQ, for instance,

explains that members joined the women-only list because they had tired of the "heavy male slant" of the existing Trek newsgroups, which apparently got "bogged down by posts comparing Troi's breasts to Crusher's." The DDEB members who participated in my case study referred to a double standard and denigration from the male participants on public fan forums:

> I was on alt.tv.x-files for awhile first, then as usu-
> ally happens whenever a woman starts to express her
> appreciation for an actor on the net we started getting
> "me toos" from women and flack from the men. (Why is it
> men can talk about actresses in public and not get
> flack, but let a woman talk about a man and we get
> jumped all over!) Anyway, that's why Julia and I started
> the original DDEB…I pretty much quit reading a.t.x. The
> signal to noise ratio got utterly unmanageable.
> (**Kellie**)[14]

> I decided as soon as I read Kellie's post. People think
> nothing of it if men talk about lusting after women, but
> if women discuss the sexual attractiveness of men, peo-
> ple act like were [sic] sluts. I wanted the freedom of
> being able to talk about lust without being exposed to
> condesension [sic] for it. (**Hollis**)

> I think it was in February of 1994. I decided to join
> because I found the news groups to be a little hostile
> to women expressing their admiration of an actor. Also I
> thought it might be fun. I decided to stick around be-
> cause the conversation was never limited to DD or to the
> X-files and because I met such interesting women from so
> many different parts of the world. (**Moll**)

Female fans are able to challenge plus male/minus male logic because of the shifts in the arrangement of discourses that make up the category of femininity. The "will to truth" of feminine discourses has been undermined by an alternative set of *feminist* discourses that emerged out of the women's movement of the late 1960s and 1970s. Chris Weedon (1987) divides contemporary feminism into two main strands—*liberal feminism*, which "aims to achieve full equality of opportunity in all spheres of life without radically transforming the present social and political system," and *radical feminism*, which, as the name suggests, obviously does (p. 4). In a similar vein, Julia Kristeva (1986) talks about three "generations" of feminisms. The first two parallel Weedon's categories. Bronwyn Davies (1990) describes the former as focusing on "access to the male symbolic order" while the latter is

concerned with the "celebration of femaleness and of difference, separation from the male symbolic order" (p. 502). The third generation constitutes "a move toward an imagined possibility of 'woman as whole,' not constituted in terms of the male/female dualism" (p. 502). Donna Haraway's now famous notion of the *cyborg* can be understood in relation to this third generation. Technologies are "crucial tools recrafting our bodies" and as such they "embody and enforce new social relations for women world-wide" (1992, p. 164). The image of the cyborg suggests

> a way out of the maze of dualisms in which we have explained our bodies and our tools to ourselves. This is the dream not of a common language, but of a powerful infidel heteroglossia. It is an imagination of a feminist speaking in tongues to strike fear into the circuits of the supersavers of the new right. (p. 181)

In forming and joining the DDEBs, members chose to take the separatist route. The quotation from Moll in particular emphasized the pleasures of inverting the binary and creating a "plus female" category. When I suggested in an early conference paper that they were cyborgs, the participants strongly objected. Given the representations of cyborgs in popular culture as muscle-bound, robotic men—Arnold Schwarzenegger in *The Terminator* films and the Borg of the television series *Star Trek: The Next Generation*[15] to name but two examples—they felt that the term stripped away not only their humanity but their femininity as well. This reaction is certainly understandable in light of the historical struggle that women have waged against being positioned as "minus male."

One reason for conducting an ethnographic investigation into online female fandom is to get beyond static schemas of feminism. Given the multiplicity of contradictory discourses offered to us, we must "live with multiple contradictions and the contradiction between femininity and feminism is one of these" (Davies, 1990, p. 501). If identity is as Frow says, produced at the moment of signification, then collection and analysis of online interaction is one means of tracking which subject positions are taken up and which ones are refused at different moments.

Women-centered slash fiction lists involve not only feminine but queer identifications. The collection of theories that fall under the rubric of queer displaces the masculine/feminine binary at the heart of feminist analysis with that of the heteronormative/nonnormative. The reclaiming of the 1950s sexual epithet began in the late 1980s with the politics of Queer Nation ("we're here, we're queer"). First used in the academy by Teresa de Lauretis in 1991, "queer" has come to embrace

a multiplicity of nonnormative sexualities, including gay and lesbian, that don't necessarily rely on homosexual practice. Eve Kosofsky Sedgwick deploys queer as follows:

> the open mesh of possibilities, gaps, overlaps, dissonances and resonances, lapses and excesses of meaning when the constituent elements of anyone's gender, of anyone's sexuality are made (or can't be made) to signify monolithically. (Quoted in D. E. Hall, 2003, p.70)

Making connections with other women, both straight and bisexual, who write about emotional and sexual relationships between male characters written as straight in the primary text is thus less a rejection of gender norms than a rejection of heterosexual norms. These "misalignments" of desire, as represented in slash texts and as experienced and discussed by its readers and writers, are parodic performances as defined by Butler.

Another identification central to female fandom is class. Sedgwick (1993a) makes the case that "the person who is disabled through one set of oppressions may *by the same positioning* be enabled through others" (p. 253, emphasis in the original). She gives the example of the educated middle-class woman who is expected to defer to men of the same class but would expect to be deferred to by men and women of lower classes. Kellie's comment about the unacceptable signal-to-noise-ratio on alt.tv.x-files was not solely a reference to sexist discussion on the public forums but also the *quality* of messages posted by "the internet masses": those participants perceived to be unable to discuss topics in an intelligent, rational, coherent and polite manner. In other words, those unable (or unwilling) to adhere to the standard of expression of the university-educated middle class. Several DDEB members singled out America Online (AOL) as the culprit, remarking that quality of discussion on public newsgroups dropped drastically when in 1996 the service provider's 10 million subscribers were given full access to the internet. As Dani quipped, "AOL = Airbrains OnLine." Similarly, the members of MRKS were as concerned about the "hotness" of slash as they were about its quality. The welcoming message sent to new members of MRKS states, "Thanks for sticking up for rational debate, RayK, and Fraser." The follow-up message of list netiquette includes a stipulation for mandatory spell checking. As such, the object of study presented in this book is more accurately described as "elite" or "discerning" female fandom.

Community On (the) Line

As noted, much of the literature on online community debates whether various definitions of "real life" communities can be applied to online communities, and whether communities can be created and maintained in cyberspace. While I concur with those who make the case that both are possible, I wish to tease out the implications for an understanding of community implied by a theory of identity performance/articulation. If the body is a truth effect, then the same can be said of community. Judith Butler (1990) states that the former has "no ontological status apart from the various acts which constitute its reality" (p. 139). By extension, what gives a community its *substance* is the consistent repetition of these "various acts" by a majority of members, acts that I refer to as *communal practices*. Drawing on David Buckingham (1993), being a member of a community is not something one *is* but something one *does* (p. 13). My working definition of community is based on one put forward by the Miami Theory Collective (1991): "a *partial* and *provisional* cathexis of social identities that binds together some of the 'loose ends' into an alignment that remains historically and politically contingent" (p. xxi, emphasis in the original).

One further distinction needs to be made between an *imagined community* (Anderson, 1983) and what I call an *interactive community*. While both involve a sense of belonging, an imagined community constitutes larger formations such as a nation in which members share a set of identifications but do not necessarily interact with one another, or perhaps more importantly, do not necessarily desire to do so. My use of community will henceforth be shorthand for the latter, the online form of which has been described by Howard Rheingold (1993b) as "social aggregations that emerge from the Net when enough people carry on those public [and private] discussions long enough, with sufficient feeling, to form webs of personal relationships in cyberspace"(p. 5). Accounts of community in CMC literature to date, however, neglect to sufficiently problematize the desire for community. Linda Singer (1991) argues that the function of communal formations "has largely been that of managing, consolidating, or overriding the dissembling effects of a *non*regulated interplay of differences" (p. 124). In other words, creating a group that uses the pronouns "we/us/our/ours" necessitates the establishment of practices that set out to create conformity and contain difference. The name David Duchovny Estrogen Brigade, for instance, overtly signals that membership involves an adherence/allegiance to a feminine heterosexual identity. While naming the lists as such was intended to exclude male fans and celebrate female desire, it also had the

effect, intentional or not, of excluding female fans of *The X-Files* who may have wanted to join a women-only list but identified as lesbian.[16] Iris Young (1990) nicely sums up the dream of community and the problem with it:

> Community is an understandable dream, expressing a desire for selves that are transparent to one another, relationships of mutual identification, social closeness and comfort. The dream is understandable, but politically problematic... because those motivated by it will tend to suppress differences among themselves or implicitly to exclude from the political groups persons with whom they do not identify. (p. 300)

In the case of female fans who were made to feel like outsiders in male-dominated forums, the dream of a community bringing together like-minded women had a powerful resonance. Yet, it is important not to romanticize communities that are formed out of exclusion and/or marginalization. Within *every* community, there is a minority who are not always able or willing to engage in the established communal practices but their desire to belong to the community will keep them from leaving. Even when conceptualized as an alignment of "loose ends," these loose ends are organized along an insider/outsider binary wherein exclusion necessarily goes hand in hand with inclusion. Another reason for conducting ethnographic research into female fan communities is to not only get at the specific communal practices that create an effect of substance but also at the ways in which those practices create insiders and outsiders, however unintentional.

Space, Place and the Heterotopia

The process of creating and maintaining online communities is not only a social practice but a *spatial* practice as well. All social relations, according to Doreen Massey (1994)

> exist necessarily *in* space (i.e. in a locational relation to other social phenomena) and *across* space. And it is the vast complexity of the interlocking and articulating nets of social relations which is social space. Given that conceptualization of space, a "place" is formed out of the particular set of social relations which interact at a particular location. And the singularity of an individual place is formed in part out of the specificity of the interactions which occur at that location (nowhere else does this precise mixture occur) and in part out of the fact that the meeting of those social relations at that particular location... will in turn produce new social effects. (p. 12)

Space, like the body and community, needs to be understood as being discursively produced through interaction and not just as a location in which interaction takes place. By the same token, Massey recognizes that "the social is spatially constituted...All social (and indeed physical) phenomena/activities/ relations have a spatial form and a relative spatial position" (p. 265). The interstice of the social and the spatial is illustrated by the historical demarcation between public space, which is supposed to be for all but in fact was traditionally the space of aristocratic or bourgeois men, and the private space of women in the household or domestic sphere. Similarly, immigration controls at designated points of entry to a nation legitimate specific social relations for a spatial context: citizens, landed immigrants, refugees or visitors from other nations. Those who skirt these points of entry are classified as "illegal aliens." The same can be said of media culture, primarily organized as a unilateral cultural "flow" from the United States and across the borders of other nations onto CD players, radios, and movie/television screens.

If space is constructed by discourse, then the binary between "real life" (RL) space and cyberspace collapses. Yet, it is resurrected as soon as one speaks of cyberspace in terms of metaphor or symbol. The locus of interaction may be *imagined* but it is done so predicated on the same sets of normative spatial relations that construct RL space. Thus, interaction in a virtual bar is likely to follow the conventions of RL bar interaction and differ from interaction in a virtual kitchen. Massey also argues that gender is "deeply implicated in the ways in which we inhabit and experience space and place, and the ways in which we are located in the new relations of time-space relations" (p. 9). It is no coincidence that Rheingold (1993b) enjoyed being part of the "global bull session" (p. 3) of informal *public* spaces, whereas interaction on the DDEBs was described by one member as "sitting around someone's kitchen shooting the breeze about whatever comes to mind." In other words, the members preferred the intimacy of a *private* domestic space associated with femininity.

Ethnographic studies have been conducted on public sites such as newsgroups and MUDs/MOOs.[17] The same is true of the commercialization and privatization of cyberspace by corporations as well as broader surveillance and privacy issues.[18] Yet very little has been done on those cyberspaces demarcated as private. Jean Camp (1996), for example, described her online experience as a female computer programmer as analogous to sailing in rough seas, "buffeted by high winds of derision and sucked down into whirlpools of contention" (p. 114). In the face of hostility and harassment, "we withdraw to a room of our own—to mailing lists.

Even the most indomitable woman needs a port of call" (p. 115). The logical choice for Camp was Systers, a listserv designed for women in the same male-dominated field. Sue Ellen Case (1996) described Sappho, the list for lesbian women, as a "serene isle...[that] floats within a wide sexist sea" (p. 84).

To read the move from public to private by female fans as simply a retreat to the traditional sphere of femininity, however, would be a mistake. Rather, the regulatory function of the binary is disrupted, resulting in variations of what Michel Foucault (1986) calls the *heterotopia*—a space in which alternatives to the dominant social order can be gleaned:

> There are also, probably in every culture, in every civilization, real places...which are something like counter-sites, a kind of effectively enacted utopias in which the real sites...are simultaneously represented, contested, and inverted. (p. 24)

Foucault stresses that the heterotopia is always marked by difference and deviation from the norm. The sites he identifies range from the older sacred and/or forbidden sites "reserved for individuals who are, in relation to society...in a state of crisis: adolescents, menstruating women, pregnant women, the elderly, etc." to the prisons and psychiatric hospitals of modern societies (pp. 24–25). However, defining such spaces in terms of deviance alone fails to accord agency to those thought of in such terms. It is important to also understand the heterotopia in terms of resistance, inversion, subversion or perhaps simply a space in which active consent to normative practices is suspended. Kevin Hetherington (1997) suggests that the heterotopia be thought of "as a practice that challenges the functional ordering of space while refusing to become part of that order" (p. 46). Members of women-only lists challenge the normative order simply by refusing to accept the fan practices engaged in by male fans and gathering in spaces of their own. According to Elspeth Probyn (1993), "being *with* women is not natural, is not a given; in fact, in our culture, it is ideologically produced as strange, as lacking something" (p. 33, emphasis in the original). Deviation from the norm is even more marked on a list like the Militant RayK Separatists where heterosexual desire is eschewed through the reading and writing of slash fiction. Finally, the presence of predominately American fans on a list dedicated to a Canadian series reconstitutes national borders by reversing the normative media flow.

The negative consequences of being marked out as Other cannot be dismissed. Women-only lists have been singled out as targets of ridicule, as this statement from a DDEB member indicates:

```
The only time I ever flamed somebody was when a certain
male personage slagged the DDEB repeatedly in his
posts…In particular I objected to his assertion that
women "couldn't possibly have anything interesting to
talk about" by themselves without men present. I REALLY
let him have it, in front of the entire X-Files mailing
list. So did a couple other DDEB sisters, and he hasn't
been heard from in a LONG time. (Mari)
```

Readers and writers of slash are subject to even more vitriolic attempts at "othering." A number of participants referred to themselves as "closeted" in fear of retribution at work or at home. One member in particular has had marital problems and nearly lost her job. My final reason for examining female fandom ethnographically is to extend an understanding of such cyberspaces as potentially heterotopic in their reworking and transgressing of normative spatial practices and relations.

Ethnography On (the) Line

The theories of online gender performance, community making, and the production of space outlined above are greeted in this book with rich ethnographic data collected over extended periods of time. I would like to start by introducing the two case studies. Next I will turn to the set of issues that arise in doing such research in a virtual "field," to larger issues of knowledge production and power relations between researcher and participant.

Life on the DDEBRP

On March 8, 1996, the listserv for the David Duchovny Estrogen Brigade Research Project (DDEBRP) became operational with the 21 members from the three DDEBs who had completed questionnaires. Two participants left the list within the first week, citing the volume of list "traffic": 50–80 messages a day for

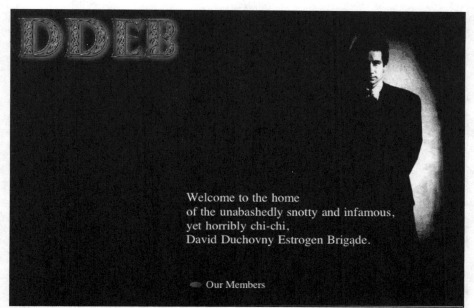

Image 1 The original DDEB FAQ.
Credit: Julianne Lee. Used by permission.

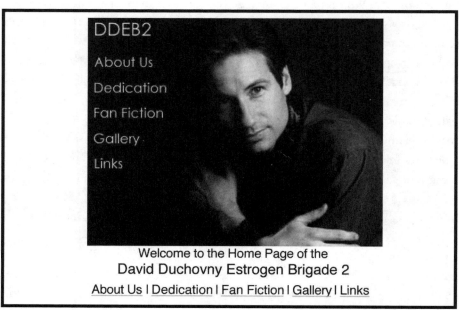

Image 2 DDEB2 homepage.
Credit: Lara E. Eakins. Used by permission.

Image 3 DDEB3 homepage.
Credit: Beth Wilson and DDEB3. Used by permission.

the first month. Within that first month, two more participants unsubscribed for personal reasons. In August and October, two more members left the list but remained part of the project. Two new DDEB members joined the project in April and June respectively after hearing about it on their respective lists. From April to June, list traffic averaged 40 messages a day. In the summer, though, sometimes more than a week would go by with no messages being posted. By September a pattern had been established in which quiet periods of less than 10 messages a day would be punctuated by intense exchanges comprising 20 to 40 posts a day over a period of several days. By April 1997, I ended data collection, having collected a large enough sample of list practices with which to start formulating hypotheses about the practices of community and performances of gender. Most of the members continued to post to the DDEBRP for another two months, when a collective decision was made to shut the list down permanently.

It is important to realize that the DDEBs and the DDEBRP were not just communities of fans but also communities of friends. I did not quantify my data, so I can only roughly estimate that 25 percent of the "threads" (messages with the same subject header) were fan related. Members estimated that between 5 and 20 percent of discussion on their respective lists was related to David Duchovny. The

bulk of the exchanges involved the sharing of life experience, supplemented by current events and politics. In relation to the first, members sought and offered advice on a range of topics, from sewing to pet care to car maintenance. They also supported one another, either by celebrating good news or by commiserating in times of stress.

The following demographic information is for 18 of the 19 participants whose contributions were included in the project: one member did not return this section of the questionnaire. Three indicated they were between 22 and 25, three between 26 and 30, five between 31 and 35, five between 36 and 40 and two indicated that they were between 41 and 45. All self-identified as white, either by using this racial category or using categories like "European-American" or "Anglo-American" (two included "non-Hispanic"). Two were Canadian and the rest were American. Although I did not ask about sexual orientation, it is unlikely that female fans who identified as lesbian would join a list whose name, however playfully or ironically, foregrounded heterosexual desire. As far as education can be used as a broad indicator, the participants would be considered middle class, all having completed a minimum of two years of university. Seven had begun and five had completed a Master's degree. Most had indicated that they were interested in politics and concerned with environmental and social justice issues. Twelve identified themselves as feminists, and three others noted that while they did not use the term, they held a number of feminist beliefs. Only one member overtly stated that the term had a negative connotation, "bringing to mind burning bras and giving speeches."

Meet the MRKS

The Militant RayK Separatists list was founded in October or November 1999 by five members of Serge, the only *Due South* slash list that emphasized the pairing of Royal Canadian Mounted Police (RCMP) Constable Benton Fraser, on assignment in Chicago, with Chicago Police Detective Stanley Ray Kowalski.[19] In the first two seasons of *Due South* (1994–1996), produced by Canadian-based Alliance Atlantis in conjunction with CBS, Benton Fraser's partner was a police detective named Ray Vecchio (David Marciano). After being cancelled by CBS, the series continued to be made and broadcast in Canada, but with Callum Keith Rennie in the role of the "second Ray." AuKestrel, one of the founders of the MRKS, emphasized in an e-interview that the fandom was and still is plagued by "the Ray

Image 4 MRKS homepage
Credit: Aukestrel. Used by permission.

wars" where fans have clear allegiances to one Ray or another. She explains how the list got its tongue-in-cheek name:

> Some of us had been active in defending Ray Kowalski on a Both Rays type list, and some of the Ray Vecchio fans started calling Ray Kowalski fans "RayK separatists." We thought it was funny, and added "militant" to the moniker, so when we came up with the idea for the list, MRKS seemed like a natural.

The list began with 25 members and had grown to 40 by the time the MRKS project got underway in March 2002. I began with a questionnaire which 13 members completed. I then arranged to join the list from May to September. Nine additional members gave me permission to use their list contributions during the data collection period. Another returned the consent form specifically stating she did not wish to participate in the study. MRKS had far less traffic than the DDEBRP. In May, June and July, 5–25 messages were posted almost daily. In August, list traffic dropped off to an average of 5 messages every other day. Perhaps surprisingly, neither the series or slash was discussed much. Members occasionally

posted stories or links to stories that they had written or either recommended or criticized other stories they came across. Instead, list discussion centered on the current media projects of actors Paul Gross and Callum Keith Rennie. Current events related to Canada or gay politics were also touched upon. Unlike the DDEBs or the DDEBRP, little emphasis was placed on the sharing of personal experience. Drucilla, a member of both lists, explained

> Unlike the DDEBs…the MRKS list was built from the start
> to be less tolerant of off-topic personal posts. This
> came about because most of us were 'refugees' from
> …"Serge" which had become a list where its 200 or more
> members were talking about everything BUT Due South and
> we were tired of that, so we deliberately requested from
> the beginning that people restrict themselves to more
> fan-specific posts on MRKS. [ellipses mine]

These comments should not be taken to mean that the relationships among members were strictly impersonal. Rather, personal exchanges took place offlist.

Of the thirteen participants who completed the questionnaires, only one was under thirty. Five were between 36 and 40, six between 41 and 45 and one was between 46 and 50. With the exception of one Canadian, all were American. Seven identified as heterosexual although several claimed to have "experimented" or emphasized the connection they felt to women emotionally. The other six identified as bisexual, two stating a preference for the term "queer," an identification I will discuss in Chapter 2. As with the DDEBRP participants, all identified as white and all had completed at least two years of college. Two had PhDs and six had Master's degrees. All but two considered themselves feminists.

How Real Is Virtual?

Consent and Confidentiality. Like any research project involving human subjects, ethical guidelines must be followed. However, there is debate in the internet research community whether consent is needed if interaction is taking place on public forums like chats, newsgroups, MUDs and mailing lists that have open memberships. Lynn Cherny (1999) feels that it is whereas Susan Herring (referenced in Cherny) does not. Barbara Sharf (1999) reports on the incredulity of colleagues that she would take the time to contact each participant and seek permission to use their contributions to an open breast cancer support list. Since the David Duchovny Estrogen Brigades and the Militant RayK Separatists are closed lists, access could

not have been gained without explicit permission of the members. I prepared formal letters of consent as part of the ethics review process at the universities where I was a graduate student and faculty member. My request to join the original DDEB, DDEB2 and DDEB3 was refused. At the suggestion of one member, I set up the research list and asked members from all three lists to join as participants. Like the DDEBs, the DDEBRP was a closed but unmoderated list; nobody was able to join and participate without the approval of the list owner (myself), but posts were automatically sent to all list members without being vetted by a moderator.

The situation was different with the MRKS study. One of the DDEBRP participants was already a member and through her I had met several other members face to face during their visit to the Toronto area to see Paul Gross in the Stratford production of *Hamlet*. My request to join the list for a four-month period was granted. The DDEBRP members gave a broad permission to use any contribution to the list, with the option to withdraw from the project at any time. Because MRKS was not a research list, I provided two options; the broad permission as with the DDEBRP and a limited permission which required me to consult with the member about using her contributions as data samples. Two participants chose this option. As for confidentiality, the names that appear are generally pseudonyms. In some instances I have used real names or "pseuds" used by the participants in fandom. For example, when quoting from writing that has been "published" online, using the project pseudonym could reveal their identity.

The Field. Christine Hine (2000) points out that ethnographers are expected to spend considerable time in the field as well as engage in a range of techniques to provide as rich a picture as possible of the everyday lives and social experiences of the participants. She then asks how a field can be constituted in cyberspace and how one goes about living and observing in this virtual field. While this does not mean being logged in 24 hours a day, conducting ethnographic research online is more than reading a newsgroup archive with no contact with participants. "Real-time engagement" with participant interaction combined with other forms of interaction with participants to provide "a kind of triangulation" is her recommended approach to virtual ethnography (p. 21). My studies with the DDEBRP and MRKS both began with a lengthy questionnaire (please see Appendix) distributed by email. Aside from providing background and personal information, the responses were very useful in helping me both hypothesize about practices I might expect to find evidence of (or not) over the course of the study as well as cross-check participants'

claims with their actions. To illustrate, almost all the DDEBRP participants claimed they did not "flame," that is, send insulting, confrontational posts, but preferred to resolve conflict and defuse situations that could lead to a flare up of hostilities. These claims were borne out by the data. Similarly, discussions on MRKS about the importance of "quality" fiction complemented their questionnaire responses on the same topic.

For the DDEB project, I conducted follow-up interviews by email, gaining valuable insight into "inter-DDEB politics" that I had sensed at times through interaction. Taken together, their comments revealed an underlying lack of trust among the members of the different brigades, partially explaining the friendly though not particularly intimate interaction that characterized the list. As I was not a reader or writer of slash, I consulted with MRKS members for explanations about jargon, acronyms and abbreviations used in the interaction. In addition to triangulation, it is critical to consider the length of the time in the field that will result in a sufficiently rich data set. As noted, I collected data for one year on the DDEBRP and I spent four months on MRKS.

Observation. The issue of observation ties into an understanding of the body as *remotely embodied* (Marvin, 1988). Without the benefit of visual scrutiny, the question arises whether the researcher can be certain of the participants' identities. "When we move from face-to-face interaction to electronically mediated contact," notes Hine, "the possibilities for informants to fool the ethnographer seem to multiply" (p. 22). Role-playing MUDs and newsgroups, however, are very different contexts from closed mailing lists. The majority of participants in both studies were interested in extending their relationships beyond the screen and so had met at least one other list member whom they did not know prior to joining the list. Some have even used their vacations to visit those who had become friends. Deception is of course part of "real life," but very rarely to the point of creating gender illegibility. Given the length of the data collection period, the checks and balances provided by a number of the participants' long-term relationships on and offline, as well as the commitment and skill required to produce a convincing gender masquerade, it is highly improbable that there were any men masquerading as women on the DDEBRP.[20] At the time of the data collection, MRKS had one male member, who openly positioned himself as an out gay man.

Lori Kendall (1999), who had access to her participants both online and face to face, points out that "the ability to access off-line environments provides

particularly useful information about the connections between on-line and off-line interaction, but such access may not always be possible" (p. 71). The latter was the case in both the DDEBRP and MRKS studies; none of the participants lived in Toronto. Corporeal processes of identity performance and community making, however, were not part of the focus of either case study. Any information I needed on RL contexts, I was able to gain through the questionnaires, list discussion, and the e-interviews. I had the opportunity to meet two DDEBRP participants socially during the data collection period. What I gained was not more "information" that helped me better understand them as remotely-embodied subjects but rather a powerful reminder of the regulatory function of the gaze and the ways in which normative discourses on femininity discipline the fully embodied female body. I had found myself making judgments, both positive and negative, about their appearance as I'm sure they did with me.

Hine also raises the issue of lurkers in online settings: those who read messages but do not post. If they do not contribute, how can they be "observed?" I had three participants on the DDEBRP I would classify as such. Together, they sent less than a total of a dozen messages, most of those in the first two months. Yet all three completed the preliminary questionnaire, and I interviewed them by email at the end of the data collection period about their mode of participation. Similarly, two MRKS members completed questionnaires but never posted any messages during the data collection period.

Speech or Text? Steve Jones (1999) aptly describes computer-mediated communication as creating "artifactual textual traces of interaction...instantaneously at the moment of utterance" (p. 13). Sherry Turkle makes a similar point, suggesting that "this new writing is a kind of hybrid: speech...frozen into artifact" (p. 183). While this blurring of the boundary between text and speech is most obvious with synchronous CMC in which words scroll up on the participants' screens as they are typed, mailing lists can approximate real-time interaction if a number of members are online at the same time and the server is fast enough to distribute the messages almost instantaneously. Even with asynchronous communication, one refers both to "messages" being "posted" or "sent" to a newsgroup/list as well as to "chats" "discussions" or "conversations." Users try to approximate face-to-face interaction by using a variety of conventions, both borrowed from novels and scripts as well as invented specifically for this medium. Nancy Baym (1995), for example, describes these hybrid features in the context of interaction on rec.arts.tv.soaps. Lynn Cherny

(1999) makes the case that MUDs like ElseMOO have developed their own register, related but not identical to those of note-taking, amateur and CB radio as well as sports commentary.

Conceptualizing newsgroups as interactive "makes them ethnographically available," notes Hine, as orality is the privileged form of communication in this type of research (p. 53). However, she contends that is it also useful to understand them as text:

> A textual focus places emphasis on the ways in which contributions are justified and rendered authoritative and on the identities which authors construct and perform through their writings. This approach to ethnography suggests a discourse analytic stance. (p. 53)

Of course, speech in any ethnographic project eventually becomes text to be analyzed, through the process of recording and transcription. Virtual ethnography eliminates this time-consuming and potentially expensive intermediary step. Having "instant data" is not just about convenience but affects the analysis and findings. On the one hand, I was able to collect very large, rich data sets. On the other, it was impossible to go through the sets in their entirety with a fine-toothed comb, even with qualitative software QSR N6, an opportunity that the process of transcription affords the researcher.

In presenting data samples from list discussion, I have tried to approximate the form of the original email messages. To save space, the only line I have used from the message "header" is the "From:" line. Unless necessary for clarity, I have removed all text from a previous message that was included in the reply. I have also removed any "signatures" or "signature files." I have not "cleaned up" any typographical errors. I have also included only the section of the message relevant to the argument, using ellipsis marks only if text was removed from that particular selection. In presenting exchanges, I have "threaded" the messages and removed those not directly relevant to the argument. Data samples presented from the questionnaires, in contrast, are identified by a name in brackets at the end of the quotation.

Ethnography as Responsible Knowledge Production

"The ground on which ethnography is built...is a contested and fictive geography," asserts Deborah Britzman (1995, p. 134). Ethnography, whether "real" or virtual, is ultimately about the production of knowledge. As I suggested in the

theory section, knowledge is not, *pace* Fox Mulder, "out there" waiting to be discovered. Rather, it is both produced and productive. According to Donna Haraway (1988), "knowledge from the point of view of the unmarked is truly fantastic, distorted, and irrational" (p. 587). She accuses researchers who take up the position of objective bystanders, the cornerstone of the positivist tradition of empirical research, of playing the "god trick." The alternative to "totalization and single vision" does not have to be relativism but "partial, locatable, critical knowledges sustaining the possibility of webs of connections called solidarity in politics and shared conversations in epistemology" (p. 584). Haraway's approach is one based on what she calls *feminist objectivity*. It "allows us to become answerable for what we learn how to see" (p. 583) and "makes room for surprises and ironies at the heart of all knowledge production" (p. 594). In a similar vein, Patti Lather (1991) talks about *post-positivism*, an approach that shifts the emphasis from reliability and validity to reflexivity. One of the goals of the researcher becomes finding ways to avoid lapsing into the position of "the silent [observing] Other who is present in, while apparently absent from, the text" (Walkerdine, 1990, p. 173). Sandra Harding (1987) argues that the best analysis

insists that the inquirer her/himself be placed in the same critical plane as the overt subject matter...That is, the class, race, culture, and gender assumptions, beliefs, and behaviors of the research her/himself must be placed with the frame of the picture that she/he attempts to paint. (p. 9)

Similarly, Deborah Cameron and her four co-authors (1992) remind us that research subjects must not be seen as passive but as "active and reflexive beings who have insights into their situations and experiences. They cannot be observed as if they were asteroids, inanimate lumps of matter: they have to be interacted with" (p. 5).

It is important to stress that none of these scholars is suggesting that rigor and method be abandoned for an "anything goes" approach. Ethical guidelines must be followed in collected data and the data collected must be interrogated systematically. What differs is the set of questions asked and the criteria used to achieve a post-positivist reliability and validity. In the end, we must recognize that all ethnographic texts are "overinvested in secondhand memories" (Britzman, 1995, p. 153). List interaction or questionnaire responses, for example, are *not* unmediated evidence of social experiences but *representations* of those experiences, constructed

first by the participants themselves and then by the researcher in the analysis of the data and the presentation of the findings as a coherent text.

To address the above-mentioned issues of responsible knowledge production, I engaged a number of strategies. First, to account for my presence in the frame of my research, I made a choice to participate actively in the community-making process. Consequently I joined and initiated discussion topics or "threads" rather than silently downloaded data. As an *X-Files* fan and list owner, I was much more active on the DDEBRP than on MRKS, where I was an invited guest and not a reader or writer of slash. Yet, I was also aware that I was an outsider on the DDEBRP as well, particularly at the beginning of the project. Several participants told me in follow up e-interviews that they had joined the list because they wanted to keep tabs on me and the work I produced. They had felt betrayed by journalists who had interviewed them and then produced stories that denigrated the DDEBs. Also when I started up the DDEBRP in 1996, my status as an online media fan "newbie" positioned me as an outsider. For example, the participants knew to place the word "spoilers" in the subject line and added enough blank lines to fill a computer screen at the start of any message that gave away plot details of an episode in case some members might not have seen it. It was only when Drucilla politely pointed out that I had failed to abide by this convention by deleting the blank lines in my responses that I recognized it for what it was. Borrowing from Britzman, it was through the process of making sense of my own practices on the DDEBRP that I was able to interpret those of the participants. In this sense, being an outsider had its advantages, for it is often through violations that rules become obvious.

In an attempt to address researcher-participant power relations, I chose to include my own practices of community and gender performances in the analysis. Some of my contributions appear in the DDEBRP data samples presented in the following chapters. When discussing DDEBRP interaction, I refer to the "DDEBRP members," a category which includes both participants and myself. Writing "we" instead of "they" made me think through my claims carefully, for it is much easier to make claims about others. Because not all MRKS members were participants in the project and not all completed the questionnaire, I use the terms "participant" in relation to the data samples of list discussion and "respondent" in relation to data samples based on the questionnaire.

I asked the participants to choose their own pseudonyms (most did), for I believe that maintaining ownership over one's name is a discursive strategy that is linked to autonomy of "voice." Their choices were interesting: one participant chose

a great grandmother's name, another her middle name. Several chose names of favorite fictional characters, others their pets. "Mrs. Hale," for example, was a tongue-in-cheek nod to *The X-Files* episode "Little Green Men" from the second season, in which Mulder uses the name of the astronomer George E. Hale as an alias. Her choice is also ironic, for this member self-identified as a feminist and in a discussion about changing one's "maiden" name, emphatically stated that she had never used her husband's name in her ten years of marriage. In the case of MRKS, a number already had online "pseuds," and I had to persuade a few that these were not good choices for the project given their public profile in online *Due South* fandom.

I also shared with any interested participants of the DDEBS copies of conference papers and publications. In writing this book, I went a step further, offering participants of both projects drafts of various chapters. The feedback was generally positive and always constructive and insightful. I am not suggesting that their interpretations were transparent or authoritative, but having to justify or clarify my claims often made me see things differently. It is "the push and pull of contradictory versions," according to Britzman, which "allows one to consider the architectonics of answerability" (p. 137). By putting my practices "on the line" in the ways described above, I was in the end able to develop relationships with the participants based on trust and respect. Although steps can be taken to (re)negotiate the researcher/researched binary, it is important to acknowledge that it can never be erased. It is the researcher who includes, excludes, arranges and manipulates the "secondhand" memories in order to construct a coherent narrative in which she has material and symbolic investments.

Lines of Inquiry

The traces of identity performance/articulation, community making and space production discussed in this book may be specific to the DDEBRP and MRKS but the *processes* are cautiously generalizable. The arguments made in this book are presented as a series of close, medium and long shots, moving from fan practices to overarching community practices to relations of space.

The first two chapters focus on the lists as fandoms. Chapter 1, entitled, "Feminine Pleasures, Masculine Texts: Reading *The X-Files* on the DDEBRP," critically examines the interpretation of both the *primary text* and *secondary texts* about the show and its actors. I focus on the performance of middle-class, heterosexual

femininities—both normative and feminist—in the context of how collective meaning is produced out of *The X-Files*. I argue that DDEBRP members deployed a number of interpretative strategies to gain shared pleasures from texts that are passed off as gender neutral but are in fact produced predominantly by men for men. Two strategies were used frequently by the research list members: Identification with the main characters and the reading of romantic story lines into the existing texts. I also consider the communal practice of critically reading the primary and secondary texts and the collective narratives produced as a result.

Chapter 2, entitled "When Fraser Met RayK: Reading, Writing and Discussing Slash Fiction," introduces the key fan practice of producing secondary texts, specifically male/male slash fiction about *Due South*. First I discuss the role of ICTs and the influx of women online in the proliferation of slash. After looking at academic accounts that approached slash through a feminist lens, I argue that slash is better understood as a queer practice. I then analyze the ways in which the queer subject position is articulated by list members. I also identify the centrality of class identifications: what is important to MRKS members is not only "hot" fiction but "quality" fiction, demonstrating that slash fiction is not a homogenous genre uncritically accepted by fans.

Chapters 3 and 4 combine data from both lists to critically examine two communal practices that extend beyond fan-related discussion and indeed beyond fandom. Chapter 3, "Possessing the 'Write' Stuff: Language Use and Humor On (the) Line," addresses the symbolic importance of language in community making. I examine the ways in which members displayed their *linguistic capital* (Bourdieu, 1977) not only by using language accurately and effectively but also by playing with language and deploying humor. I make the case that these practices are imbricated with performances of middle class-ness. In Chapter 4, "Nice Girls Don't Flame: Politeness Strategies On (the) Line," I draw on feminist sociolinguistic literature on politeness behaviors in "real life" and online contexts to examine the ways in which members of both lists attended to face needs. Strategies included avoiding imposing on others, trying to make others feel validated and liked, and avoiding offending others through debate or disagreement, apologizing and self-effacement. I argue that these gendered practices are imbricated with class.

Chapter 5, "Cyberspace as Virtual Heterotopia," broadens the discussion from one of community to one of space. The first section of this chapter begins with a *genealogy* (Foucault, 1980a) of the gendering of social space from the Classical Age to the Information Age, examining the ways in which technologies have both

reinforced and blurred the public/private boundary. The DDEBs are then discussed as examples of virtual heterotopia in this context. In the second section, I focus on media flow, fandom and national borders. With American media culture dominating movie and television screens and internet fan forums around the world, including Canada, *Due South* represents a case of reserve media flow, a Canadian show broadcast in the US that garnered a loyal following of American fans. MRKS is then discussed as a virtual heterotopia, its members embracing myths of Canadian identity to produce a Canadian cultural landscape. The concluding chapter offers "lessons from the virtual kitchen" for both mass media and internet scholars who are likely to have a different set of interests and concerns. I also discuss the implications of the research findings for the future of online female fandom, other media fandoms and for media and internet scholarship.

Notes

1. Following a discussion on the listserv for the Association of Internet Researchers, I decided not to capitalize "internet" for reasons of consistency and continuity. I do not see the internet as constituting a "second media age" (Poster, 1995), but rather the most recent technological development, which, like the (non-capitalized) telephone, radio and television, has become part of the fabric of everyday middle-class North American and Northern European life.
2. See Brian Reid's reports at <http://www.tlsoft.com/arbitron/jul95/>. For current statistics on the Usenet, see <http://www.usenetrocket.com/usenetstats.htm>. Both sites accessed June 2004.
3. A listing of Usenet groups can be found at <http://www.google.com> by following the link to Groups. There are also a few television discussion groups listed in, under rec.arts. Accessed June 2004.
4. To review any of the surveys by the Graphics Visualization and Usability Center, please go to <http://www.gvu.gatech.edu/user_surveys/survey-01-1994/>. Accessed June 2004.
5. A few public forums from this time period could be described as women-centered. Baym's study of rec.arts.tv.soaps, for instance, indicated that the vast majority of participants were female, hardly surprising given the genre of media text.
6. MacDonald notes that qllc was also known as the Quantum Leap Lust Club.
7. A reliable site that acts as a clearinghouse for internet surveys is NUA: <http://www.nua.ie/surveys/>. Accessed June 2004.
8. Following the lead of other feminist scholars, I consider the use of "man" as a generic noun to be erroneous.
9. For accounts about gender and cyberspace, see Cherny (1996), Harcourt (1999), Herring (1996), O'Farrell & Vallone (1999), Spender (1996), and Wolmark (1999).
10. For work on race, see Rodman, Kolko & Nakamura (2000) and Nakamura (2002). On sexuality see Case (1996) and on issues of digital divide see Van Dijk (1999), and Katz & Rice (2002).
11. See Saco (2002) and Barney (2000) for both sides of the democracy argument.
12. For a critique of Butler, see Weir (1996).
13. I am grateful to Robert Morgan for this turn of phrase.
14. "Kellie" and "Julia" are real names and I have used them with permission in the context of this particular quote, for the DDEB website identifies them as the founders.

15. The Borg, an alien human/machinic race, were never explicitly identified as male, but all the actors who played these "villains" were male. The exceptions are *Star Trek:Voyager*'s Seven Of Nine (Jeri Ryan), a sexy blonde former female drone, and the Borg Queen (Alice Krige), who appears in the film *First Contact* and in the series finale of *Voyager*.

16. After the formation of the DDEBs, the Gillian Anderson Estrogen Brigade (GAEB) was set up as a safe space exclusively for lesbian and bisexual women. Their website <http://gaeb.teatime. com> was accessed June 2000 but is no longer active as of June 2004.

17. Examples include rec.arts.tv.soaps (Baym, 2000); alt.support.eating.disord (Herskowitz, 1999); BlueSky (Kendall, 2002); ElseMOO (Cherny, 1999); and LamdaMOO/furryMuck/JennyMUSH (Reid, 1999).

18. See Ludlow (1996) and Gurak (1997).

19. For more background on *Due South* and a guide to the episodes, please see <http://home.hiwaay. net/ ~warydbom/duesouth/episodes/index.html>. Accessed May 15, 2004.

20. See Stone (1995) for a detailed account of the now legendary tale of the New York psychiatrist, Sanford Lewin, who became "Julee" on a usenet support group. He went to great lengths to convince others that "she" was a severely disabled woman, but eventually he was found out.

☙ Chapter 1

Feminine Pleasures, Masculine Texts:
Reading *The X-Files* on the DDEBRP

With *The X-Files* functioning as the glue that initially bound its members together, the David Duchovny Estrogen Brigades are, at their primary level of connection, online fan communities. The same can be said of the DDEBRP, a sizeable portion of interaction related to the series and its actors. In this chapter, I will take a close look at the push of normative feminine and pull of feminist discourses in collectively making sense of the primary and secondary texts. I will also examine the performance of class as *bourgeois aesthetics* in critically assessing those texts.

It is not so long ago that scholars spoke exclusively in terms of mass media "consumption." Whether the atomized individual of behaviorism or functionalism or the cultural dope/dupe of Marxism, the viewer was seen as a passive receiver. In the 1970s, the uses and gratifications paradigm emerged out of functionalist sociology. In Elihu Katz's words, this approach, "asks not what the media do to people, but what people do with the media" (quoted in Lull, 1990, p. 29). It recognizes viewing as a heterogenous activity that may be planned or spontaneous. At times it may involve a high level of attention and at others, it may serve simply as a background for another activity.[1] John Fiske (1987) has also written extensively about the active television viewer. Relying on semiotics, he describes viewing as "typically a process of negotiation between the text and its socially situated readers" (p. 64). The text is thought of as "a structured polysemy" that has "a potential of unequal meanings, some of which are preferred over, or proffered more strongly than, others" (p. 65). By actively taking up the meanings that work for them vis-à-vis their social locations, viewers get pleasure from such texts.[2] Fiske was also

one of the first scholars to recognize the importance of *oral culture*—talk about television—and its relation to the processes of viewing. As David Buckingham (1993) puts it, "it is primarily through talk that the meanings and pleasures of television are defined, negotiated and circulated" (p. 266). Beginning with David Morley's *The 'Nationwide' Audience*, (1980), numerous ethnographic studies have been conducted that track the heterogeneity of meaning-making processes while still paying attention to the power of dominant ideologies or normative discourses.[3]

When I asked the DDEBRP members what drew them to *The X-Files*, it is significant that no one mentioned the themes emphasized by the writers and producers and heralded by television critics as the reason for the show's popularity:

From: Moll
I couldn't believe that something that sounded so lame could attract so much attention so I watched my first episode in January of the first season. It was Beyond the Sea and I was hooked. :-)

Strangely enough, what attracted me to the series first wasn't DD [David Duchovny] but Gillian Anderson and the character of Scully. This was the most intelligent, competent woman I had ever seen on a tv show and her partner treated her as an equal. Which is also one of the reasons why I find Mulder so attractive.

From: Drucilla
I started watching from the first episode. I started raving to all my friends...you get the picture. I was hooked. Two strong, intelligent characters, a female lead who wasn't a bimbo, a male lead with a *brain* as well as looks! Intelligent, challenging scripts that refused to tie everything up neatly each week. How could I resist?

From: Erin
I couldn't agree more! I kept seeing adverts for the show and thinking, "Man, this is going to be some lame alien thing...but I've seen that actor before, where I [sic] have I seen him?."

Both Moll and Erin immediately dismissed the alien theme as "lame." Moll and Drucilla pointed to the lead characters and their relationship. Only one member expressed an interest in Mulder's quest for "the truth" about paranormal events:

```
From: Megan
Although I am trained as a scientist (maybe I should say
'because') there are still things in this world that
can't be totally explained and I like that challenge to
my rational and practical mind. I think that's one of
the things that attracted me to the X-Files (DD being
one of the other!)I also love the character of Dana
Scully. I was a major ST:TNG [Star Trek: The Next Gener-
ation] fan and I was really getting tired of some of the
stories that they were giving the female characters on
that show. Scully was very refreshing.
```

As was the case with the others, though, it was ultimately the main characters and the actors who played those roles that appealed to Megan and made her a fan of the show.

Of Fans and Femininity

Henry Jenkins (1992) was the first scholar to break down the category of the active viewer and focus specifically on the media *fan*. His seminal work, *Textual Poachers*, challenges the popular conception of the fan as a social misfit who needs to "get a life," the words of William Shatner of *Star Trek* fame as part of a *Saturday Night Live* sketch. Drawing on the work of Michel De Certeau, he describes fans as nomads and poachers who struggle for control of meaning imposed by producers and screenwriters. Like Fiske, he argues that making meaning in ways other than intended is an act of resistance. What distinguishes the fan from the "bystander" is the level of emotional commitment:

> Fans, as committed viewers, organize their schedules to ensure that they will be able to see their favorite program…The series becomes the object of anticipation: previews are scrutinized in detail, each frame stopped and examined for suggestions of plot developments; fans race to buy TV Guide as soon as it hits the newsstands so that they may gather new material for speculation from its program descriptions. Secondary materials about the stars and producers are collected and exchanged within the fan network. (p. 57–58)

The members of the DDEBRP engaged in a range of these fan practices. Beyond being committed viewers, thirteen said that they collected items such as t-shirts, comics, novels and magazines.

Jenkins also recognizes that male and female fans are perceived differently. In the 1920s, when the abbreviation of the Latin *fanaticus* came into use, sports writers used it playfully whereas film and theater critics used it pejoratively in reference to

women who supposedly attended performances for the sole purpose of admiring the actors. Mia Farrow played one such "matinee girl" in the Woody Allen film, *The Purple Rose of Cairo*. Her romantic fantasy comes true when her idol walks off the screen and into her life. The *fangirl* quickly became a powerful heteronormative minus-male subject position offered to those of us with female bodies who express admiration for a male celebrity. Laura Mulvey (1989) uses both Freudian and Lacanian notions of (hetero)sexual difference to argue that the narrative structure of Hollywood film operates on a binary logic of an active male subject who gazes at a passive female character as object. The woman who looks, however, is not constructed as a desiring subject capable of objectification. Instead, she is "in love" with the male celebrity, unable to separate fantasy from reality.

Since the 1980s, feminist and gay discourses have aligned to create a space in which heterosexual women can be active spectators. The softer masculinity of the "new man" who covets the gaze has become commonplace in contemporary media texts.[4] David Duchovny wore the look of the new man well back at the height of his popularity. His image appeared frequently on the covers of entertainment and fashion magazines. Many of the poses are clearly intended to position him as an object of desire. These include head shots in which the actor pouted at the spectator, as well as torso shots in which he appeared with his shirt unbuttoned, wearing only an undershirt, or not wearing any shirt at all. Then there are the images of him with legs casually sprawled apart to draw the viewer's gaze to his crotch.

The DDEBRP members explicitly rejected romantic fantasy in favor of the objectifying, desirous gaze of the active heterosexual female spectator. Consider the following exchange:

```
From: Drucilla
I don't think we want to be subjected by DD [David
Duchovny], and I think the whole concept of trying to
fit the image of romantic love onto the DDEB is a bit
far fetched. Hell, we're a bunch of healthy, lustful
women who find DD attractive, both physically and intel-
lectually. What does that have to do with the concept of
courtly love???
```

Desire, for this research list member, was not about "courtly" or romantic love but about lust. Rather than viewing female desire as based in biology, as Drucilla seems to be suggesting, it is important to recognize desire as a discursive product/process. Following Bronwyn Davies (1990)

> Desire is spoken into existence, it is shaped through discursive and interactive practices…Desires are constituted through the narratives and storylines, the metaphors, the very language and patterns of existence through which we are "interpellated" [or articulate ourselves] into the social world. (p. 501)

For her part, Sonya was willing to accept that talk about Duchovny contained some elements of romance, which she defined as "fantastical" and "idealistic": "I see that aspect in the lists in the various situations we wish/dream on…DD in various states of dress/undress, mental and physical stimulation, etc." As Catherine Belsey (1994) argues

> The role of fantasy in the construction of desire cannot be overestimated…The fascination of the beloved stems to an unknown degree from meanings and values, some personal, some cultural, which invest this body, these actions. People fall in love with film stars, or with voices on the telephone, or with the authors of the books they read. They imagine what is absent. This is only mildly eccentric. Roland Barthes asks, "whether the object is present or absent?" Isn't the object always absent? Is desire real, the only reality, or unreal, precisely romance, fairy tale, a temporary madness, an obsession from which we recover? (p.78)

Belsey points out that desire is never about "the real" or "the present"; the object of desire is always discursively produced. That said, her choice of words—"fairy tale," "madness," "obsession"—have the unfortunate effect of offering up the specter of the fangirl whose desires control her and not vice versa. Sonya made it clear that she rejects this version of fantasy:

```
HOWEVER, I will vehemently deny that these fantasies
involve us being, or desiring to be, "powerless." In
that area, I would say that the women on the lists are
Modern Women (or Post-Modern) who have no desire to be
in a relationship of unequal power, in reality or fan-
tasy.
```

Others also make it clear that they drew a line between reality and fantasy:

```
From: Liz
I don't feel anything romantic either. Romance, to me,
has *infinitly*[sic] more to do with love than with
appreciation or even lust. I'd say, just off the top of
my head, that anyone who felt *romantic* toward a person
they'd never met should have their head examined.
```

```
From: Mrs. Hale
They assume I drool over him and think he can do no
wrong. They assume that I am jealous of his girlfriend
or that I stalk him. All of these assumptions are wrong
and I find them offensive.
```

In rejecting the fangirl discourse of desire as delusion, the DDEBRP members were not just decoupling romance from erotic desire, but were challenging other normative feminine storylines as well.

```
From: Moll
I also find it very empowering that we are able to
express ourselves as sexual beings in this group. Fickle
sexual beings too since we usually end up discussing the
latest flavour of the month anyway. :-)
```

Not only are "good girls" not supposed to have sexual desire without love but they are supposed to be true to their man and jealous of any rival for his affections. Moll's comment about the "latest flavour of the month" suggests a wanton infidelity. Moreover, the DDEBRP members *share* their object of desire, be it the actor or the characters he plays, disrupting the heroine/other woman rivalry of the romance narrative. This collective desire is further highlighted by Liz:

```
*We* are the ones in power with this…We have as much
'of' DD, Mulder, Jake⁵ whoever as we want. With *that* we
can do as *we* will.
```

Fangirls together, by contrast, are supposed to whip each other up into a hysterical frenzy, their expression of desire reduced to fits of crying and screaming. Indeed, the section on fandom at the Rock and Roll Hall of Fame in Cleveland is dominated by huge blowups of hysterical female fans of Elvis, the Beatles and Rolling Stones. Hence the concern on the part of some members with being associated as a member of an "estrogen brigade":

```
Don't discuss it much. Mostly people are surprised and
impressed, but I don't describe it as a fan club, but as
a support group. (Bel)

IRL [In Real Life], they thought I was a bit weird [at]
first. I was a bit embarrassed at first too. But once I
made them understand that we talked about a lot more
```

> than the X-files, they got used to the idea and found it
> interesting that I was getting mail from so many
> different places. Online, it seems that we are often
> perceived as a bunch of fangirls. **(Moll)**

> I don't publicize that fact on the Net unless I am
> specifically asked. I never put it in my .sig
> [signature] file, as I want to be taken seriously by
> everybody I email **(Mari)**

To get around the negative fangirl label, these members emphasized the friendship aspects of list membership or were very selective in disclosing this information. This concern also arose on the list when I made a reference to what I described as a "slavering" account by a DDEB (but not DDEBRP) member posted to her brigade's website about attending a Jay Leno taping when Duchovny was a guest. Hollis and Mrs. Hale immediately distanced themselves from fangirlish behaviors.

> **From: Hollis**
> Please don't judge the rest of us by her behavior! No
> doubt she's a very nice person, but she is also very
> young, and it shows. I don't believe that her attitude
> or behavior is typical of the DDEB members. Her
> shrieking at the Leno tapings was a great source of
> embarrassment to many of us. While we could appreciate
> her enthusiasm, we were absolutely mortified to see
> someone acting like such a teenybopper in the name of
> the DDEBs.

> **From: Mrs. Hale**
> Don't get me started. That was one of the most
> humiliating things I ever read.

Two members of this person's "home" brigade then joined the thread to challenge this version of events.

> **From: Erin**
> She let out one shriek…one. (and she wasn't the one who
> let out the 'meep' that so interested DD on his last
> Leno appearance <g>)…I'm trying like hell not to take
> any of this personally since I happen to know and like
> the person to whom you are referring, but just let me
> say that they have been things done by other DDEBers
> that have embarrased [sic] me more. [second ellipsis
> mine]

From: Paula
I've got to add my $.02 here. I really think the
accounts of our member's activity have been overblown; I
don't at all remember these incidents the way you're
portraying them: "slavering"??? M'ghod, no way! Excited,
yes. Nervous, of course! And that is an honest reaction
by a very sincere, nice person - if DD took offense at
that, he is truly a jerk and doesn't deserve ANY of our
attention!

Hollis apologized for "coming down too hard on her," explaining that without the same "background knowledge of what she's like, she really did come across as a bit gushing. The DDEB has been mercilessly ridiculed for that in the past." The discussion then shifted to the emotional response to meeting a celebrity and how to comport oneself.

From: Mrs. Hale
I can understand why the DDEBx[6] member in question lost
her composure, but I still think it is possible to con-
trol one's impulses in public. Or at least make the
effort. Certainly it's not something to brag about;
rather like losing control of one's bladder in public.
I'm certainly not proud of losing my cool with [*X-Files*
producer] David Nutter. And it's one reason I have
actually turned down an opportunity to meet David
Duchovny; I would never forgive myself if I acted like
an idiot in front of someone who absolutely defines
"cool".

This member captures the balancing act undertaken by female fans who admire male celebrities and yet are concerned about being dismissed as fangirls.

Stories for ~~Boys~~ Girls

While talk that positioned Duchovny as an object of desire did occur on the DDEBRP (to be discussed in Chapter 3), the focus of fan-related interaction was unquestionably *The X-Files* and its characters. By joining a DDEB, and then the DDEBRP, members signaled a desire to negotiate a collective meaning for the primary text. For such a process to work, notes Henry Jenkins, "a certain common ground, a set of shared assumptions, interpretive and rhetorical strategies, inferential moves, semantic fields and metaphors" must exist among the community members (p. 89). More importantly, he makes the case that gender plays a significant role in

that process. In examining the interpretive practices of female fans of the *Star Trek* series, Jenkins found that they "focus their interests on the elaboration of *paradigmatic* relationships, reading plot actions as shedding light on character psychology and motivations." In contrast, the male fans of the David Lynch series *Twin Peaks* "focus on moments of character interaction as clues for resolving syntagmatic questions" (p. 109). The first practice can thus be understood as extending the text vertically through character development, whereas the latter extends it horizontally by sketching in details that advance the plot lines. Jenkins links these gender-differentiated interpretive practices to socialization, tracing them back to "our earliest encounters with fiction" (p. 113). Even today, as any visit to a bookstore will confirm, action, adventure and science fiction narratives are deemed appropriate genres for boys while romance and other relationship-centered narratives are posited as suitable for girls.

Jenkins' account, however, stops short of explaining *why* boys and girls would be offered different narratives in the first place. It also relies on a modernist understanding of gender as a cause or source of certain behaviors. Rather than throw away the proverbial baby with the bathwater, however, I wish to hold onto the notion of gender-differentiated reading practices but make sense of it in terms of gender performance/articulation. The publishing house, the film and television studio, the school, and the family are all sites which serve to circulate normative discourses on gender-appropriate texts and interpretive practices. Being an intelligible boy or girl, man or woman, in part involves reading prescribed genres in certain ways and gaining pleasure from them. I distinctly remember that as a fourth grader I was discouraged by the school librarian from reading nonfiction books about animals and advised instead to take up *Little Women* or *Little House on the Prairie*—in other words "stories for girls." In adult narratives, the gender boundary is most obvious in popular texts. The *Harlequin* (Canada; US) or *Mills and Boon* (UK) romances and daytime TV soap operas are associated with women and devalued as a result. Romantic comedies (*Sleepless in Seattle*) and those centered on female relationships (*Divine Secrets of the Ya-Ya Sisterhood*) have come to be known as "chickflicks," a term which has a derogatory connotation. Reading the romance, to appropriate Janice Radway (1984), and other relationship-centered texts is a performance of heterosexual feminine identity, and as such, the textual pleasures can be described as ones of *recognition*. John Fiske suggests that this is a moment at which the discourses of the subject and the text intersect, a moment in which the reader takes up the offered subject position.

"Stories for boys," on the other hand, largely remain unmarked. Blockbuster action films revolving around the "hard" masculinities of Sean Connery, Arnold Schwarzenegger (most recently "starring" as governor of California), Sylvester Stallone, Bruce Willis, and Jean-Claude Van Damme are never labeled "guyflicks." Thematically organized around Fox Mulder's alien/paranormal quests that are constantly hindered by shadowy government conspiracies almost exclusively involving men in black, The *X-Files* primarily offered viewers stories for boys on a weekly basis. Yet, as I have indicated at the beginning of this section, the characters of Mulder and Scully and their relationship were also developed throughout the series' nine-year run, enabling female fans like the DDEBRP members to read the show *paradigmatically* to produce feminine pleasures.

Watching the Detectives: Spotlight on Scully

As noted earlier, one of the main sources of pleasure for the DDEBRP members was the character of Dana Scully. Moll described her as "the most intelligent, competent woman I had ever seen on a television show and her partner treated her as an equal." Similarly, Drucilla praised the casting of "a female lead who wasn't a bimbo." Finally, Megan described the character of Scully as "refreshing" in comparison to the female characters in *Star Trek: The Next Generation*. In her reply, Drucilla elaborated on the problems she had with the female characters of the series: "I loved TNG, but I got so SICK of the constant 'caretaker' roles they assigned to the women. Bleah. Barf." The characters being alluded to were Deanna Troi, the ship's counselor, who did not even wear a Starfleet uniform for the first five seasons but rather low-cut, clingy outfits, and Beverly Crusher, who was not only seen in her professional caretaking role as the ship's doctor, but as the (over-?) protective mother of her adolescent son, Wesley. The only high-ranking female commanding officer, Chief of Security, Tasha Yar, was "killed off" at the end of the first season. These characters, however, were improvements over the ones on the shows that the majority of the DDEBRP members grew up with in the 1960s and 1970s. As Liz wryly noted:

```
Frankly, *I* always wanted to be one of the Musketeers.
I always identified with the swashbuckling hero…The
women's parts were always soooo…icky. They always needed
rescuing and all. How boring.
```

Taken collectively, our viewing experiences cast into sharp relief the dearth of alternative representations of femininity traditionally found in popular American television series and underscored our refusal to take up the "damsel in distress" subject positions offered to us by these texts.[7] However, that did not mean that we read Scully in the same way. For example, we all valued Scully for possessing traits normally associated with representations of masculinity—practicality, objectivity, and rationality. Yet my suggestion that Scully, as scientist and skeptic, was "second fiddle" to Mulder within the series narrative was challenged:

From: Moll
Mulder may have started this quest, but now they both own it. They have both lost a sister to it.[8] They give each other the strength to journey on...I'm pretty impressed with the job that these hormonally challenged men have done so far in writing a kick-ass female character. [ellipsis mine]

From: Geneva
Mulder would long since have been unemployed and/or dead meat if Scully wasn't there to protect and support him. Mulder is dependent on her for the weekly information dump, running interference with their superiors and bringing him back down to earth when his theorizing becomes too wild.

These members made it clear that Scully was Mulder's equal. In addition, Moll stressed the "feminine" aspects of the quest in terms of shared emotional investments. Similarly, Geneva positioned Scully's role as one of protection and support, a role associated with motherhood or marriage, not simply a working partnership. This defense of Scully is informed by a liberal feminist discourse of equality. I was left wanting a more radical representation of feminism, a partner who directly challenged systemic gender inequities.

A range of investments in both normative femininity and feminism among the DDEBRP members emerged out of discussions involving Scully and her status as Mulder's partner in several episodes from the fourth season. The first centered on the opening scene from the premiere, "Herrenvolk" (Fox, 4 October 1996).[9] The conclusion to the third-season finale, "Talitha Cumi," it basically involves Agent Mulder on a search to uncover a secret government experiment on a bee farm in Alberta involving alien cloning, an experiment that might lead him to the whereabouts of his sister. The supporting characters key to the plot are Jeremiah,

a benevolent alien whose extraordinary healing powers Mulder hopes can cure his mother who has recently had a stroke; a malevolent alien of the same species, referred to on the list as Chuckles, Lumpy or Terminator, who is out to assassinate Jeremiah; "Ms. X," a United Nations employee who is introduced as Mulder's new informant to replace "Mr. X," who has been executed, presumably for leaking Mulder information; and the powerful conspirator known as The Cigarette Smoking Man or Cancer Man who is behind both assassination plots.

A number of members had been discussing the episode with great enthusiasm when Drucilla began a separate thread, objecting to Mulder's treatment of Scully:

> Okay...does it bother any of you when Mulder runs off and leaves Scully?
>
> I mean, they're supposed to be *partners* but he seems to feel no compunction at all about haring off on wild alien chases and not letting her in on what's going on. Take the scene in "Herrenvolk" when he goes off with Jeremiah in the boat and leaves Scully there in the millyard with a (hopefully) dead alien to explain. I was sitting there "inventing" dialogue for her at that point..."Mulder! Get back here! Mulder don't you dare go off and leave me here with this dead guy! Mulder, you asshole!"

Her post immediately generated a flurry of responses from members who had had the same reaction at the moment of viewing:

> **From: Sonya**
> This is funny, because right when that happened, I talked to the television (for Scully)..."You asshole!" To me, it was unspoken, but very loud. :-)

> **From: Megan**
> I love the really pissed look on here [sic] face when he finally called her from Canada. And I seem to remember the word "asshole" popping into my head right about then as well.

The negative reaction to Mulder's treatment of Scully in this scene can be understood as a gap between representation and subject location. These members expected Scully to be portrayed by the series writers and producers as Mulder's equal and expected Mulder to treat her as one within the series narrative. As Drucilla's

Image 5 Scully left behind in the mill yard.
Credit: 20th Century Fox™ and Fox ©1996.

post suggested, this includes making joint decisions about how to proceed in an investigation. When Mulder makes the unilateral decision to take off with Jeremiah, these members were required to *extend* the scene by having Scully swear at Mulder, to bring the representation of a professional female character in line with their own subject locations as professional women who expect to be treated equally by their male colleagues.

Others felt the same unease/disapproval but tried to make sense of the scene as written.

> **From: Liz**
> On the other hand, at least they're consistant [sic]. He
> *always* does this. It's not so much a plot device as a
> character bit. :-)

> **From: Ardis**
> It is one of his more annoying habits, and while he
> hasn't outgrown it after all this time, at least
> Scully's figured out how to deal with it. She just
> leaves him to his own devices and goes off to do her own
> thing. And you know that plays into Mulder's logic about
> it, i.e., "She's a big girl, she can take care of her-

```
self"...I wish that boy would learn, tho. Sometimes you
just wanna indulge in the Shaken Mulder Syndrome.
```

Ardis implicitly relied on norms of masculine and feminine behavior to make sense of the scene. She linked Mulder's behavior with masculine immaturity by referring to him as a boy and advocated a "straightening out" as a mother would do a child. On the flip side, she read Scully's appearance of acceptance as a sign of maturity. Responding passively to acts of violence, cruelty or rudeness has long been praised as a feminine virtue in Western society. In her study of girls' comics, Valerie Walkerdine (1990) notes that the story lines posited such responses as

> the conditions for resolution: selflessness, even though it brings pain and suffering, brings its own rewards...The heroines suffer in silence: they display virtues of patience and forbearance and are rewarded for silence, for selflessness, for helpfulness. (p. 95)

Yet Ardis was also articulating a more feminist discourse, for her comments make it clear that she valued Scully's independence and recognized her silence as perpetuating a problematic situation. Winnie took up a similar normative feminine position, stating that her reaction to Mulder's actions "is always some sort of mild resignation." When Mrs. Hale joined the thread, however, she directly challenged the consensus that Mulder's behavior was unacceptable:

```
To be honest, I really can't see why everyone is so
focused on this. If Scully had been a man, I don't think
anyone would have thought twice about Mulder running off
in pursuit of a suspect. I give [Chris] Carter full
marks for TREATING her as Mulder's equal, and not
shackling Mulder with a lot of emotional baggage about
protecting her, going back for her, etc. In fact, he
*did* call her later, when they were on the ground again
(cell phone calls from airplanes are bad for your
health), and he was very solicitous. How the hell was he
to know she was in trouble, when her answer to "Are you
all right"? was "Fine"? If I had Lumpy sitting behind me
with an icepick in my ear I'd manage to say something
other than "Fine." Frankly, I think you guys are missing
the forest for the trees.
```

Not mincing her words, she turned the issue on its head, equating differential or "special" treatment to patriarchy and paternalism. She also put the onus on Scully to communicate any problems she had with her partner's treatment of her, thereby

refusing the position of the helpless/hapless female for both Scully and herself. This position can be classified as "postfeminist." Proponents often accuse feminists of disempowering women by turning them into "victims" of patriarchal oppression. While a strong argument can be made that this position misrepresents both liberal and radical feminisms and in fact is reactionary and anti-feminist, it is one that nevertheless resonates with many white, middle-class, heterosexual women who do not want to think of themselves as victims and, more importantly, do not *feel* like victims. It also allows women to reclaim the subject position of feminist in a way that avoids accusations of being dismissed as a "whiner."

Mrs. Hale's bald assertions ("I give Carter full marks"), use of mild swearing ("How the hell was he supposed to know") and final sentence directly criticizing the position of the other participants in the thread ("Frankly, I think you guys are missing the forest for the trees") had the effect of creating tension on the list. Several members, including Drucilla, responded with indignation and sarcasm: "Gosh…I didn't realize how sexist I was. Thanks for enlightening me." Daphne distanced herself from a feminist position, indirectly accusing Mrs. Hale of being the one unnecessarily reading gender into the scene:

> **From: Daphne**
> I would feel the same if Scully was a man. Mulder gets
> so intent on his own pursuit that he LEAVES his partner
> in dangerous circumstances. Lone wolf is one thing,
> leaving your partner in danger is another…She's
> perfectly capable of taking care of herself, we know
> that. If Mulder is a partner, he has to act like
> one. [ellipsis mine]

Daphne's use of the pronoun "we" serves to rebuild a unified position that had been undermined by Mrs. Hale's criticism. For her part, Mrs. Hale apologized for her antagonistic tone but reiterated her point, this time recasting Assistant Director Skinner in the role of Scully:

> But if Skinner was annoyed with Mulder for doing that,
> he would not have said "Fine" when Mulder asked him how
> he was. He'd have given him hell. What does it say about
> Scully that she puts up with this treatment from her
> partner?

It was not Mulder's masculine behavior that she interpreted as problematic but Scully's feminine acceptance of it. Yet in answering her own question she did not condemn Scully, suggesting that Scully recognized such treatment as "part of the territory," which could imply a liberal feminist understanding of the difficulties in working in a male-dominated field where sexism abounds. But then she immediately added, "If she's not worked up about it, I don't know that I'm going to be. It seems pretty much in character for her to 'carry her own water' from where I stand."

It is clear that none of the members who participated in this thread was completely comfortable with identifying with this normative feminine response. At the same time, they were not prepared to devalue it or suggest that Scully was a victim. Daphne's final remark, "Maybe she yells at him off-screen. But I'd like to see it," sums up the difficulties that confront female appropriators of male-produced texts: the subject positions that are proffered around femininity may not be the preferred ones but they are not always so easy to turn down. As Michel Foucault (1972) points out, true discourses, "exercise a sort of pressure, a power of constraint upon other forms of discourses" even if they are unable to banish them completely (p. 219). A feminist interpretation is susceptible to being undermined by true discourses of normative femininity.

In contrast, *X-Files* narratives that lent themselves more easily to being interpreted as feminist were unequivocally embraced. This was the case with another fourth-season episode, "Never Again" (Fox, 2 February 1997). Sarah Stegall's review of the opening scene in which Scully does confront Mulder is representative of the list response:[10]

```
Dana Scully, having come to a minor crisis in her life
brought on by depression, finds herself rebelling
against Mulder, against her job, against her self. When
Mulder is forced to go on vacation (to Graceland, of
course), he reluctantly leaves her in charge of a case.
In a scene we have waited for [sic] *years*, Scully
finally asks why she does not have a desk, flat-out
refuses to investigate a farcical case, and stonily
refuses to be drawn into a debate with Mulder over her
commitment to The X-Files. Mulder goes from clucking
over his case like a hen with one chick to an astonished
and angry sarcasm.
```

The phrase "in a scene we have waited for *years*" is significant, for it serves to bind together female fans into a community whose interests are often at odds with those who control the story lines.[11]

This collective position fragmented during the discussion of Scully's ensuing acts of rebellion: going to a bar by herself, picking up a man with a tattoo and then getting one herself on her buttock. I began the thread by expressing both disappointment and annoyance with the plot development for equating rejection of patriarchal authority with having heterosex with a stranger and for portraying Scully as confused and weak:

```
It seems that she's worked hard to establish herself as
an equal to Mulder and now she's suddenly crumbling.
Yes, it's true, it is Mulder's work but she seemed to
have taken a lot of her own initiatives.
```

Those who replied to my post, however, held a different view. Moll thought Scully's resentment and confusion were understandable in light of the traumas she had experienced in the last two years.[12] Drucilla agreed, adding that this episode "showed us that Scully's *human*, not a superwoman." As the thread continued, Scully's rebellion was characterized as a reversal of the "good girl/bad girl" binary:

```
From: Moll
I think this episode takes a good look at the Scully who
does what she's told. This is not just with Mulder, but
with the Bureau itself. She started out as the good
agent, following whatever orders they gave her. After
hanging out with Mulder for a while, she starts to show
signs of rebellion and now doesn't do everything the
bureau way.
```

```
From Daphne:
[I]t's interesting to see, when [Scully] starts getting
mad at herself about doing whatever other people tell
her, that she indulges in "bad" behavior.
```

While these members might not have agreed with the writers' choice of rebellious behavior for Scully (Daphne acknowledged that her actions were "a trifle out of character" within the series narrative), they were able to make sense of it and gain pleasure from the text as written. The final paragraph of Moll's post makes

explicit the emotional reality that the portrayal of a female character struggling to assert herself held for these members:

```
Now she's rebelling against Mulder...who does have a
tendency to try to control her, even though I don't
think it's calculated on his part. It's the hardest kind
of rebellion because it's against someone she cares
about. This is a thing I think most women face at some
time or other. We like to help the people we love but
sometimes in doing that we can lose sight of what we
need for ourselves.
```

Moll's last sentence in particular recasts Scully's professional struggle as personal and emotional and positions Mulder as the male authority. In doing so, Moll effectively draws on the liberal feminist slogan recognizing the personal as political.

Watching the Detectives: Vulnerability Becomes Him

The identifications with Scully described above did not preclude alignments with Mulder at other moments; pleasures of recognition do not necessarily take place along gender lines. In other scenes in "Herrenvolk," for example, Mulder's behavior evoked sympathy and empathy, as in this excerpt of Sarah's review:

```
It seems to me a great turning point has come for Fox
Mulder in "Herrenvolk." In the hospital scenes in Act
Four, I was struck by his silence, his anguish, his
hopelessness. In the United Nations scenes which follow,
the normally glib Fox Mulder is struck dumb with grief.
The naturalness of this performance is one of David
Duchovny's finest portrayals, as he manages to convey in
an entirely authentic moment the depths of Mulder's
despair and bewilderment.
```

The hospital scenes mentioned in the review involved Mulder sitting at the bedside of his unconscious mother and confessing his feelings of grief and self-doubt to Scully. The "United Nations" scene advanced the series narrative by introducing Mulder to his new informant, providing him with a reason to believe that his sister may be still alive ("Not everything dies, Mr. Mulder"). It was his open display of emotional distress, however, that struck a chord with those who responded to the review.

Image 6 Mulder at the bedside of his unconscious mother.
Credit: 20th Century Fox™ and Fox ©1996.

From: Rhiannon
I thought the final scenes with the grieving Mulder were
superb and DD very convincing indeed.

From: Daphne
WOW! What a really great episode! There were parts of it
I really, really liked, esp the bits where David gets to
ACT and breaks up. The part he did in front of the new
Ms. X was particularly effective.

As the excerpt from Sarah's review suggests, the character of Mulder had never expressed any doubt about his quest to find out the truth about his sister's disappearance. The emotional displays, combined with the "baring of the soul," associated with normative femininity, function to "feminize" Mulder, producing cross-gendered pleasures of recognition.

It is also significant that this interpretation is framed by a discourse of formal criticism, even by those like Daphne and myself who were not writing a review for public consumption. Given that those of us who participated in the thread had at least one degree in English or a related discipline, it is not surprising that we would deploy the critical reading strategies that we learned through literary or film studies.

Rather than talk about the character of Mulder as if he were a real person having a breakdown, Sarah referred to Duchovny's "authentic" performance. Similarly, I used the term "convincing" and Daphne "effective" to describe the actor's performance. She also framed the events as if taking place in a play ("scenes in Act Four") rather than in "real life." Maintaining a distance from a text in order to evaluate it "objectively" is, according to Pierre Bourdieu, a cornerstone of *bourgeois aesthetics* that continues to be reproduced by the academy (referenced in Jenkins). The "untrained" reader is incapable of distinguishing "good" texts from "bad" and simply identifies with the characters on an emotional level. Fans are thus perceived to be "sitting too close," to quote Jenkins (p. 60). For female fans steeped in such an aesthetic, the pleasures gained from identifying with the characters of Scully and Mulder are at best ambivalent.

If Mulder's displays of emotions were valued, more normative masculine behaviors were not, even if they seemed justifiable under the circumstances. In "Terma" (Fox, 1 December 1996), for example, Mulder punches out a minor character, Alex Krycek, who once posed as an FBI Agent assisting Mulder's investigations. As it turned out, he was working for Cancer Man, under whose orders he executed Mulder's father. Despite Krycek's portrayal as a "bad guy," most participants of the thread expressed sympathy for him, indirectly expressing disapproval of Mulder's violent response:

> **From: Daphne**
> Poor guy! Mulder was sure beating the crap out of him last night, huh? It was pretty sadistic.

> **From: Bel**
> I felt so sorry for Krycek. First Mulder, then [FBI Assistant Director] Skinner pounding on him. "He'll be safe here." says Skinner and then proceeds to beat on him. I bet Krycek almost had second thoughts.

After Daphne suggested that perhaps Scully should have taken a swing at him as well, Bel added:

> She certainly had good reason to, but she is much calmer than the guys, I guess. Or perhaps it's that she strongly believes in "justice"? (I didn't memorize her opening statement, but she seemed to comment on believing in what the department stood for.)

This member overtly linked the recourse to violence to masculinity by contrasting it with a more "cool-headed" feminine response. Only Mrs. Hale approved of Mulder's violent response: "If someone murdered my dad and delivered my partner into Duane Barry's hands, I'd be out for blood. I thought Mulder showed admirable restraint."[13]

Reading (in) the Romance

If the quest for a powerful or magical object (or in Mulder's case, the truth about extraterrestrial existence) can be considered a masculine quest, the search for "true love" is the feminine equivalent. Bronwyn Davies (1992), drawing upon Helene Cixous, nominates Pygmalion as the quintessential romantic narrative—the myth of the Greek king for whom Aphrodite brought to life the carved ivory figure of a beautiful woman whose sole purpose is to love the king. Pam Gilbert and Sandra Taylor (1991) provide a sketch of this narrative:

> The private world of the emotions is the world of the romance heroine. She is alone: emotionally isolated except for the possible ministrations of a female friend who may or may not be totally trustworthy. All women are potential enemies because they are looking for men. Consequently the quest for love is a lonely quest and it is in dead earnest, because the promise of a loving and lasting heterosexual relationship is seen to demonstrate the successful acquisition of femininity. (p. 81)

Like other genres, the romance has changed over time. According to Winnie, a DDEBRP member who is both a reader and writer of romantic fiction:

```
There are three major types of romance novels--the
Regency, the historical and the category. The Regencies
are the ones that I think are more likely to get our
hackles up--the "la, sir, I think I shall faint." The
ones that hit the best-seller lists--the Danielle
Steeles, Jude Devereauxs, Beatrice Smalls--tend to write
in the historical vein. The ones that *really* drive the
romance train are the category romances. The category
romances are the lines that put out four to six new ones
a month--the Harlequin Intrigue line, Silhouette Desire,
Silhouette Intimate Moments, Loveswept, etc.
```

As her comments about "getting our hackles up" indicate, the traditional swooning heroine is no longer a source of pleasure for many contemporary readers of the genre. Beginning in the early 1970s, contemporary romance texts mobilized liberal

feminist discourses, putting "qualifications on the kind of love that overcomes all problems and obstacles…qualifications that are inextricably intertwined with the full development of the heroine as an individual in her own right" (Thurston, 1987, p. 7). Carol Thurston's sketch of what she calls the *neofeminist* romance is supported and filled in further by Winnie:

```
Category romances have contemporary settings with
equally contemporary heroines in real-life situations --
single mothers, divorced women, career women, etc., who
don't faint, are in control of their lives and--gasp!--
have sex.
```

Romance, formally symbolized by the kiss, is no longer separated from sexual desire.

Weaving romantic narratives into the alien/paranormal narratives of *X-Files* episodes was a second paradigmatic practice engaged in by the DDEBRP members. That said, a full-blown romance between Mulder and Scully was rejected out of hand. In the fourth season, creator and producer Chris Carter was still insisting in interviews that a relationship between these two characters would never happen, the implication being that it would detract from or even devalue the normative masculine quest narrative.[14] Thus, an episode like "The Field Where I Died" (Fox, 3 November 1996) has Mulder learn, through regressive hypnosis of his past lives, that the wife of a doomsday cult leader was his fiancé during the American Civil War, thus explaining the instant connection he feels with her when they meet during an FBI investigation into the cult's activities. Scully, on the other hand, was his company sergeant. List sentiment about this scenario was summed up by Daphne's comment that it was "entirely fitting that [Mulder and Scully have] been together beyond this life and were 'comrades in war', in more than one lifetime." Megan referred disparagingly to those who had been hoping for any evidence of a romantic relationship, even in a past life, as "relationshippers" who must have "barfed up a lung over Mulder and Scully not being soul-mates." Yet, she did not distance herself from this position completely, adding, "although I think they are, just of a different sort." As with the acceptance of Scully being portrayed by the writers as "carrying her own water" in "Herrenvolk," there is an acceptance of this narrative that effectively forecloses the reading in of the romance.

Yet, as with Scully's rebellion in "Never Again," any scripted hints of sexual tension between Mulder and Scully were spoken of with enthusiasm. In "Tempus Fugit" (Fox, 16 March 1997), Mulder makes a point of remembering Scully's

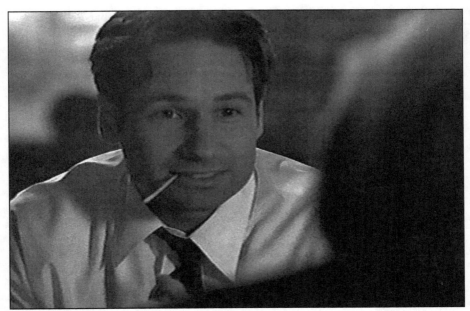

Image 7 Mulder surprises Scully on her birthday.
Credit: 20th Century Fox™ and Fox ©1997.

birthday, having the waiters in a bar sing while presenting a snowball cake with a sparkler in it:

> **From Daphne**
> That was such a cute scene. Mulder gets so thrilled
> giving Scully stuff, and it's SUCH weird stuff. :-> The
> football video really took the cake, tho. :->
>
> **From: Drucilla**
> Yeah, but the Snowball with the sparkler in it was so
> cute.
>
> **From: Daphne**
> It was adorable. And he looked so cute and boyish,
> didn't he? DD does cute and boyish very well.

The use of the adjectives "boyish" and "cute" are indicative of the heteronormative narrative of the awkward male suitor. The Mulder/Scully romance is contained, though, by Daphne's use of a critical discourse to comment on Duchovny's acting ability.

Sometimes romantic sub-narratives involving other characters were woven into episode discussion and, as above, their pleasures were ambivalent. In the context of the "Herrenvolk" discussion, for example, I speculated on a possible affair between Cancer Man and Mulder's mother.

> **From: Rhiannon**
> In the [third season] finale, I thought [Cancer Man's]
> comment to Mulder about knowing his mother for a long
> time was telling, perhaps implying that they had had an
> affair. Also,[in "Herrenvolk"] he seems genuinely upset
> about Mrs. Mulder's illness and I thought his explana-
> tion to the "Terminator" seemed a pretext, that he
> really wants her saved because of his own personal
> feelings. I dunno.

Moll was skeptical but acknowledged that "an affair may well have happened. Of [sic] perhaps CM just wanted her but couldn't have her." In the end, she resorted to an explanation for Cancer Man's concern for Mrs. Mulder that fit within the male quest/conspiracy narrative:

> I think it may very well be that CM wanted her to
> recover…the bit where we see a hand holding hers and
> then it pulls back to show it's him, not Mulder, really
> makes that point. At the same time, I think the fact
> that Mulder has survived for so long, especially when
> the Morphin' Dude [alien assassin] has had so many
> opportunities to get rid of him, gives a great deal of
> support to CM's reasons. If Mulder is a vital part of
> the equation, then they need to be able to predict his
> actions. Take everything away from him and there's no
> telling what he would do.

Her final line is in fact a paraphrase of Cancer Man's words to his fellow co-conspirators, who in a previous episode advocated Mulder's execution to protect their secret project of alien colonization from being exposed. My other suggestion that Cancer Man could have been Mulder's biological father was also met with skepticism. Moll referred to such a plot development as too "soap operaish," interesting for its devaluation of a genre of television text so closely tied to normative femininity. Mobilizing a similar critical discourse, Mrs. Hale thought it was too "cliched" but she acknowledged that she liked the idea of Cancer Man as the "jilted lover."[15] The romantic story line is thus a dangerous one for women

familiar with literary standards to embrace too wholeheartedly. As well, the subsequent consensus that had formed among those members positioned me at that moment as a community outsider.

As with the "snowball cake scene," romantic sub-narratives were embraced when legitimated by the episode writers. Take the reaction to the introduction of FBI Agent Pendrell:

> **From Drucilla:**
> [quoting from Sarah Stegall's review of "Teliko"]
> >Howard Gordon has written some good Scully ("Dod
> >Kalm") and some great Mulder ("Grotesque"), and here
> >he gives us wonderful Pendrell. The lovelorn Agent
> >Pendrell (Brendan Beiser) waiting hopefully for Agent
> >Scully, then sagging in despair when Mulder teases him
> >that "she has a date", outdoes even David Duchovny in
> >the wounded puppy-dog look department. Only Mulder
> >drooling on himself could top it.
>
> Yes! I loved that scene. I do hope they're not setting
> up Pendrell to [sic] killed later on in the season. That
> would really piss me off.

Liz and Drucilla did not hesitate to weave their own romantic narrative, fleshing out Pendrell's character as scripted to make him a suitable match for Scully:

> **From: Liz**
> Personally, I think it would be cool if he actually got
> up the nerve to ask Scully out and she *went*! Or, even
> better, if *she* asked *him* out sometime. :-) Surely
> he's got more of personality and I'd like to see it. :-)
>
> **From: Drucilla**
> He has *tons* of personality. You can tell. :-) I wonder
> how his genetic material is? :-)
>
> **From: Liz**
> hehehehehe! I'm just thinking that he could probably be
> great fun and very interesting (once he stopped tripping
> over his tongue) and Scully deserves someone like him.
> :-)

These members performed a normative feminine identity with the repeated use of the "smiley" and the written representation of "giggles." Drucilla's suggestion that

Scully ask Pendrell out also provides a feminist reworking of the romance in which women refuse the traditional role of waiting passively for men to initiate a date.

The paradigmatic potential provided by Pendrell came to an abrupt end in the final scene of "Tempus Fugit" when, as Drucilla feared, the character is "killed off"—shot in a DC bar, with "birthday girl" drinks in hand, by a man aiming at an important witness whom Scully is protecting:

> **From: Rhiannon**
> POOR AGENT PENDRELL!!!! Years of unrequeited [sic] love,
> he finally gets to buy the lady the drink and look what
> he gets for his trouble. Do you think he's going to die?
>
> **From: Drucilla**
> I hope not. Killing Max [a UFO abductee] was bad enough!
> Grrrrrr!
>
> **From: Daphne**
> Yeah, poor guy. I yelled at the tv. Why do they always
> shoot someone who we like? :->....
>
> **From: Drucilla**
> To keep us from writing fanfic about them?

Having a sanctioned romantic sub-narrative foreclosed by the producers was greeted with open hostility and cynicism. The use of the pronouns "they" and "we," as in previous data samples, reinforces a sense of community and highlights the faultlines that run between female fans and the predominately male writers of *The X-Files*.[16]

Another fissure between the DDEBRP members and the producers opened up around "Ms. X," the United Nations official introduced in "Herrenvolk," who is not only set up as an informant but also a potential love interest for Mulder (he is seen going to her apartment at night and leaving in the morning). Reaction, as the following message reveals, was scathing:

> **From: Hollis**
> After seeing that they hired Barbie (TM) as the new X, I
> fear that The X-files may be pandering more to the main-
> stream audience. Bad idea.
>
> Barbie X gets on my nerves. I find it really jarring to
> have someone who looks like a fugitive from Melrose
> Place thrown into the midst of a program that has been

```
so good about using average looking people. Sure
Duchovny and Anderson are both attractive, but at least
they aren't good looking in a bland cookie cutter way.
```

With references to the character as "Barbie" and "a fugitive from Melrose Place," Hollis leveled criticism at the writers for creating a female character made from the blond, beautiful "bimbo" mold. Liz agreed with this assessment but hoped the producers would be clever enough to play on this stereotype.[17]

```
The *only* way I can think of this working is if they
*use* that fact. If somehow the fact that she *is* of
the 'cookie cutter' variety allows her to blend in and
be ignored by many of the people in the circles she
moves around. Maybe she fosters the image to encourage
the MIB [Men in Black] to underestimate her (and so not
see her as a threat) or to gain their trust (they see
her as a sex object). Just trying to figure out how they
can do this without utterly screwing things up. (Pun
intended. :-)
```

Given the investments in aligning ourselves to some degree with a strong female character like Scully, it is not surprising that Ms. X, despite her professional status, would hold no appeal for us. In fact, Megan made the contrast clear by trying to imagine Scully's reaction to Mulder's relationship with Ms. X: "Its [sic] going to be interesting to see her reactions to Ms. X too. Its [sic] one thing to be dumped to chase after aliens and mutants, but another entirely to be dumped for boinking a leggy blonde." This reaction drew on a stereotypical plot device of the traditional romance which sees the heroine's quest for "true love" thwarted (at least temporarily) by the arrival of the Other Woman.

The Limits of Feminine/Feminist Pleasures

Unlike "Herrenvolk" and "Tempus Fugit," episodes that were generally liked despite the detractions discussed above, a few episodes were dismissed outright because of their lack of paradigmatic potential. "Home" (Fox, 11 October 1996), for example, concerns an investigation by Mulder and Scully into the disappearance of the mother of a family of hillbillies who live on an isolated, run-down farm in rural Pennsylvania. It contains a great deal of graphic violence as the sons, who are suspected of killing their mother, have booby-trapped the farm house with a variety of weapons that impale, decapitate and otherwise kill their victims in some

unpleasant way. The agents do manage to successfully enter the house where they find the limbless but otherwise unharmed mother (who, it turns out, willingly bears the children of her sons to continue the family line) hidden under the floorboards. The following posts from the thread capture the general distaste expressed by list members:

> **From: Hollis**
> Dang! I stayed home to watch The X-Files, but
> mysteriously found a drive-in movie playing on my tv
> that had Mulder and Scully in it…The hubby was so
> grossed out that he stopped watching after the first 20
> minutes. Memo to Morgan and Wong [episode writers]:
> Ickiness plus violence does not necessarily equal scary.
> They did have a couple of nice touches like Scully's
> line and the music in the Cadillac. Aside from that,
> though, this is not the kind of episode that I watch The
> X-Files for.
>
> **From: Sonya**
> I agree. I was on irc #xf [X-Files chat], and we were
> all grossed out. I think it's probably a good thing I
> was watching on a black & white tv. It was way too
> violent. Someone on #xf mentioned that the kid's use of
> the word "bitch" was new for XF, too, which I had also
> noticed (and didn't like--it's just not XF).

Both members saw "Home" as deviating from the narrative norms of the show, placing it in the slasher/horror category, a genre in which much of the violence is directed against women. In pointing out the use of the word "bitch," Sonya hinted at the underlying current threat of such violence. In my message, I directly took issue with the incest theme. The only redeeming moments identified by those who disliked the episode involved emotional intimacy between the main characters. Drucilla, for instance, noted, "I'd love to edit out everything but the Scully and Mulder bits and just watch those, though." One of these "bits" involved Mulder and Scully outside the farm house talking about their families and what it would be like to be parents. The scene served to create a sense of intimacy between the characters.

The only member who enjoyed the episode was Sarah, who, in her review, "Family Plot," cast Scully's key role in the investigation into sharp relief against the themes of violence and incest:

> Scully takes the driver's seat both literally and
> metaphorically in this episode. Warm, funny, and wise,
> Gillian Anderson's "uber-Scully" is a warrior-scientist
> mother figure who strides across this story like
> Brunnhilde in a tailored suit. Despite Mulder's
> insistence that this case is not an X-File, she persists
> in liberating the helpless woman she is convinced is
> being held in the Peacock house. She leads the investi-
> gation with her head but backs it up superbly with her
> heart,…unwilling to risk leaving a defenseless [sic]
> victim in peril another minute even if it means risking
> her own life.

Sarah took up a feminist discourse, positioning Scully as a powerful figure, a "warrior-scientist" or "Brunnhilde" who "strides across the story" wearing the "power suit" that symbolized the Career Woman. At the same time, she performed a more normative feminine identity, interpreting the agent as a mother figure who is able to identify emotionally with the situation of another woman in distress, acting with not only her head but her heart. It is interesting that Sarah's review was never referred to in the thread on the episode, perhaps because there was no common ground upon which consensus could be built.

Armchair Critics

To argue that female fans read male-produced narratives paradigmatically is not to suggest a lack of concern with syntagmatic issues of plot. Fan criticism was an interpretative practice widely engaged in on the DDEBRP. A plank of bourgeois aesthetics, it is "concerned with the particularity of textual detail and with the need for internal consistency across the program episodes" (Jenkins, p. 278). In the sample presented below, Daphne posted four questions related to the plot of "Herrenvolk":

> 1. When Chuckles had Scully by the throat, why didn't
> she just shoot him in the face? She had her gun in her
> hand, and I think (despite Mulder's warning) that I
> would have, just to get him to back off.
>
> 2. Why didn't Jeremiah and Mulder take the telephone
> repairman's van?
>
> 3. Why was the repairman still out on the road? If he
> had a work order, and didn't return, don't you think the

```
company would have sent someone looking for him? And
there was NO other traffic on that road for a full day?

4. Why did Jeremiah get all weak and floppy when Mulder
was knocked out and Chuckles was after him? Yes,
Chuckles smashed the van into the car, but it wasn't
THAT bad of a wreck.
```

Note that Daphne's criticisms were framed as questions. Jenkins points out that unlike literary critics, fan critics do not simply compile a list of "flaws" that take away from the text, but "work to resolve gaps, to explore excess details and undeveloped potentials" (p. 278). Moreover, questions rather than statements provide the opportunity to arrive at a collective resolution. This is what happened on the "Herrenvolk" thread. In explaining why Scully did not try to shoot the assassin, for example, Liz referred to information about the alien assassin's physiology revealed in previous episodes: "It would likely have killed her. Remember, they bleed a highly toxic and corosive [sic] chemical." Unlike Daphne, she thought it plausible that a body could remain undiscovered for a full day "in places way out in the middle of nowhere." With the second and fourth questions, however, she also had no explanation and responded by praising Daphne for pointing out the gap that she had not noticed herself and by commenting "I think that's one of the mysteries." Drucilla speculated that Jeremiah may have been suffering from "sheer terror." As for Mulder and Jeremiah not taking advantage of the telephone van to escape from the assassin, she acknowledged its implausibility by jokingly referring to a later scene: "Silly, because then Lumpy wouldn't have been able to use it to run them down!" Other plot concerns that members worked on together included the problem with Mulder and Jeremiah driving to Alberta seemingly on one tank of gas, and Mr. X, Mulder's government informant, being assassinated in the hallway of Mulder's apartment building without any of the neighbors hearing the gunshots. As long as an episode containing such plot inconsistencies also had paradigmatic potential, though, such flaws did not detract from the pleasure of making meaning from it. Daphne, for example, concluded her list of questions by noting that they were only "nitpicks" in light of Mulder's open display of grief and despair.

Just as members had differing levels of investments in the characters or the romantic narrative, they had differing levels of investments in fan criticism. One DDEBRP member told me in confidence of her misgivings of the practice:

> Well, starting quite some time ago, I noticed how hyper-
> critical my fellow brigadiers were getting. They would
> rip apart every episode, not just in a good-natured
> analytical sort of way but with a certain jadedness and
> bad attitude that annoyed me. So I stopped reading their
> messages because they depressed me and made me think
> less of them! I'm more easily amused, I guess, and
> though I may see the same flaws in something that some-
> body else does, I don't think I take it so personally.

Too much criticism spoiled the pleasures of the text, to play with an old adage. This member's refusal to not only engage in the practice but follow the threads that did so, resulted in her silent self-exclusion from the DDEBRP at the level of a critical fan community.

Star Gazing

Just as the primary text can be read paradigmatically, so can the texts produced *about* the show and the people associated with it. By its third season, *The X-Files* had generated a string of feature articles in entertainment and lifestyle magazines such as *GQ, People, Rolling Stone, TV Guide, Us* and *Vanity Fair*, as well as appearances by Chris Carter and the lead actors on talk shows and television industry award shows. Referring to them as *secondary texts*, John Fiske (1989) points out that their function is to "extend the fan's pleasures by extending the primary text" and "invite fans to explore the intertextual relations between the representation and the real" (p. 66). Just as the primary text offers narratives revolving around a set of characters, the secondary texts offer narratives about the actors who play those roles. That said, the "real" actor must also be recognized as a media text representation. In other words, the stories we read about celebrities in entertainment magazines or hear on talk shows are also fictions, constructed by writers, interviewers, editors, and, of course, the celebrities themselves. As narratives, they require interpretation and, as with primary text, become "real" on an emotional level.

On the DDEBRP, tales of Gillian Anderson and David Duchovny occasionally generated extended discussions and provided their own pleasures or disappoint-ments. The next data sample is excerpted from a thread that began with the news that Gillian Anderson, not David Duchovny, had been nominated for an Emmy award in 1996. While some felt his "understated" style of acting had cost him the nomination, Erin felt his performances in the third season had been "lackluster," not for lack of talent but lack of enthusiasm for his craft:

> Well, as much as I like David, I do think Gillian is a
> better actor. I think a large part of that is Gillian
> loves acting...it's what she wants to do more than
> anything. David is not too sure acting is what's for
> him...(esp acting in a TV show) he's expressed doubts
> about this quite often. It's hard to give something your
> [sic] not sure you love your all...and it often shows.

Not knowing the actor personally, Erin's information on Duchovny's feelings about acting is obviously based on a variety of secondary sources. The story of the person whose heart is not in his/her work is emotionally real for her as her last sentence indicates. Others joined the thread, fleshing out the story of Duchovny's supposed unfulfilled desire to write and the ways in which he dealt with his frustrations:

From: Erin
Yeah...and I think that's why he's so prone to whining...I
do think that he's a whiner by nature (takes one to spot
one <g> [grin]), but when you aren't happy with what you
are doing, complaining about it comes much easier. :)

From: Mrs. Hale
It would probably help if he would stop publicly and
openly *bitching* about his life to the press. I'm sure
the nominators are no more fond of having their profes-
sion so consistently dissed by someone who has made a
success of it than anyone else would be.

Erin again identified with Duchovny through this middle-class story line of being the thwarted artist unable to contain his/her frustration. Mrs. Hale, took a different position, suggesting that the frustrated artist should "grin and bear it." She also "feminizes" Duchovny by associating the act of complaining with the use of the term "bitching." Later on in the thread, Duchovny's appearance on *The David Letterman Show* came under scrutiny:

From: Erin
So many people expect him to congratulate Gillian on her
nod and get pissed when he doesn't, but why should he?
They are just co-workers...they are not joined at the
hip...I don't go around telling people about the achieve-
ments of my co-workers. I wouldn't expect her to do the
same if the situation was reversed...<sigh> I just don't
get it. [second ellipsis mine]

In defending Duchovny, Erin recontextualized his work experience to fit her own. Drucilla then did the same but took the opposite view:

```
Let me see if I can explain it. Most of what he said I
could have accepted as funny, but it was what he
*didn't* say that was telling. When Letterman was going
on and on about how DD was the reason people watch
X-Files did he have *one* *word* to say about the fact
that he and Gillian are *both* part of the show? Or
anything kind to say about the rest of the cast and
crew? No. Not a word. Yes they are "just coworkers" but
I think that acknowledging his coworkers would be
gracious and appropriate.

If someone I work with does something really fabulous,
you BET I'm going to sing his or her praises! Why *not*?
The only reason I could see for not doing so would be
pettiness.
```

In expressing strong disapproval of Duchovny's behavior in this situation, implying that it was inappropriate and a case of "sour grapes," she distanced herself from the actor and by extension, Erin. Daphne then joined the thread, supporting Drucilla. Instead of reconstructing the celebrity as an "ordinary person" with a job like herself, she placed the celebrity on a higher plane as one whose behavior should be exemplary. Specifically, she cited Gillian Anderson as possessing the qualities that fans expect celebrities to embrace:

```
From: Daphne
Yes! GA can be extremely gracious, and that's what
people expect out of celebs. We WANT them to say that
everyone they work with are wonderful and funny and
hardworking and a joy to be around. DD has got to learn
to play that game. It's basic niceness...I think his
attitude is very sad.
```

These fans thus expected both male and female celebrities to be "nice," a code word for a set of moral behaviors that has been historically associated with the performance of middle-class identity in general and feminine middle-class identity in particular. In her study of female spectatorship of Hollywood films from the 1940s, Jackie Stacey (1994) notes that the fascination that the female stars held for her participants was a combination of both "the recognition of familiar aspects of everyday life" as well as "the possible fantasy of something better" (p. 126).

Daphne's emphasis on the phrase "we want" suggests a collective desire for celebrities to rise above the petty behaviors that mark daily life and maintain the illusion of good relations and harmony even in situations where they do not exist. In other words, being "nice" is a job requirement that allows fans to fantasize about an ideal world.

The collective "we," however, effectively excluded Erin who did not share this particular view, as well as anyone else who might have disagreed but stayed silent. When Mrs. Hale joined the thread, any sense of consensus was undone:

```
I don't want David to be nice. I want him to be honest
and sincere. Rudeness would have been dissing GA on
Letterman. Hypocrisy would have been some false senti-
mental blather about how happy he is for her, and John
Bartley, and Jeff Charbonneau, and so forth…Best to do
what he did and preserve a dignified silence on the
subject while *Letterman* rubbed it in. [ellipsis mine]
```

Mrs. Hale uncoupled "nice" from "rude," inverting its valued status by linking it with insincerity and false sentimentality. Daphne held her ground, insisting that "people can be honest and sincere and nice at the same time," and argued that Duchovny would have to learn to compensate for not having a naturally "bubbly personality," a phrase almost always used in relation to women. "Niceness" became a contested behavior, the participants in the thread drawing upon their own contexts to argue their point:

From: Liz
```
If someone compliments me about my job performance and
asks me about it, I'm going to talk about me and my job
not about my coworkers or the help desk or anyone else.
```

From: Daphne
```
Yes, and if someone was giving you credit for what was
essentially a group effort, would you take all the
credit? David did.
```

In light of the above, it is clear that some members were more heavily invested in the discourse of niceness than others.

By contrast, disapproval was collectively expressed of Duchovny's rumored sexual mores. Erin added to the "Emmy thread" by offering another explanation of the actor's lackluster performance in the third season: "As one person put it, 'he

seemed too busy testing out the springs in his trailer to have the energy to give his on camera performance his all.'" Mrs. Hale then suggested that his "bimbo-chasing" would divert him from his "true vocation"—writing. She concluded her post by chiding Duchovny directly, noting, "sex, too, is an art form but not an Olympic sport, David hint hint hint." Hollis replied, "Hint hint, indeed, especially considering that according to Woman's Day, it sounds like his event would be speed sex!"

In positioning Duchovny as a philanderer, he was woven into the neofeminist romantic story line as the obstacle to achieving and maintaining romantic love. Moreover, he was also positioned as being a lover who does not take the time to sexually satisfy his female partner. When Duchovny did adhere to the romantic story line, he received collective praise. When the rumor that Duchovny had married actress Tea Leoni was made official with press releases from both celebrities' publicists, Winnie posted a quotation she had read on an entertainment website: "And yes, that sound you hear is the collective heart of the 'David Duchovny Estrogen Brigade' breaking." The participants overtly rejected the way in which the media positioned them as being "in love" with David:

> **From: Winnie**
> I'm having lunch with a fellow DD admirer today and we
> plan to lift a congratulatory glass. Any hearts broken
> out there? Mine's fine.
>
> **From: Megan**
> Mine seems to be ticking along just fine.
>
> **From: Drucilla**
> Mine's intact as well.
>
> **From: Bel**
> Takes more than that to break my heart. I'd actually
> have to personally *know* the guy for it to affect me.

It is clear from these comments that the marriage of the couple was not a source of grief or jealousy, the response anticipated by those who would construct the DDEB members as fangirls, but one of great pleasure as the desired culmination of the romance. However, given that Duchovny had been cast as a "womanizer," not all members were convinced that it would end "happily ever after":

From: Liz
I'd love to see it work out for them...but I can't help
being somewhat pessimistic. If he cats around on her, I
hope she dumps him hard and fast.

From: Winnie
I think that pretty much sums up how I feel about it
too. "Best of luck, D&T -- but heaven help ya, DD, if
you're unfaithful!"

Instead of being "jealous" of Leoni, they aligned themselves with her, positioning her not as the traditional bride who will stand by her man even if he breaks his vows, but as a contemporary romance heroine who is an equal in a relationship and will have the strength to walk out on the lover who betrays her. As in the discussions of Scully and Mulder, these members performed a heterosexual feminine identity based on a discourse of gender equality and fair treatment.

Notes

1. James Lull (1990) has developed a comprehensive "social uses" typology.
2. Fiske has been criticized by scholars such as Doug Kellner (1995) for overestimating the power of the viewer and underestimating both the power of dominant ideologies and the political economy of media.
3. Other major book-length studies include Ang (1989), Buckingham (1993), McRobbie (2000), Radway (1984), and Stacey (1994).
4. See Barnard (1996) and Moore (1988) for discussions of the male body as erotic spectacle.
5. Jake is the character that Duchovny played in the HBO series *Red Shoe Diaries.*
6. I have deliberately withheld the number of the brigade to avoid linking the participants of this thread with their "home" brigades to ensure confidentiality.
7. For a detailed account of female television characters from the 1950s through to the 1980s, see Douglas (1994).
8. Mulder's sister disappeared from the family home when they were children in what he believes was a case of alien abduction. Scully's sister was shot to death by an assassin who had intended to kill Scully.
9. Discussions about individual episodes generally took place shortly after their initial air date, which I have provided in brackets beside the episode title and the American network that originally aired them.
10. Sarah Stegall was a member of the DDEBRP and regularly posted copies of her *X-Files* reviews that appeared on her website to the list. To preserve confidentiality, I have used her real name in this context, not her pseudonym, with her permission.
11. Only six episodes in the first four seasons were written by women. (Sarah Stegall, personal communication, October 27, 1997).
12. Scully was abducted by aliens in cooperation with the government (Mulder's explanation which she is only now starting to seriously entertain) and developed a deadly cancer as a result of the experiments performed on her.

13. Duane Barry was a minor character who was the subject of a two-part episode in the second season (Fox, 14 October 1994). Believing he is about to be abducted again by aliens, he kidnaps Scully and takes her to the abduction site to offer her in exchange. Mulder arrives at the site but it is too late. After being presumed dead, Scully mysteriously appears in a Washington, D.C. hospital in an episode aired several weeks later, with no memory of what has happened to her.

14. By the seventh season, Chris Carter had begun playing overtly with the romantic quest theme, with the famous Mulder and Scully kiss on New Year's Eve 2000 ("Millennium," Fox, 28 November 1999). In the eighth season, the possibility that Mulder is the father of Scully's unborn child is confirmed in the season finale, "Existence" (Fox, 20 May, 2001).

15. Chris Carter gave official sanction to a possible Cancer Man/Mrs. Mulder liaison in "Demons" (Fox, 11 May 1997). In this episode, Mulder becomes suspicious enough of an affair between them to confront his mother, whose reaction is to slap him in the face without answering the question. Unfortunately, the data collection period had ended by the broadcast date so I have no record of the participants' reactions.

16. The two-parter "Tempus Fugit" and "Max" were written by Chris Carter and Frank Spotnitz.

17. *The X-files* did play with this stereotype in a third season episode "War of the Coprophages" (Fox, 05 January 1996). A female entomologist called Bambi, who is intended to look and act like a bimbo tries to help Mulder solve a case involving mutant cockroaches. In one of the pivotal scenes, Bambi and Scully arrive at a building in which Mulder is trapped. Scully tells the frightened Bambi to stay put while she pulls out her gun (a Sig Sauer P228 according to Sarah Stegall) and leaps out of the car to rescue Mulder.

⚅ Chapter 2
When Fraser Met RayK: Reading, Writing and Discussing Slash Fiction

"Ray…" he said, the word raw and dark. "I need to fuck you," he finished, then reached up to haul Ray down into a kiss that was slippery and salt-bitter and thick and just as shockingly seductive as the word he'd never thought to hear Fraser use. Definitely rewrote the script for him. ("Manners" Kellie Matthews)

One need never to have seen an episode of *Due South* to recognize that the partner/buddy script has most definitely been rewritten by this slash fiction author and member of the Militant RayK Separatists. One of my central arguments in the previous chapter was that the feminine pleasures gained from *The X-Files* depended on their paradigmatic potential. This chapter is organized around the queer pleasures of the text that go beyond the collective negotiation of meaning to the production of a genre of fanfiction known as *slash*. As was the case with the DDEBRP, bourgeois aesthetics and class identifications were also central to MRKS and will be discussed in the final section of the chapter.

A Whole Lot of Slashing Going On(line)

The origins of fanfiction can be traced back to science fiction (SF) fandom in general and *Star Trek* (the original series) fandom in particular.[1] The first fan-produced magazine, known as a *fanzine* or simply *zine*, based on the television series was published in 1967 with stories that would be today classified as *gen*, that is, fiction suitable for all ages. By 1972, *het* fiction, fiction depicting characters having heterosexual relations, began to be published in "adult" zines. Two years later, the first slash story was published intimating a same-sex encounter/relationship between the Enterprise Captain James T. Kirk and the Vulcan, Spock. The term "slash" came into use because of the typographic symbol signifying the same-sex pairing, as in

K/S for Kirk/Spock. Because there are two characters called Ray in *Due South*, Vecchio and then Kowalski, the convention is to use either both initials for the characters—BF/RV or BF/RK—or last initials only—F/V or F/K. As the decade progressed, fans began to "slash" other popular television series that revolved around the partnership of two male protagonists, including *Starsky and Hutch, Miami Vice, Blake's 7* and *The Professionals* (Jenkins, 1992).

The reading and writing of fanfic is also unquestionably a gendered practice. Although women were traditionally a minority in SF fandom, a large base of "character fans" formed around *Star Trek* (Boyd, 2001). As with the appeal of *The X-Files* for the DDEBRP members, these fans were not necessarily attracted to the themes of space exploration or conflict but rather interested in the relationships between the characters. As existing zines began to include fic and then new zines dedicated to fiction were set up, a space for female fans eager to move beyond interpretation to production opened up. Mary Ellen Curtin (2003) did a statistical analysis of zines archived at Temple University and estimated that pre-1967, only 17 percent of zine publishers were female. By 1971, an astonishing 83 percent were female. Writing in the mid 1980s, Camille Bacon-Smith estimated that 90 percent of all stories were written by women (referenced in Jenkins).

Two decades later, slash is written about a wide range of television and film characters from critically acclaimed dramas such as the American HBO series *Oz* to recent blockbuster trilogies such as *The Matrix* and *Lord of the Rings*. Female pairings (f/f) are also common as are pairings involving secondary characters. Textual boundaries are deliberately pushed to create crossovers (the pairing of characters from different primary texts), AU's ("alternative universes" in which major changes have been made to the primary text setting or storylines) and actor slash[2] (fic involving the actors, not their characters). Moreover, a number of subgenres of slash now exist: "first time" (first sexual encounter between the protagonists), "PWP" ("Plot, what plot?" with emphasis on a sexual encounter, described in graphic detail), "issue" (stories that deal with political issues like gay marriage or gay pride parades), "angst" (emphasis on the emotional connection), and "death" (one or both protagonists die). A genre such as "hurt/comfort" ("h/c," in which one protagonist is injured and then comforted by the other) is considered slash if the act of offering comfort is sexual. If not, it is sometimes referred to as "smarm" (Curtin, 2001, April). Stories involving sexual practices other than oral and anal sex are labeled BDSM (bondage, domination, sadism and masochism) or non-con (non-consensual sex e.g., rape, incest).

Not surprisingly, fans of slash have preferences for certain genres and types of stories. As a result, authors will often label their stories by subgenre as well as rate them according to the system used by the American entertainment industry (G; PG; R; NC17). While three of the thirteen respondents to my questionnaire noted that they would read any BF/RK pairing provided that the story was well written, two identified other pairings within the DS universe and two mentioned enjoying AU's. Four said that they particularly enjoyed "first time," two also mentioning the pleasures of romance or romance/sex. Similarly, "angst" was thought of favorably by four respondents, Thea explaining that it "makes the happy endings all the sweeter!" Only Estraven expressed a reservation:

```
I'm not a huge fan of angst - but angst is hard to avoid
in even remotely well-characterized dS fiction. I tend
to prefet [sic] Kellie and V5's lightness of being.
Their characters…tend to be more self-assured. They know
who they are, even when they don't realize that their
entire gender orientation is shifting, and come late to
the concept. Yeah, they're upset and confused, but not
feeling suicidal or whatever. [ellipsis mine]
```

The reaction to h/c, however, was mixed. Three stated that they did not like it, two said that they didn't mind the occasional story as long as "the torment" was not "treated salaciously" in Alain's words. Meghan was the only one to embrace this genre whole-heartedly, describing herself as an "angst slut" who loved a "100 page story filled with believable h/c." Interestingly, she was the one MRKS member who said she did not object to "physical violence, although the author should be prepared to build an incredibly strong case for partner betrayal." Three others drew the line at BDSM or non-con, Alain noting that she "avoid[ed] rape stories like the plague." Other genres mentioned that had more detractors than supporters were "death" and "issue" fic.

Nine of the respondents were writers as well as readers, and a similar pattern emerged in terms of the types of stories they created. Crossovers were mentioned by three members, angst, first time, AU and PWP twice. Meghan wrote h/c and Penelope mentioned a "death" fic that she was in the process of "fixing" so no one died in the end. Several others claimed that their work could not be categorized or was a blend. Drucilla remarked that she also wrote novellas and novel-length stories.

The popularity and heterogeneity of slash can, in part, be attributed to the rapid spread of ICTs. Fanfic was originally distributed in two ways. The most common

method was, as mentioned, through publication in a zine. Henry Jenkins emphasized the amateur, non-profit, and democratic orientation of zine publishing: "Anyone who has access to a word processor, a copy center, and a few hundred dollars start-up cash can publish their own zine" (p. 158). While fans could learn about new zines through larger resource publications or at conventions, Jenkins admitted that the lack of centralization as a problem for wider distribution. Alternatively, story circuits were established in certain fandoms in which fans would mail copies of stories to each other and make copies of the ones that they liked before returning the originals. Often one fan took on the role of central clearinghouse for collection and distribution. Again, finding out about a circuit in one's fandom depended on word of mouth or contacts made at conventions.

Given the importance of home- and office-based technology in the (re)production of stories and zines and the number of women with these skills, it is hardly surprising that the rapid increase in the numbers of women with internet access by the late 1990s engendered a veritable slash explosion. Unlike the DDEBs, the spaces that female fanfic writers formed did not need to be explicitly designated "women only": historical precedent assured that such forums were *assumed* to be dominated by women, much like the Usenet group, rec.alt.tv.soaps discussed by Nancy Baym. When I asked the MRKS respondents about the participation of men in online *Due South* (DS or dS³) slash forums, all indicated that very few men were involved. Two stated that they would not join a list that intentionally excluded men but admitted that this was not really an issue.

The data available indicates that publishing and accessing of slash is now primarily done online. Out of the 210 adult slash fans who completed Kelly Boyd's questionnaire (2001) in late 1999, 70 percent did not limit their publication to print zines.[4] In addition or as an alternative, they named websites (personal and archives), listservs and the sharing of stories with friends through email. To find interested participants for her survey, Boyd searched 364 web pages and 129 mailing lists. I did a search using Google and came up with one site, <www.fictionresource. com>, which contained 720 links to websites dedicated to some form of slash fan fiction. With no link to <www.mrks.org>, I can be certain that it is incomplete. While my sample is too small to make a generalizable claim, the participant responses do support Boyd's findings. Only three out of the thirteen respondents came to slash through print zine culture:

I first remember hearing about slash waaaay back in the
1970's when I was in high school. I heard slash
mentioned in connection with Star Trek the Original
Series (though we just called it Trek because there were
no later shows yet), and also Starsky & Hutch. There was
a local science fiction bookstore called Lois Newman's
which kept a stock of fanzines that you could go in and
read at your leisure. I read a (very tame by my current
standards) Kirk/Spock story and was shocked. At the time
I thought it was weird and strange and kinky and wrong.
Hah. Little did I know that two decades later I'd be
writing it. ;-D **(Drucilla)**

In the 1970s, when I was in college…friends were writing
and editing some of the original Kirk/Spock zines. I
thought the zines were fun and silly, but didn't really
get that involved with slash until I started reading and
writing it in the early 1990s. **(Marguerita)**

As a long-time science fiction fan, I caught the second
wave of ST:TOS [The Original Series] fever…The first
time I heard that people were writing K/S was in one of
the 'underground' free magazines - the type that flour-
ish around university campuses. These publications tend
to be very liberal on all fronts - sexual included.
(Estraven)

It is not the age of these respondents that distinguishes them from the others—all but two were between 36 and 45. Rather, it was their longstanding connection to science fiction and *Star Trek* fandom. As high school or college students they had come across print zines in science fiction book stores or on campus.

The rest discovered slash through online forums and/or searches related to a particular fandom. In the case of Phoebe, Clegret and Tikva, it was *Due South*. Others named *The X-Files* (Alain), *Star Trek: Deep Space Nine* (Jeanne), *Highlander* Meghan), *Sports Night* (Penelope), and *Star Wars* (Thea). Some discovered slash by accident through a search for general fan information; others were referred to specific slash sites by friends and acquaintances from both "real life" and online contexts. Kenzie's story is interesting as she was referred to DS slash by her female life partner:

My partner found it first and was hesitate [sic] to tell
me about it. She finally broached it by telling me she
had found some websites where people had written stories
about these characters and had made them into couples.

```
And that it was pretty explicit. My first reaction was
"oh, so they're writing gay porn about fictional
characters?" It was fine that she was reading it, I
didn't care. I was writing my dissertation and didn't
have time for other stuff. Well, she was going to visit
her family one weekend and before she left she said "go
to www.hexwood.com". So I did and well, forget the
dissertation. I fried my eyes reading all weekend and
that was that. I've been hooked ever since.
```

Of those who had pre-internet exposure to slash, only Marguerita mentioned that she continued to read print zines, though Jeanne remarked on buying "the odd zine over the years." Some members—Clegret, Tikva, Kenzie—only accessed a few DS archives, author websites and lists while others like Meghan and Marguerita put the total number for all fandoms at a hundred and several hundred respectively. As for the writers, six out of the nine had produced between 2 and 10 DS stories by the first half of 2002, and these were "published" on personal websites, sites such "Exwood"(Due South Archive), Due Slash, as well as announced on or posted to MRKS, Serge and/or Asylum. Drucilla had written the most DS slash at 31 and Phoebe was next at 21. Given their long association with fandom, Marguerita and Drucilla had produced the most fanfic overall at 50 and 68 stories respectively. The former also published in print zines. Interestingly enough, it would seem that print zines are being created as a result of online story production. *Serge Protector* was the first and only zine dedicated to F/K, yet it also has a web version. At the time of writing in early 2004, four respondents are listed as having stories published in the latter.

Queer as Fen[5]

The link between romance and femininity can be drawn on to explain the pleasures that women experience in reading and writing het fic. But what of m/m slash? These seemingly misaligned identifications or cross-identifications have dominated much academic discussion. Slash has been described by Joanna Russ (1985) and Constance Penley (1991) as "feminized" pornography that rejects anonymous, emotionless sexual encounters informed by patriarchal relations of power. Patricia Lamb and Diana Veith (1986) take the opposite view, positioning slash as a reworking of the romance that rejects the role of passivity and subordination of the heroine. Speaking specifically of K/S slash, Russ and Lamb argue that the male characters are feminized or androgynous, while Penley maintains

that they are clearly coded as male. There is also disagreement among these theorists as to whether slash as a practice is feminist because of its rejection of patriarchy, or anti-feminist because of its exclusion of women. Both positions, though, are based on the notion that what women desire most are intimate relationships among equals and that normative discourses do not enable such relationships to be imagined in a heterosexual context.

Based on my analysis of the MRKS data, I am no longer convinced that slash is merely a response to problematic gender relations. All the MRKS participants, except Phoebe and Penelope, defined themselves as feminists, several emphatically ("Oh yes!" "Definitely!") However, when I asked if they thought slash was a feminist practice, only three were unequivocal:

> Yes, I do, although I know that's a controversial belief
> and some of the slashers I know would disagree
> strongly…Obviously, reading/writing slash doesn't make
> someone a feminist, nor do all feminists read/write
> slash. However, I feel that any practice that strength-
> ens and affirms me as a woman is a feminist practice.
> **(Alain)** [ellipsis mine]
>
> It can be, and it is for me, but that's not necessarily
> so for those who don't see it as such. **(Marguerita)**
>
> Yes. Having the freedom to read/write/watch/be whatever
> I like, without restraints or repercussions, is a
> feminist practice. **(Tikva)**

It is interesting how both Alain and Marguerita acknowledged that their interpretation was contested among slash writers. Alain, in a related question, was the only one to specifically mention the importance of a relationship among equals: "There are no pre-existing sexual politics or power issues—they make the relationship up as they go. That's exciting." Tikva's comment suggested a very broad interpretation of feminism that was in line with Phoebe's view that slash is a libertarian practice. Drucilla noted that she used to see it as feminist but has since come to see it as "humanist." Jeanne was willing to acknowledge the influence of feminist thought in her practice:

> On a personal level, I will say that I don't write as an
> overtly political act (in feminist terms), but given
> that I've been shaped in part by feminist ideology,

```
feminism has some sort of impact on how I write and how
I interpret what I read. (Jeanne)
```

The others rejected the notion outright, Kenzie's response being the most forthright:

```
For some people I suppose it is. Not for me. I don't
read it out of a political agenda, or because I think
it's a cultural study phenomenon. I read it because I
like reading about men. Period. Dot it, file it, stick
it in a box marked done.⁶ I don't want to be a part of
anyone's feminist agenda.
```

Her final comment could well have been directed at me, or, more generally at feminist academics. On the other hand, everyone rejected the idea that slash was "anti-feminist" because of its exclusive focus on men. Phoebe outlined her reasoning the most fully:

```
I think for the most part that just because women aren't
a part of it doesn't mean that it is, for instance,
anti-woman. They're simply not a part of it. I get a
little miffed from time to time, in fact, when slash
writers and readers complain at the lack of good female
original characters and I usually say to them, "This is
slash. By definition, we're writing about two guys.
Therefore any women in the story are going to be there
as dramatic devices, because that's not what we're here
for." It's not against women, I mean - it's just that
women aren't a part of the relationship I'm interested
in exploring.
```

Jeanne took a somewhat different view, preferring "stories where the world is inhabited by a whole range of women...and *still* the two men choose to be together."

In *Textual Poachers*, Henry Jenkins makes a useful corrective by drawing on the early work of Eve Kosofsky Sedgewick on homosocial desire. Slash is not about androgyny or the retooling of normative masculinity to address unequal gender relations. Rather, it foregrounds problematic relations *among men*:

Slash throws conventional notions of masculinity into crisis by removing the barriers blocking the realization of homosocial desire; Slash unmasks the erotics of male friendship, confronting the fears of keeping men from achieving intimacy...Sexuality exists on a

continuum within slash that blurs the constructed boundary between friends and lovers...As such, the genre poses a critique of the fragmented, alienated conceptions of male sexuality advanced by a patriarchal culture. (p. 205)

The reason that most writers do not focus on female pairings, he contends, is that relations among women have historically been more fluid and less restrictive.

For the MRKS participants, as already suggested by Kenzie, slash was clearly about men. Marguerita declared that she disliked "sloppy characterization that falsely feminizes the characters." Similarly, Alain said that she was "picky about characterization and having the guys be guys, not 'girly' <g>." On one list thread, participants collectively created an "effeminate" Ray obviously meant to be an object of ridicule not desire:

From: Drucilla
Anybody here think that Ray K. is a 'thin' 'smaller' man with low self esteem?

From: Penelope
I've always thought of my Stanley[7] as a slender blonde. ::ducking::

From: Donna
Come on, now. He's not slender, smaller or weak, he's *delicate*. It's probably from that bout of TB when he was a kid. You know, the one that causes him to swoon repeatedly in times of stress, or whenever Fraser is around to rescue him.

In another thread, Drucilla bluntly stated: "I'm finding that the longer I'm in slash the less tolerance I have for that sort of sloppy and chickish fic...even in my OWN writing." She also made it clear that if she wanted to read and write about relations between female characters, she would do so in a different fandom. Participants then debated portrayals of Fraser or Ray crying.

From: Drucilla
I've known quite a few guys in my life and nearly *all* of them have cried at some point. So why do people find it so bizarre to have a man cry in a fic? Now obviously I'm not talking about a Ray who bursts into tears because his souffle fell, or a Fraser weeping over the state of global warming, but there *are* occasions where men cry now and then. It's a natural human response to extreme emotional stress.

Phoebe remained unconvinced:

> I don't know. Even someone who writes *well* can write a
> stupid reason for crying. For me it's not just mediocre
> fic. It's that most guys don't cry for the same reasons
> or under the same circumstances that women do…[M]aking
> guys cry is often used the same way that death often is
> used, and no matter how technically good the author is,
> it's a shortcut to emotion, a dramatic device and if
> it's misused - if it's generally speaking, a situation
> in which you tend to think, uh, no, most guys I know
> would NOT be crying about this - then it's not going to
> be effective no matter how well written it is. [ellipsis
> mine]

In response, Leah stated her preference for "goddamn manly slash fiction" but then conceded that "if I can reasonably believe that the character would *ever* cry, then maybe I'll buy it even with my 'machismo rantings.'" As happened on the DDEBRP, these members worked to avoid overt disagreement and negotiate a common position.

Having Fraser or Ray cry in a story was therefore not a strategy to feminize but an attempt to produce a *normative* masculinity and, as such, crying happens rarely and only under extenuating circumstances. This emphasis on classic macho is a direct contrast to the alternative masculinity valued by the DDEBRP members, represented by Mulder's displays of emotion in several *X-Files* episodes. While MRKS members may well identify with the SNAG (sensitive new age guy), what turns them on in the context of slash is "manly" men turning each other on. Two different processes are clearly at work: queer objectification vs. heterosexual female identification. This reinforcement of normative masculinity casts doubt on the conceptualization of slash as bringing about a crisis of masculinity. I argue that what is really being produced is a crisis of *heterosexuality*. I am not suggesting that gender is irrelevant, but the axis of analysis of slash needs to be shifted to sexuality. Gender is thus subsumed under the category of sexuality. Specifically, I will draw on queer theory to make sense of reader/writer identifications and pleasures.

Alexander Doty's discussion (1993) of media culture is of particular relevance to making sense of the queerness of reading and writing DS slash. Doty defines queer texts or textual elements as "a range or a network of nonstraight ideas" in which the lesbian, gay and bisexual or other nonnormative sexuality are combined (p. xviii). Moreover, he talks about gay, lesbian and queer pleasures of the texts

depending on the location of the viewer/reader. For example, a gay man's erotic response to the relationship of male characters would constitute a "gay pleasure" whereas the same man's response to a lesbian porn flick would be "queer." He also tellingly remarks, "you might identify yourself as a lesbian or as a straight woman yet queerly experience the gay erotics of male buddy films" (p. 16). Ultimately, "queer reception…stand[s] outside the relatively clear-cut and essentializing categories of sexual identity under which most people function" (p. 15).

Because queerness does not have the same legibility as gender, Doty argues that biographical information about those involved in practices of production and reception is critical to rendering it visible. The feminist analyses of slash discussed earlier presumed a heterosexual female reader and writer. Shoshanna Green, Cynthia Jenkins and Henry Jenkins (1998) were the first to recognize that "lesbian and bisexual women have always participated alongside straight women" (p. 11). Boyd indicated that 52 percent of the respondents to her study identified as bisexual, lesbian or gay. As noted in the Introduction, seven MRKS respondents self-identified as heterosexual and six as bisexual, yet most refused such fixed classifications. Jeanne, for example, defined herself as "straightish": "I tend to feel closer emotionally and just about every other way to women these days, but my sexual attraction is primarily toward men." Blue spoke of being "mostly straight, but not narrow." Marguerita refused to be pinned down: "I fall into the cracks between straight and bi, so I don't really buy into labels. If I have to use one, it's queer, but I prefer human." Thea also used both "bisexual" and "queer" in her response.

Doty also cautions that queer readings, productions and identifications should not be assumed to be progressive. Personal and cultural histories are always part of the articulation, meaning that as a politics, queer can range from the "reactionary to the radical to the indeterminate" (p. 15). Distinctions between the politics of gay, bi and queer came up in a MRKS exchange between Marguerita and the only male member, who was openly gay:

> **From: Marguerita**
> "Bisexuality" is a heavily loaded political term in gay circles. To a lot of people, someone who's bi isn't and can't be committed to the gay political agenda, isn't considered "gay enough" to be included in social events and often isn't considered "safe" to have sex with or get involved with because he's always going to be heading back to the other side of the street. (All this

```
from gay guys I've talked with.) If there's a hierarchy
in gay guys' minds, at least some of them, gay men are
equal to lesbians but bi's are way down at the bottom of
the stack.
```

From Orion:
```
Uhh. It's not that they aren't 'gay enough'. It's that
they aren't gay period. Just ask anyone who's bi, and
they will make damn sure you understand that they aren't
one of those gay people. Some bis are very committed to
a queer political agenda -- but they are rarely
committed to a gay one.
```

Orion agreed with Marguerita that gay men do not trust bi men, noting, "It is rather disconcerting to be nonchanlantly [sic] introduced to your boyfriend's fiancee...(first I had heard of it)." On the subject of hierarchy, he pointed out that "the usual complaint about bis is that they consider themselves better than gay folks." Other members joined the thread to discuss gay/bi/queer tensions in their communities.[8] In presenting this data sample, I wish to foreground that in the samples that follow, I recognize but do not attempt to resolve these different positionalities.

Queering the Erotic Romance

Doty argues that the pervasiveness of heteronormative culture required early queer directors like George Cukor to work within the Hollywood system and conventional narrative. While social norms have obviously changed, my review of 20 BF/RK stories by MRKS participants, as well as the questionnaire responses, indicate that the story of preference is best categorized as a queer erotic romance. Alain made a direct parallel with the published genre of romance:

```
This is no different to me except that slash is not work
that is likely to be commercially available. In many
cases, the quality of slash writing actually surpasses
the published work I read, although of course there is a
great deal of dreck in both fanfic and published work.
It makes me sad sometimes that the brilliant slash writ-
ers I read are not likely to find a broader audience
unless they write about a more conventional subject.
```

"Conventional" in this context obviously means "heterosexual." Jeanne and Kenzie, however, emphasized the difference between the published romance and slash, noting that slash had more "depth" or was free of the genre's restrictions. Phoebe

stated her dislike of "harlequins" but recognized that some slash did resemble them and that she disliked that type of slash as well. As discussed in the previous chapter, the contemporary romance no longer involves virgin heroines and chaste kisses. References were made regularly on MRKS to the appeal of graphic sex scenes in slash texts. For a month or so, Phoebe used the following quotation from another list member's message in her signature file: "and that's fine, they can stay in bed and fuck for 300 more k as far as I'm concerned." Similarly, Alain used another member's words, "Plot that doesn't end up with guys fucking is a bad plot." The limits of good taste are raised, albeit humorously, in the sample below:

```
From: Alain
I said:
>>But what's the difference between my little innocent
>>preference for frottage and someone else's
>>full-fledged perversion? <g> And where does it go over
>>the top?
Phoebe said
>RIMMING!⁹ And *never* OTT! No such thing as too much!
Oh yeah. Well, that's a special case. To paraphrase the
old Jello advertisements, there's *always* room for
rimming. Plus, it's canon. Fraser licks stuff. ;)
```

Another member joked about having to cut out four pages of her story, to which Alain replied, "Excuse me, ma'am. If you have four pages of rimming, I think you'd better just hand them over without delay. For, uh, 'official purposes.' Yeah. Official. That's it. ;-) Better toss in any frottage that's in there too."

At the same time, members acknowledged a distinction between slash and gay male erotica/pornography written by men for men:

```
Gay porn tends to be, well, different. Less relation-
ship-oriented. More into action than interaction, if you
know what I mean. (Blue)
```

```
Anonymous. Quick couplings of various permutations.
Partners chosen strictly by their appearance. Underlying
theme that the appearance was enough to insure compli-
ance, since this was a purely sexual act. It was nothing
like the slash that I cherish. (Estraven)
```

That said, Phoebe alluded to the influence of gay porn on slash:

> When I started writing slash, I was just new to slash,
> fanfiction, even m/m sex. I didn't even know how two
> guys had sex, aside from the obvious blowjobs and
> handjobs. And at the time there were a bunch of new
> writers in dS who were in the same boat, so we were all
> learning from each other, talking, discussing.

For her part, Drucilla stated that she had "purposely bought a bunch [of gay porn] as 'instructional materials'." Yet she also differentiated between the two genres, pointing out that slash "generally does not involve detailed measurements of genitalia or euphemisms like 'man-pussy' both of which I've seen used in male-written gay erotica. ;-D"

To provide further insight into the F/K story as an erotic romance, I will present excerpts from a story called "Like a House on Fire" by Kellie Matthews and Beth H.[10] I chose it because it fits the profile of the type of story popular among the MRKS respondents: a first time with romance, some angst and a NC-17 rating. It is a long story, and it is "Post-CotW," meaning that the story takes place after the *Due South* series finale, "Call of the Wild" (CTV, 14 March 1999).[11] In focusing on one story, I am not suggesting that all F/K first-time romances are interchangeable. According to Kellie, this story was, in part, intended as a response to fan comments that Paul Gross had gained weight in the final seasons of the series:

> That led to wondering under what circumstances F. might
> possibly actually *get fat, and that led to the specula-
> tion that if he were suffering from situational
> depression it might become an issue, because people
> suffering from depression tend to be less aware of
> things than their non-depressed counterparts...[W]e
> started adding in the other aspects- the 'trading' of
> characteristics between RK and BK, for instance. We also
> were consciously trying to 'echo' the episode "Burning
> Down the House." [ellipsis mine]

The story begins with Ray still in Chicago working as a police detective and Fraser[12] now an RCMP Corporal in a northern Saskatchewan community. Ray gets an opportunity to go to Saskatoon on a crime-related matter and decides to drive the extra 500 km north to drop in unannounced on his old friend and partner with whom he has had little contact since he left Chicago two years before. An underlying attraction between the men is suggested by the intense happiness both feel at seeing each other again:

"Anyway, who cared if there were a couple of bad patches on the drive, right? I was on a mission." "You were?" Fraser asked, interested. "What mission would that be?" Ray reached out as if he were going to ruffle Fraser's hair, then let his hand fall, sighed and shook his head. "Coming here, Fraser. Seeing you." Fortunately the chill air gave him an excuse for pink cheeks, because his face felt remarkably warm.

Typical of female characters in the romance, the characters tend to blush a lot and feel awkward around each other in the unacknowledged "courting" scenes. Fraser also feels embarrassed about his weight gain in Ray's presence. Other scenes circulate normative feminine discourses by emphasizing the domestic. Fraser, for example, frets that he does not have fresh towels or clean sheets for his unexpected guest. As Mirna Cicioni (1998) puts it, "household chores are seen as just as valid part of life as the confrontations with the villains" (p.166). Kellie told me that some readers thought that this scene unnecessarily feminizes Fraser, but she and Beth refused to cut the scene, arguing that it fit with his "semi-Victorian" upbringing.

The next morning, Ray sees Fraser asleep on the couch and recognizes the extent of his emotional and sexual feelings toward Fraser:

Holy shit. Considering all of the frickin' clues he'd had staring him in the face, how could it have taken him this long to put all the pieces together? Some detective he was. For God's sake, he'd slept with Fraser's shirt wrapped around his pillow, and he'd gotten turned on! What was that? Just some giant coincidence? How could he have not figured out that something more than missing his partner was going on? What kind of a moron was he? He guessed he was just so used to thinking of Fraser as his friend and partner that the other stuff had kind of slipped in under his radar.

Fraser's recognition does not take place until later in the day after he is called in to investigate an unexplained fire and Ray assists in an unofficial capacity:

[S]ince the day they'd met he had been plagued by certain highly inappropriate, or, at any rate, inexpressible feelings toward his partner. Fortunately he'd managed to keep them under strict control, at least externally. Internally...they had definitely not helped ease the separation. When he'd left Chicago he had assumed that time and distance would lessen the attraction. He'd been wrong. He thought about Ray all the time. Missed him. And the attraction had never lessened. That had been made even clearer earlier in the day after he'd sent Dief in to investigate the scene of the fire. He'd turned to find Ray watching him, eyes bright with amused comprehension, the corners of his eyes crinkled, and his lips curving in a faint smile he was trying valiantly to suppress. He'd looked - incredible. Beautiful. Their gazes had caught, and held. Fraser had known he should look away, but couldn't bring himself to as those long-suppressed feelings had reasserted themselves with a vengeance.

As the investigation progresses, the partners begin to realize that their feelings are mutual. The level of sexual tension mounts accordingly. Their first kiss takes place at a stakeout, although it ends abruptly when they end up crashing to the ground when the plywood structure they are sitting on gives way. The arrest is eventually made and they return to Fraser's place. The authors then include a h/c scenario—Fraser has some cuts and bruises as a result of the chase after the suspect, injuries which Ray treats with ointment. Cicioni refers to such scenarios as "the eroticization of nurturance." Even if not sexual, they "give a physical dimension to the closeness of the bond between the partners" and build toward both sexual and emotional intimacy (p. 162–163). Extended kissing and sexual touching in this story only take place the following morning as Ray is getting ready to drive back to Saskatoon for a court appearance:

> Fraser's mouth came down on his, gently at first, in a sort of "hi, nice to meet you" kiss. But after they both figured out they already knew each other, it warmed up fast. Pretty soon they were back to where they'd had to leave off the night before when they were interrupted by a minor avalanche. And just as quickly past that point. Fraser was apparently just as perceptive in bed as he was out of it, because when his fingers brushed Ray's nipple and it tightened and Ray gasped, Fraser went for the little nubs like there was a neon sign on them or something. Stella had always thought it was weird that Ray liked to have his nipples played with more than she did. Clearly Fraser didn't find it weird at all.
>
> With his few functioning brain cells, Ray realized that he could finally do what he'd wanted to do last night, and got both hands on Fraser's ass and squeezed. Fraser, in the middle of raking his teeth across one of Ray's nipples, bit down almost too hard, and Ray barely managed not to yelp. Once he was sure Fraser's teeth were clear, he petted again and Fraser moaned breathily against his chest, clutching his shoulder as he rocked his hips, pressing the hard length of his cock against Ray's thigh.

On its own, this scene supports Russ and Lamb's position that sex in slash is about women's sexual desire: the emphasis on the caressing of nipples and buttocks rather than direct genital stimulation. However, the authors delay, but do not leave out, scenes depicting oral and anal homosex. Realizing the extent of their feelings for each other, Fraser decides to drive after Ray and Ray turns back. In keeping with the romance convention, the characters first share feelings of intimacy and dependency at the side of the road:

> "Ray....I...." he had to swallow down the lump in his throat before he could go on, could say the words he'd never said to another living soul. "I need you." Ray leaned in, his weight

coming full against Fraser, touching from knees to groin to chest, solid, warm, unbearably...
near. "That hard to say?" he asked, his tone strangely conversational, in contrast to the
intensity of his gaze. "You have no idea," Fraser grated, his voice barely functioning, unable
to look away, mesmerized.

"Yeah, I do," Ray said, his eyes drifting closed as his lips brushed Fraser's. "I know exactly
how hard it is. I. Need. You," he whispered, punctuating each word with another brush
of lips, the last one prolonged as his hands came up to cup Fraser's face, his long,
oddly-jointed thumbs lying along his jaw, stroking slightly, holding him still for a kiss that
was deep, and sweet, and no less hot for all that sweetness.

The "sweetness" is then followed by sex in a motel room where first they reach
orgasm by thrusting up against each other:

The scent of sex was strong in the air, his own familiar smell, and a new one layered with
it, rich and strange. He wanted to imprint the moment on his senses, to call up on future
lonely nights when he needed comfort. The sound of Ray's breathing, the feel of his sweaty,
spunky skin, the taste of his mouth. The taste of his throat, and his collarbone, and...Fraser
turned his head to pull free of Ray's slackened grip and slid down his body, licking a swath
through the thick, pale fluid coating Ray's belly where they'd been pressed together, savoring
the salt-bitter-sweetness of their mingled flavors, feeling the swirl of wet hair against his
tongue as he cleaned Ray off.

Enjoying the smell of sweat and "spunk" and licking up semen does not fit easily
into a heterosexual frame of romantic female fantasy. Indeed, the feminine norm
of finding bodily odors and fluids "icky," to quote one participant, was recently
reinforced for me on a trip to my local drugstore: the only type of condoms on
display in the "feminine hygiene" section and so meant to be purchased by women
were advertised as rainbow colored and fruit flavored!

The goal of romance is finally achieved in the story with a commitment to build
a life together in Chicago. First, both partners must get their work situations sorted
out, a process that involves separation and then another reunion. The subsequent
sex scenes, interwoven with moments of tender romance, domesticity and humor,
progress from oral sex to fingering, "rimming" and finally anal penetration. Cicioni
observes that the latter is presented in slash from a heterosexual female perspective,
ranked "as the ultimate sign of trust and the ultimate surrender of self to the
partner" (p. 168). While this is true of MRKS slash to a degree, the progression can
also be read as two novices in homosex gaining confidence and skill:

It was really kind of weird, Ray thought, kissing his way down Fraser's naked back, running his tongue across the cratered scar next to his spine before moving lower, but so far nothing they had done had turned him off at all. And in the last two days they'd done damned near everything he'd ever heard of that two guys could do. Okay, well, just short of everything. There was one thing Ray had been avoiding because he was afraid Fraser wouldn't like it. Fraser seemed to want it. Acted like he wanted it. Bad. Bad enough to lay there spread out on the bed like an invitation to a wet dream. Not that Ray minded, since it let him return a favor from the night before, but he wasn't sure that Fraser really knew what he was asking for.

Unlike the short euphemistic paragraph quoted by Cicioni from *Professionals* slash ("their loving was indeed slow and gentle" p. 168), this description is detailed and graphic, filling two screens with text:

"Oh, fuck," he breathed, feeling himself sliding in. Just as tight and hot as he'd felt around his fingers. Almost like being sucked, but different, better...He stopped, just the head of his cock inside Fraser. Benton. Waiting. Felt Fraser relax. Okay. Slow, he told himself. Slow. He pushed a little harder. Felt that snug channel yielding to him, opening up, but just barely enough to let him in. Felt so damned good. Fuck. Fuck. He was losing it.

The scene "climaxes" as follows:

Fraser let his head drop forward, bent, and Ray knew he was staring down the length of his own body to watch as Ray jacked him. Each of his thrusts forward was met by one of equal strength back against him, and he felt Fraser start to shudder under him. He tightened his grip, moved harder, faster, and then Fraser was coming, hot slickness spurting against his fingers, against Fraser's belly, his whole body taut and shaking. Ray managed a few more ragged thrusts but the close, hot channel that gripped Ray's cock seemed to pulse, squeezing him, dragging him over the edge. He started to come just as Fraser's knees gave out. Ray pancaked down on top of him, one arm trapped beneath him, laughing and gasping, and coming, his whole body nearly shorted-out with pleasure.

Queer Pleasures and Identifications

My interest is not whether scenes such as the one above are accurate descriptions of male homosex but rather the queer pleasures that such scenes afford to straight/bi women. All but two respondents made direct reference to sexual desire:

```
I'll be up front and say it's sexually stimulating. Guys
like F/F porn, women like slash. It's nice to 'see' all
that maleness-- it's [sic] intrigues me. Reading
```

```
detailed descriptions of some woman's sexual responses
doesn't turn me on but reading about some guy's sexual
responses? Oh yeah ;-D (Drucilla)

It's hard to define. All I know is that reading about a
male/male relationship titillates me. (Penelope)
```

The range of queer desire is illustrated by the following two responses:

```
[I]t's what I told my husband when he finally broke down
and admitted that he thought slash and homosexuality
were just sick and that I was a lesbian because I liked
it. <G> I said, "If one is good, two are better." And
that's a big part of it - just that it's two guys. I
have decided I'm really pretty heterosexual - guys do it
for me, and so do their sexual organs. I've definitely
become more aware of good looking men and nice bodies
since reading/writing slash too. (Phoebe)

As bisexual women in a monogamous lesbian relationship,
it is nice to have some men in our lives! (Clegret)
```

For Phoebe, her sense of heterosexuality was heightened while Clegret was able to explore the multiplicity of identification and desire, refusing a singular identification as lesbian. Others gestured toward the imbrication of desire with a gay politics:

```
I read and enjoy slash on two levels. At the basic
level, it feeds my kinks and gives me a thrill to read
really good slash where the author has taken the time to
work on the characters. It doesn't have to have a great
plot, or any plot. Just good characterization and sex.
On another level, there is the whole two men realizing,
sometimes for the first time, they are in love with
their male partner and dealing with all the ramifica-
tions that go with such a revelation. (Meghan)

Also, it's an undeniable turn on for me to read a
well-crafted story with the well crafted sex-scene. I
like those in M/F but in the original fiction. It's
almost as if once I decide that a pair of guys is a
couple, that's a turn on in itself, and I'm rooting for
them to overcome, get it right. (Estraven)
```

The "ramifications" and that which needs to be "overcome" are likely oblique references to heterosexism and homophobia that men who decide to enter into a same-sex relationship face in "real life."

A similar range of queerness is performed by the respondents in pinpointing the sexual orientation of Fraser and Ray. Unlike many slash readers and writers, particularly those of h/c or smarm, even the self-identified straight MRKS participants made it clear that they were not interested in queer denial. Meghan underscored this point, stating that she avoided "'I'm not gay' stories." In the context of a list discussion of a letter sent to the syndicated advice columnist Dan Savage, Sylvia asked "Is it just me, or is there a contradiction in the statement: 'I'm a straight guy, but I want to suck a guy's cock.' I mean, wouldn't that indicate a leaning toward, say, bi-sexuality? <g>" Several members also rejected the letter writer's attempt at "hetero-flexibility." [13] Drucilla noted humorously, "Denial is not just a river in Egypt. ;=D"

The members who provided the "straightest" readings of the characters' sexuality stressed the limitations imposed by the primary text.

In a given work of slash, I could be convinced that either one is gay and has just been closeted (or in denial) for a lifetime, but it would take a damned good writer to make me believe it (unless it's in an AU).

Generally, I do believe that Ray loved his wife (and that was a very long term relationship), and I believe Fraser was...well...if not in love with Victoria, then at least in lust/obsessed with her. However, I don't see much in the way of chemistry between either of them and most of the female characters on the show (regulars or guest stars) and I *do* see chemistry between Fraser and Ray, so...if I have to attach a label, I'd say bisexual is the only sensible label for either of them, most of the time. **(Jeanne)**

For the purposes of the fic I write/read, I would have to say bisexual, as each has had at least one serious het relationship in his past (as defined by the show's history/canon). When I watch them on-screen, however, there is only the barest sub-text--for all intents and purposes, they are straight. I can and do extrapolate in various ways, since neither has ever said anything canonical about their sexuality. Ray, in fact, has said he'd "try anything once," and Fraser's "only ever loved one woman" in his life. **(Penelope)**

The next set of responses position the characters firmly as bisexual.

> Bisexual, I guess. More queer really. I once heard a
> Unitarian Universalist minister…preach on the topic of
> sexuality and his these [sic] was that the more he knew
> of sexuality the more he realized how useless labels
> are. Yeah, sure, he is gay, but…what "turns him on" is a
> combination of factors unique to him. That spoke very
> strongly to me and is what I have come to identify as
> Queer theory. **(Clegret)** [ellipsis mine]

> I think they're bisexual. (Actually, I consider all
> characters to be bisexual until it's been demonstrated
> otherwise, because I like to be difficult that way. But
> with Fraser and Kowalski, I think there's a lot more
> evidence that they are.) **(Thea)**

As she did in discussing her own queer identification and articulation of desire, Clegret gestured to the multiple discourses of nonnormative sexualities with which she read Fraser and Ray. Thea refused to position her reading on the level of subtextual, the same position held by Alexander Doty:

> I've got news for straight culture: your readings of texts are usually "alternative" ones for me, and they often seem like desperate attempts to deny the queerness that is so clearly a part of mass culture. The day that someone can establish without a doubt that images and other representations of men and women getting married, with their children, or even having sex, undeniably depict "straightness," is the day someone can say no lesbian or gay have ever been married, had children from heterosexual intercourse, or had sex with someone of the other gender for any reason. (p. xii)

Estraven, Drucilla and Phoebe placed the characters further along the queer continuum, between bisexual and gay. Estraven admitted that the "facts" of the primary texts at best enable the former but, in line with her articulation of desire in reading slash, she saw "a solid foundation for a budding gay relationship." Similarly, her next comment raise issues around identity politics: "I'm not one that would hound a gay guy to death in hopes of 'reforming' him, or like Nurse Chapel,[14] hoping that the love of a good woman would win through and change things…" In other words, she refuses to impose her heterosexuality onto the characters. For Drucilla, the characters' sexual identity shifts depending on the episode. She was also the only respondent who read Fraser's sexuality ("primarily gay") as different from Ray's ("more bisexual"). Finally, Phoebe's long response underscores the

complexities of queer reception/production and the shifts that have taken place in her writing strategies over time:

> The convention at the time was that F and K were
> straight/bisexual, and it took some months of writing
> and discussing and exploring for me to feel secure
> enough with that read to move out of the envelope and to
> start to write them as bisexual shading into gay. About
> two years ago I started an AU and part of the reason I
> wanted to write the AU was to escape from the canon,
> which posits significant female others for BOTH men and
> thus contributes mightily to the "bisexual" read <G>,
> and just be able to write Fraser and Kowalski as gay
> from the starting gate. In the past year or so I've
> moved more into the "gay shading into bisexual" read, in
> part because of my friends and in part because writing
> them as gay is so much more fun than the angsting over
> "am I gay?" that so many writers have done to death.

Phoebe's approach, though, is not typical of the slash I have read. While a few stories had Fraser and Ray in an established bisexual/gay relationship,[15] in most the characters start off as straight and experience their first homoerotic attraction. "Like a House on Fire" is unusual in that the authors do specify and explicitly track the shifting identifications of the characters. Fraser is characterized as first having sex with other boys as part of a dare when he was thirteen. A brief relationship with one of the boys is implied but Ray is the first adult male for whom he experiences homosexual desire. Fraser is also presented, from Ray's point of view, as sexually repressed and uncomfortable with women. Ray is characterized as having no desire for other men, so he makes sense of his intensifying feelings for Fraser by comparing them to those he had for his ex-wife at different stages of their long relationship. The rationale provided for Fraser and Ray taking so long to recognize their mutual sexual and emotional attraction is that they have misread each other as straight. Once the characters make a commitment to each other, however, the authors position them explicitly as gay.

Even a gay identification, though, did not lead to the endorsement of gay politics. As noted earlier in the chapter, the respondents expressed a dislike of "issue fic." The idea of writing a story involving a gay pride march was criticized roundly in one list discussion:

From: Phoebe
This - this is a classic example of the kind of story
notes that would send me racing for the back button.
------ Forwarded Message
Subject: [allslash] Pride Challenge!!
> Well ladies and gents, pride is coming up and here is
>a challenge for that event. Lets show our support and
>start writing some pride marching, rainbows, coming
>out, h/c pride slash. The only requirement that pride
>have something to do with or around the story. So pick
>your favorite characters and start tapping away at
>those keys.

From: Drucilla
Yea verily, amen.

From: Jeanne
I saw this message this morning posted to Serge, and I
must admit to uttering the words "Eeek! Blech! Go away!"
(among other things).Queer as Folk (US)? Okay...they've
already done the marching thing, but I just can't see it
with most other shows' characters. I mean, god knows
there's nothing wrong with Pride marches; I've been in
them for heaven'ssake.

It's just...who's supposed to be doing the marching? Bodie
and Doyle? Starsky and Hutch? Ray Vecchio and Ray
Kowalski, arm in arm? (sorry for *that* scary image <g>)
Hercules? Spock? I'm just not seeing it.

Mirna Cicioni quotes a *Professionals* slash writer who believes that the avoidance of gay politics is indicative of underlying homophobia in the fandom. This charge cannot be leveled at these MRKS participants, as issues of gay rights and politics were regularly discussed (see Chapter 5). Even in this thread, Jeanne stated her support for pride marches in "real life" and in a show like *Queer as Folk* where the characters are written as openly gay. The implication is that the heterocentric discourses of the primary text prevented her from imagining Fraser and Ray as out enough to participate in such events. Still, I am left wondering why it is so difficult to imagine a story set well after "Call of the Wild" in which Fraser and Ray attend if not actually participate in a pride event, or a story in which they become politically active members of the gay community. Perhaps it is less adherence to the DS "canon," to be addressed more fully in the final section of the chapter, than the convention of the romance that focuses on the personal (domesticity, emotional and sexual intimacy) as separate from the political. The function of romance fiction,

even if it is queer, is to provide an escape from unpleasant realities; simply put, issues detract from the fantastical pleasures of such texts.

The Slash Closet

The MRKS participants may not have wanted to read and write about gay politics but their penchant for slash puts them at odds with heteronormativity. As with any queer practice, slash evokes the discourse of the closet and one's relative position to it in terms of "in" or "out." Since the gay liberation movement sparked by Stonewall, legislative gains have been made in areas of protection against discrimination, same-sex benefits and even same-sex marriage. Yet Eve Kosofsky Sedgwick (1993b) argues in her now classic essay, "Epistemology of the Closet," that far from losing its force, the closet continues to be the "fundamental feature" of gay (queer) social life:

> [T]he deadly elasticity of heterosexist presumption means that, like Wendy in *Peter Pan*, people find new walls springing up around them even as they drowse: every encounter with a new classful of students, to say nothing of a new boss, social worker, loan officer, landlord, doctor, erects new closets whose fraught and characteristic laws of optics and physics exact from at least gay people new surveys, new calculations, new draughts and requisitions of secrecy or disclosure.

As a practice specific to fandom, reading and writing slash does not seep into all aspects of social life, resulting in experiencing the closet as intensely as described above. Alain indirectly raised another difference between taking up a single queer practice and a non-straight lifestyle: "We share a feeling of being different and/or special. I say special because slashers decide for ourselves to be outside the normal fan world." That said, all the MRKS respondents have had to make "choices" about secrecy and disclosure outside of their slash communities. About half considered themselves reasonably comfortable in telling family and friends.

```
I usually don't tell [people] if I don't think they'll
be cool with it. Luckily most of my friends are cool. :)
(Meghan)
```

```
I'm very OUT. I am one of the few slashers I know who
uses their real name. That's in part because my family
knows, and my boss and co-workers know, and I work at a
university where no one really cares about stuff like
that. (Drucilla)
```

> I'm far more out than many writers; but I have less to
> lose. However, I don't see a need to scare or upset
> people by telling them what I write when they're homo-
> phobic or prejudiced in other ways. Some people don't
> have to know everything. **(Marguerita)**

All three responses contain direct or indirect references to homophobic reactions: being or not being "cool"; caring or not caring about "stuff like that." Both Drucilla and Marguerita also acknowledge that they are the exceptions in terms of being in a position to be out. Thea made a direct link between dealing with the closet as a bisexual woman and slash, although she rejected the term "closeted":

> I have a small handful of good friends who know I'm
> involved in slash. My acquaintances basically know I'm
> bisexual (I don't "come out" to them, but if we're
> talking about attractiveness, I don't hide the fact that
> I find women sexually attractive.)…I don't tell my fam-
> ily any of these things, about being bisexual or writing
> slash, because they wouldn't want to hear it. I know
> them well enough to know that. And I'm secure enough
> with my own identity that I don't need validation from
> others. [ellipsis mine]

Phoebe had a similar response in seeing slash as a possession that she was under no obligation to share, but she had mixed feelings about her choice to remained closeted:

> This [slash] is MINE and I don't feel I have to share it
> with anyone who doesn't get it. I don't want to share it
> if they don't get it. I don't want to be judged; I don't
> want to have to justify what I read, write, like, as
> long as I'm not hurting someone else or imposing my
> likes/dislikes on them. On the other hand, I get con-
> flicted about it. I feel that the negative reaction to
> slash is in part related to just a sort of general
> cultural homophobia and I wonder how much it's our
> responsibility to be "out and proud" of slashing to
> combat that. On the third hand <g> no one has a right to
> tell anyone else how or when to 'come out.'

Not everyone experienced the slash closet negatively. As a bisexual woman who knows all about the closet, Clegret relished slash as "my little secret" that "has put a gleam in my eye. It makes me feel like a woman of mystery!" The pleasure in

having a shared secret also came up in a list thread entitled "Our secret lives" in which Kenzie reported a conversation with her supervisor's secretary, who expressed surprise that she would read popular novels. Kenzie almost choked on her coffee "as I wondered what her reaction would have been if I'd told her that I really only read novels to fill in the gaps between slash postings." For others, such as Jeanne and Drucilla, it was not the homoerotic aspect of slash to which others would react negatively, but the fact that the m/m pairing involved two characters from an obscure television series.

It would be a mistake to assume that the risks of reading and writing slash are nonexistent or minimal. Because of their discretion, few respondents have experienced repercussions. Estraven and Tikva remarked that getting "caught" reading slash at work or having slash on their work computers could cause problems. Others like Penelope and Alain were more concerned about the general embarrassment or being perceived as a "pervert" or as "sexually deviant." No one has paid a higher price than Phoebe, personally and professionally:

> My erstwhile husband found out about the slash by
> snooping in my personal email and on my computer - one
> reason I have a laptop now. He reacted very badly and it
> took him about two years to come to terms with it. He
> tried at one point (before I had had any problems with
> fandom) to take the children away from me and the house
> and part of what he used against me, or was planning to
> in the divorce action, was the fact that I read and
> wrote slash, to the point he had taken a zine and given
> it to his lawyer. (It was at that point that I switched
> to using a pseudonym online and began to try to remove
> my real name from stories and websites.)

The negative reaction described by this respondent was vehemently homophobic: her husband told her that he was sickened by the homosexual practices she described in her stories and accused her of being a lesbian. Moreover, he outed her to her parents, although this strategy backfired. After two years, Phoebe and her husband reconciled: "he's not completely comfortable...but he's more accepting now." Still, she refuses to allow him access to her computer. Phoebe has also been victimized by another writer who, out of spite, outed her to whom she believed was Phoebe's current employer. Fortunately, she had recently found a new position at a university; otherwise she could have been fired. Stories about Fraser and Ray

marching in pride parades are therefore not necessary to forge a link between slash and gay politics. Phoebe put it this way:

> I identify with discrimination against gays and general put downs because I've experienced some of that just because I write slash, and I'm just more aware of it in general because I'm writing about gay (or bi) men in contemporary culture.

Slash communities like MRKS are important precisely because their members do not have to negotiate their position vis-à-vis the closet:

> I think that fandom in general is a constellation of tiny communities, and when we find the places that fit us, those feel like our "home". For me, it's all about finding a group of people who "see" the source material as I see it. I found some groups who see DS as a love story between Fraser and Kowalski and, in that environment, I can talk openly. **(Alain)**

> It's very important to have someone with whom you can share secrets, and slash is like a huge secret from the "mundane" world. Only with other slashers can I talk about what has become such a huge part of my life. Whether I do this on-line or in RL, the connection is very important to me. **(Penelope)**

> It is nice to be able to talk about Fraser and Kowalski without shame. **(Thea)**

Kenzie underscored the queerness of her slash community, contrasting it with both the larger straight and gay/lesbian communities:

> It's funny. I'm bisexual and I think the slash community is the first place where I've ever felt like that's really accepted and okay. I mean, the gay community doesn't want you because they think you're not committed and the het community doesn't know what to do with you. But in the slash community, it's really okay. I say "okay, really, I'm not a lesbian, I'm bisexual and my partner's a woman but I just don't think that automatically makes me a lesbian." And they say "okay." And talk about other stuff because it's a non-issue.

Like the DDEBRP members with *The X-Files*, a common interest in slash has formed the basis of close friendships:

> There are many slashers with whom I communicate fairly
> regularly, but there are at least a half dozen women
> I've gotten to know through slash reading/writing/ dis-
> cussing with whom I'm *very* close. We visit each
> other's homes (some of them don't live in the same part
> of the country as I do), share meals, send gifts to each
> other, talk all the time (online and on the phone),
> share family and work problems, etc. **(Jeanne)**

> Some of my best friends are slashers. I've done more
> travelling, done more interesting things, and been much
> more socially connected since I became a slasher than I
> was in the years previous. I find I can talk to them
> more freely and easily than I can many people because I
> know we 'speak a common language.' **(Drucilla)**

Given these comments, it is nonetheless important not to romanticize or idealize slash communities. A few members noted that they felt no particular connection to others just because they had a common interest in slash. In one thread, appropriately given the subject header "fannish ennui," Jeanne expressed dissatisfaction with the status quo of fandom:

> It's not that they've lost interest in their favorite
> shows (or films or bands), per se, but rather that the
> sameness of the list conversations (especially true when
> one moves to a new fandom and sees replays of
> conversations that had just taken place in the *old*
> fandom), the fannish rivalries, the unwillingness to
> venture out-of-the-mainstream opinions, etc. are all
> adding to their feelings of estrangement from fandom
> generally.

A Critical Eye for the Queer Text

The pleasures and identifications discussed above may be queer rather than feminist but they are not based on queerness alone. An underlying theme running through the data samples presented in the previous pages is the *quality* of the fiction. Part of the "thrill" for Meghan, for example, was reading "really *good* slash where the author has taken the time to work on the characters." The "turn on" for Estraven was "a *well-crafted* story with the *well crafted* sex-scene" (emphases mine).

Thus descriptions of two men kissing or having sex, did not bring pleasure in and of themselves. To date, scholars have paid little attention to this aspect of slash. Constance Penley (1991) is the exception, discussing the importance of good writing in relation to "professionalism." She describes the pleasures of receiving critical acclaim from readers but stops short of linking this discourse with class. As I demonstrated in the context of the DDEBRP, valuing quality writing and assessing it critically is an application of bourgeois aesthetics and performance of middle-class identity. If slash is a highly nonnormative practice in terms of sexuality, a concern for quality is highly normative in terms of class.

In the quotations that follow, MRKS respondents unpacked the term quality:

```
[A]ccurate characterization, attention to canon and then
spelling and grammar, in order of importance, but the
key is if they add up to a story that is pleasurable to
read for its construction as well as its content. Some
of the slash stories I've read are written so beauti-
fully that images and whole paragraphs stick in my mind.
As a writer, I frequently have serious "line envy",
wishing I could have written a specific piece of
dialogue myself. (Alain)
```

```
Writing, writing, writing. I want the characters to
sound and act like themselves (voice is vital!). I want
the sentences to flow. I like clean, well-crafted prose.
I want to see believeable [sic], meaningful situations
that play out logically. And, sure, hot sex is nice, but
I'd rather read a well-crafted story that merely hints
at the slashy elements than a poorly written sex fest.
(Meghan)
```

```
I look for characterization first. I have to be able to
"hear" the character's [sic] voices in my head when
reading slash; otherwise I won't read it. Next most
important thing is spelling and grammar. I'm an editor
and if I find myself proofreading and correcting a story
as I go, I can't get through it. It's literally too much
like work. Another important thing is canon. Unless the
story is labeled an AU, I expect canonical events and
characterizations. Research is also very important. I
know that some authors extensively research background
events, locations, etc for stories and I appreciate
that. I also expect that a story will have been beta'd
by at least two people. (Tikva)
```

Together, these three responses cover the qualities of "good" slash: characterization, part of which involves adherence to "canon" in non-AU; a plausible, logical though not necessarily detailed or intricate plot; verisimilitude achieved through research; effective and accurate use of language and style; and finally editing (referred to in software testing terminology as a "beta").

The issue of *canon* is the one feature unique to fanfiction. In the popular cultural context, the term refers to the characterization and character development across the history of the series. The term clearly mobilizes a discourse of authority: like the literary canon, the primary text is not to be trifled with. When I joined the list in May 2002, for example, I received a FAQ detailing life histories, behaviors and characteristics of both characters established in the episodes. Here is an excerpt around the naming conventions for Fraser:

```
*Fraser introduces himself as "Benton."

*His father and other family friends and enemies call
him Benton or Ben (Quinn, Eric, Buck Frobisher, Gerrard,
Buck Frobisher's daughter, Victoria, Mark Smithbauer).

*The only person to call him "Benny" is Ray Vecchio.

*Ray Kowalski calls him "Fraser," and, very occasion-
ally, "Frase" or possibly "Red."

*Other policemen at the 27th, including Lieutenant
Welsh, refer to him as "Red" or "Big Red," although
Welsh prefers to address him as "Constable."

*Thatcher also calls him Ben once (in WATE) when she's
trying to imply an intimate relationship between them
for the benefit of Henri Cloutier who is harassing her.
```

Knowledge of canon is a form of what John Fiske (1989) calls *popular cultural capital*. It is based on Pierre Bourdieu's notion of cultural capital. Just as people have material resources, they also have cultural resources that have symbolic value. While Bourdieu was particularly concerned with higher education and highbrow culture, Fiske redeployed the term to recognize the high symbolic value that popular culture carries in many quarters of contemporary North American society. As university-educated fans, the MRKS participants had investments in both traditional and popular forms of cultural capital.

The effect of these investments was to create an insider/outsider binary between the MRKS community and the larger DS fandom. In one of the longer list discussions, Phoebe identified the two positions on writing slash as "craft" vs. "fun." What particularly irked her was an attitude she has encountered which lumped all women in the "fun" category:

```
I have no problem with the concept that there are people
out there writing for reasons different than mine. The
only thing I object to is when I sense a gathering moral
superiority and attempts to make one way the "only" way
- that the "fun" way is better than the "craft" way, for
instance, or the condescension of "it doesn't matter,
it's just fanfiction/for fun/for women," which is
actually a pretty damn insidious way of dismissing what
we do, and dismissing (by implication) the people who
take the craft of writing "just" fanfiction seriously
much more completely than those writers who are "fooling
around" or writing as an explicit (or implicit) leisure
activity.
```

In another post she criticized the "just for fun" position as an excuse to avoid the hard work that craft required. At the same time she recognized that some writers may not have the required levels of cultural capital to produce well-crafted stories. Deirdre agreed with Phoebe, and positioned communities like MRKS who care about quality as a minority.

```
Far as I can tell, most *people* are lazy and uncaring
about the degree of craft and care they bring to any
pursuit. I'm sure in any hobby group or whatever that's
mostly male, there's some minority feeling annoyed/
disgusted/whatever with the rest of the members of the
group who are sloppy/uncaring/'just in it for fun'.
```

Sylvia's reply reaffirmed the collective view that the majority of any group will "settle for mediocrity." When Donna joined the thread, she disrupted the consensus around the "us vs. them" position:

```
And I realize this is probably not the forum for
disagreement on this issue, but...<holding my nose and
jumping in> I think posting sloppy, poorly written,
poorly characterized fanfic is okay. I personally won't
read it, and truthfully I don't know where they're
getting positive feedback from, but it's still okay with
```

```
me that they do it…The folk on the Way Too Intellectual
TS Critique list used to take this kind of writing as a
personal affront, as far as I could tell.
```

This participant was clearly concerned about the consequences of expressing disagreement, but a common position was quickly reestablished by Phoebe, who asserted that she had no problem with others posting "dreck," repeating the term Donna had used to conclude her message (not quoted). Her objection, she explained, was being put down by those in the "fun" camp for "rewriting a sentence 27 times or agonising over a point of characterisation or dialogue." What was coalescing was a liberal humanist position of "equal but different." Angela spoke for the community when she declared, "I'm in the live and let live school, like probably everyone on this list— it's part of being a mature adult."

That said, some participants did not always adhere to this school of thought. Several list discussions revolved around criticizing or mocking fiction perceived to be poorly written. These discussions are particularly interesting because in pointing out the "bad," what counts as "good" is cast into relief, not always without ambiguity. Furthermore, such performances of middle-class identity function to consolidate MRKS as a discerning slash community:

From: Angela
```
However, a couple of sentences in an intro will make me
run screaming for the hills:

"I've never seen any of the eps, but I've read lots of
fic."

"I rushed this together between classes"

"I was supposed to be studying for a <insert high school
class here> test, but my friend IM'ed[16] me with a plot
bunny <most hated term!> and begged me to write it."

"Beta? What's a beta?" <Different from self-beta'ed>

"I like the name Stanley."
```

Angela is referring to the story notes provided by many authors. Whether these lines are actual quotations from story notes or loose paraphrases is neither clear nor important. They signaled to her that the fiction would be lacking in quality because the author was unfamiliar with the primary text, didn't spend any time developing

characters, a plot, or proofreading, only wrote the story as a challenge, is unfamiliar with the custom of having an editor, and prioritizes personal taste ("Stanley" instead of "Ray") over canon. She concluded her message by asking others to add to her list, and a number of members responded. Most were humorous variations of the same themes. Penelope, for example, punctuated the offending intro with disapproving "sounds.": "Benny <aargh> and Stan <aaargh> go shopping/bake pies/go to the zoo <aaiieee>." Beyond violations of naming convention and nonsensical plots, Penelope also flagged spelling and punctuation:

> "Ray and Frasser's relationship flourishes and gets a
> little help from Dief." (Okay, I'm cheating, that's an
> actual summary from a new F/V fic on due Slash. Spelling
> is as I found it.) This may be too general, but…anything
> with exclamation points, or ALL CAPS…I'm tapped out.

Once the criticisms shift to inspirations for stories, the waters of quality become murkier. In two separate posts, Drucilla pointed out the following intros as problematic: "I have <insert disease of choice> and thought it would be interesting to see how Ray and Fraser would react if one of them came down with it too;" "After the recent (insert event here) I wondered how Ray and Fraser would react to being in that situation;" and "I just broke up with my significant other and decided to write this story." Presumably, the problem is a lack of critical distance/objectivity. As discussed in Chapter 1, these fan authors were perceived as "sitting too close," the characters mere non-canon mouthpieces for political interests or emotional state/physical condition. For some participants, the line between emotional attachment and critical distance was not so clear cut. Leah responded directly, noting that the "recent event" inspiration "can work, but it's got to be handled subtly and carefully." As for the "break up" influence, she agreed, "nope, that's never good" but then admitted that she was "guilty of scary author's notes" and gave an example: "I've been listening to George Michael nonstop for ten days. Enjoy." Whether her post was intended to be tongue-in-cheek is not clear, but it prompted this reply:

> **From: Deirdre**
> I've got to say, this thread is making me think about
> what *actually* inspired some of my stories and all's I
> can say is, man, I'm just glad I didn't 'fess to any-
> thing too massively stupid in my story notes. Yikes.

This post served to rupture the communal position, blurring the binary between well-written or poorly written fiction. Worth noting is the inclusion of "all's I can say." As a proficient user of standard English, Deirdre's choice of this colloquial but grammatically incorrect expression was deliberate and functioned to further distance herself from the middle-class community standards of language use.[17] Drucilla moved to smooth over this awkward moment by teasing her that was okay to have these inspirations as long as one did not confess to them in story notes. Jeanne then joined the thread to reestablish a sense of community by asking members about what inspired their stories. She then provided some personal examples:

> [Title 1], for example, came from a single image
> floating around in my head: a kiss at twilight in Ray's
> kitchen doorway - and that ended up being the first
> scene I wrote (even though it came in the middle of the
> story). [Title 2] was a combination of things...part based
> on various discussions (privately and on lists) about
> what constitutes craziness where Fraser's concerned...and
> part based on hearing Patsy Cline's song "Crazy" right
> after I re-watched "Strange Bedfellows." And [Title 3].
> Appropriately enough, I pretty much dreamed it...and then
> wrote it the next day.

Others followed her lead and volunteered their inspirations. Yet the mention of a song and a dream by Jeanne do not seem so unlike the notes that had been criticized for failing to demonstrate appropriate critical distance. Toward the end of the thread, the participants did acknowledge that story notes in themselves were not a useful criterion:

> **From: Drucilla**
> Actually for me it's a combination of factors, but
> certain types of story notes definitely tend to put me
> on 'alert status' and the first few paragraphs of a
> story will usually be enough to tell me if that alert is
> warranted or not. So do certain author names. So if,
> say, I saw a story by someone I have read and enjoyed
> before with a note about- say-- it having been inspired
> by a breakup or a natural disaster, I would probably
> read it anyway, while if it were by an author whom I
> have generally found lacking in some way, it might be
> enough to make me skip it.

To be fair, MRKS participants also meted out praise for fiction by other writers and measured themselves against it accordingly. An excerpt from the thread, "Fic Rec" follows:

> **From: Phoebe**
> Doing my flyby maintenance of due Slash and there's a
> new story up called "From Afar." It's F/K, post CotW,
> pretty long, and she can string complete sentences to-
> gether. Worth a look if you need that bedtime reading.
>
> **From: Drucilla**
> This is a major understatement.(off to burn everything
> I've ever written)
>
> **From: Phoebe**
> Well, you know me. Very few things actually blow me
> away. But this was technically well written, a major
> plus compared to some of the stuff out there lately.
> Could have used a beta. <G>

As Phoebe's post contained a minor criticism, Drucilla conceded there may have been "one or two small things" but then affirmed that she had been "too engrossed" to pay attention. Phoebe's response is conciliatory and face saving:[18] "Uh, maybe you'll catch 'em on the reread, says the wanna-be copy editor." Drucilla agreed: "Most likely—I tend to notice things more the third or fourth time through. (as you know) ;-D." Later on in the thread, Drucilla admitted that she had violated her own rules about not reading "unbetaed" stories from a first-time slash writer. To shore up her position as a critical reader in the community, she emphasized that her statement about burning her stories had been hyperbole, a rhetorical strategy she had assumed the others would recognize as such. As well, she reaffirmed her support for the story: "I know my first story ever was a hell of a lot less well done than hers was :-." Leah, by contrast, would only say the story was "nice." Although she played down her lack of enthusiasm by saying "it was not her style," she also offered more concrete criticisms about it being too long and having "wayyy too many adjectives!"

What I hope these data samples illustrate is not that the MRKS participants are hypocrites or that the craft vs. fun binary is completely arbitrary; rather, bourgeois aesthetics is a double-edged sword that can cut those who wield it in an effort to make distinctions on the basis of "quality" or "good taste." Upholding community standards based on bourgeois aesthetics too often has the unintended

effect of creating an insider/outsider binary *within* the community. Ironically, the importance of upholding such standards for the participants is likely reinforced by the charges of "sitting too close" or perversion made by high-culture aficionados and homophobes. As I will argue more fully in the next chapter, the denigration that they experience as fans in general and slash writers in particular may reinforce their desire to mark themselves out as legitimate members of the university-educated middle class.

Notes

1. See Boyd (2001), Jenkins (1992) and Penley (1991).
2. Actor slash is controversial in fandom and not approved of by the MRKS participants.
3. "dS" is used by some MRKS participants because the series title is written without a capital "D" in the opening sequence.
4. This result is not surprising given Boyd sought out participants through the web and her survey instrument was conducted online.
5. "Fen" is used by some fans, including some members of MRKS, as the plural form of "fan."
6. This line was spoken by Ray Kowalski in the Due South episode "Eclipse" (CTV, 21 September 1997).
7. The use of the name "Stanley" instead of "Ray" is also part of the joke. With the exception of the character's mother, who appears in one episode, no one calls RayK by his first name.
8. This exchange is also discussed in term of managing disagreement in Chapter 4.
9. Rimming is slang for the licking of the anus.
10. "Kellie Matthews" and "Beth H." are the real names of the authors. I have not used their MRKS project pseudonyms in order to ensure confidentiality.
11. In "Call of the Wild," Fraser and Ray are last seen heading off together into the northern Canadian wilderness on the trail of the doomed Franklin expedition to find the Northwest Passage.
12. The MRKS participants always referred to Benton Fraser by his last name only, as his partner Ray K. did in the series. I have followed this convention as well. This naming convention will be discussed in more detail later in the Chapter.
13. I am grateful to Lee Easton for this turn of phrase.
14. Nurse Chapel was a character in the original *Star Trek* series.
15. Ardent's "Simply Ray" starts with Fraser and Ray living together as an out gay couple up north "post-CotW" and deals with some of the relationship difficulties they experience. Similarly Kellie Matthews' "Unforeseen," positions both men knowing that they are gay before they begin a relationship and Fraser as experienced in homosexual practice.
16. "IM" stands for "Instant Messaging; in this example, it is used as a verb to "IM" someone.
17. I will elaborate on language usage in relation to practices of community in Chapter 3.
18. Face needs and politeness strategies as community practice will be discussed in Chapter 4.

≚ Chapter 3
The "Write" Stuff: Language Use and Humor On (the) Line

The previous chapters have discussed the David Duchovny Estrogen Brigades and the Militant RayK Separatists as fan communities. More broadly speaking, they are communities of university-educated women, with performances of gendered and classed identities extending beyond fan-related discussions. In Chapters 1 and 2, I discussed class in relation to the discourse of bourgeois aesthetics and its deployment in assessing *X-Files* episodes and *Due South* slash. Here I will look at the accurate and effective use of language as an overarching communal practice and the investments of members of both lists in *linguistic capital*.

Bringing English to Order[1]

Since the 1500s, grammars, dictionaries and writing handbooks have served to construct and legitimate the "rules" of language usage. Until the Elizabethan era, English had no grammar, spelling rules or a national dictionary. It was one of the last vernacular languages in Europe for which a grammar was produced, in 1586 by William Bullokar, following the Spanish in 1492 and the French in 1530 (Howatt, 1984). According to Anthony Howatt, the first English grammars were modeled closely on Latin, the language of schooling, and were aimed at three groups: foreign students of English, primarily academics and scholars who needed a good reading knowledge of the language; school pupils for whom a basic course in the vernacular was designed to help them with Latin; and finally private scholars with an interest in the philosophy of grammar. With the emergence of the nation state and nascent capitalism, members of the bourgeoisie began attending universities along with the upper classes, and English became an official subject to be taught with the same rigor as Latin or Greek (Goodson & Medway, 1990). What has become known as

"standard English" is in fact the variety spoken and written by the dominant social groups. Deviations have been positioned as "substandard" and in need of correction. Until the 1970s, for example, African Americans were presumed to speak grammatically incorrect English. Based on his fieldwork, sociolinguist William Labov made the case that Black English Vernacular (BEV) was simply a different but not inferior variety (Cameron, 1992). "Errors" such as double negative ("I can't get no satisfaction") and use of concord "be" ("I be going now.") were, in fact, following the syntactical structure of West African languages.

While linguists may no longer endorse prescriptivism in theory or practice, the educated lay public is another story. As Deborah Cameron (1995) observes, "I have never met anyone who did not subscribe, in one way or another, to the belief that language can be 'right' or 'wrong,' 'good' or 'bad,' more or less 'elegant' or 'effective' or 'appropriate'" (p. 9). Cameron discusses in detail what she calls the "the great grammar crusade" (p. 78) of the late 1980s and early 1990s. Ideologically conservative politicians and educators (even Prince Charles jumped on the band wagon) bemoaned the supposed mangling of the English language in the mouths and at the hands of youth and advocated for curricular reform. Indeed, educational institutions play a leading role in prescribing language usage, directly through instruction and assessment, and indirectly through the use of style guides and writing handbooks. Cameron coined the term *verbal hygiene* to describe efforts that promote the "cleaning up" or reforming of language. While the explicit goal of grammar crusaders may be to stamp out "incorrect" usage, the function of a discourse of prescription is to differentiate those who possess the "write" stuff from those who do not. As James Gee (1990) argues,

> languages are social possessions, possessions that partly define who count as "real" members of the group, "insiders," we might say. As the language becomes a complicated and intricate form, not tied in any very obvious way to meaning, only children, people born into the culture, can master it fully, effortlessly…while "late comers" never fully master these intricacies, and so always mark themselves out as "outsiders". (p. 78)

A normative identity such as upper or middle class-ness, in part, is performed through regular and repeated use of the standard variety. It is also produced through the policing of that standard—in other words, through a practice of verbal hygiene.

Pierre Bourdieu (1977) uses the concept of *linguistic capital*, a form of *cultural capital*, to underscore the function of language in determining social status and class identity. As with material resources, people have varying amounts of symbolic

resources, including language, at their disposal. The value of these resources will depend upon the particular language market (*habitus*). If we think of internet sites of interaction collectively as a language market, it would be fair to say that the hybrid form of communication makes assessing the value of the standard more complicated. Because many people treat CMC primarily as oral rather than written communication, they may well be able to write accurately and effectively but not feel it necessary to do so, or at least not feel it necessary to proofread and spell-check their messages for accuracy or effectiveness. It is also clear from my data that many media fans on public forums, including fanfic writers, do not value the standard, and unlike in educational or professional markets, there are no sanctions for not adhering to it; on the contrary, those who attempt to reinforce it are dismissed as "snobs." Winnie (DDEBRP), for example, was flamed as a result of her investment:

```
I foolishly :-) got involved in a discussion of grammar
and editing on the alt.tv.x-files.creative newsgroup,
and ran afoul of someone who took exception to my belief
in the importance of good grammar, and who insisted that
believers in the use of proper grammar were snobbish,
elitist, etc.
```

As noted in the previous chapter, Phoebe (MRKS) felt she had been disparaged for rewriting a sentence multiple times. In another thread, she elaborated on the "charges" of elitism:

```
If the fact that women (and/or men) enjoy getting
together and talking about what they think is good and
bad in fanfic - on this list or on any other - is
"elitist," who's that really hurting? Why call it names?
What's the opposite of "elitist"? (Serge? <G>) We saw
that a lot with Bindlestitch, the "anything goes" list.
I don't disagree that they have a right to have a list
where anything goes and where canon is an option. But I
expect them to extend that same right to other lists, to
allow that there may be people out there for whom not
everything goes or for whom canon is not just an option.
If they want to laugh at us for being elitist, that's
their right; but we're not wrong to want to share
conversation and ideas with other people to whom that
conversation is important and who show respect to those
ideas.
```

Although Phoebe was not exclusively addressing language concerns, she clearly felt like a minority, and as a self-identified libertarian, mobilized a discourse of "rights." The implication is that in the market of online media fandom, the stock of linguistic capital is so low as to make a normative identification deviant. Yet as a child of "parents who gave me Ayn Rand to read in pre-school," Phoebe went on to say that she had met very few people in "real life," even among the educated middle classes, who shared her concerns for language, knowledge and critical thinking—in Bourdieu's framework, the possession of high levels of cultural capital; online fandom provided her with a sense of community and belonging in that it gave her the opportunity to meet others, like the members of the MRKS, with similar investments:

> For me [online] fandom is and remains a refuge, some-
> where where I can be all my parts together and be with
> other people who share those ideals, those concerns,
> those commitments, those interests. It's something I
> never had before this, certainly not to this extent, and
> because it's this important to me is probably why I'm
> still in fandom.

Meghan's contribution to the thread added a somewhat different perspective:

> I believe there are some fans whose favorite pastime has
> become the mutilation and degradation of other fans. Not
> just in the writing arena, either. I admit to my own
> part in some of the rendering of flesh. It's a natural
> progression when we start talking about characteriza-
> tion, good plot and just plain correct grammar. I do
> remember, however, a time when it wasn't so much about
> how awful fanfic is as the fact that there IS fanfic. I
> suppose as fandoms grow, that's a natural offshoot.

Meghan acknowledged that some fans who possessed high investments of cultural capital could be accused of elitism She included herself in this category and, by use of the pronoun "we," the other members of MRKS. Her reference to a recent past when the existence of slash offered satisfaction in itself indicates that class tensions only surfaced when a large enough fanfic base had been produced. Lists like the DDEBs and MRKs have emerged as language sub-markets of online media fandom in which cultural and linguistic capital are strong currencies. To examine the ways in which such capital was displayed on the DDEBRP and MRKS, I reviewed the

exchanges from which I excerpted the data samples used in this book, admittedly a small but manageable percentage of the total.

From Hybridity to Verbal Hygiene

Drawing on Lynn Cherny's (1999) typology of features used in CMC, I make the case that the approximation of informal face-to-face interaction was a practice valued by the two communities. First, members regularly mimicked informal oral patterns when agreeing, ("uh-huh," "yeah," "yep"); disagreeing ("nah"); interjecting or exclaiming ("eh," "gosh," "hey," "hmm," "oh," "oops," "uh," "um," "you know," "wow," "way to go"); and expressing laughter ("hehehehe'), or frustration ("grrrr"). Slang and colloquialisms were also common ("he's dead meat," "dropping like flies," "that's cool," "way cool," "that really sucks," "she's freaking out," "more crapola," "Todd and I were canoodling"), although they certainly did not appear in every message. Appearing occasionally were morphological phenomena such as contractions of formulaic expressions ("cuz," "dunno," "gonna," "gotta run," "kinda," "lotsa luck," "wakin' up tired," "wanna," "whaddyou know").

As has been demonstrated in the context of MUDs, IRC and Usenet, play with modality was typical on both lists. Three emoticons or "glyphs" were used on a regular basis in descending order: "the smiley," variations of which include :-), :), and :D; the "wink" ;); and the "face" of sadness or disappointment :(. Text symbols such as the asterisk were used for emphasis but sometimes capitalization signaled a raised voice, particularly for the "sound" of laughter (BWAHAHAHAHA). It is worth noting that this practice was still the norm in 2002 when the MRKS data was collected despite the widespread use of web-based email with the capability to easily change font appearance to bold or italics. This preference may have indicated a desire on the part of the CMC "old-timers" to preserve the hybridity or uniqueness of the form. Moreover, members sometimes included descriptions of physical gestures and actions, which they set apart with the < > symbols: <grin>, <bg> (big grin), <clearing throat>, <pounding head against table>, <holding out a handful of Thorazine>). I noticed in the MRKS data set that the <grin> or its abbreviation was used as an alternative to the smiley more so than in the DDEBRP set. Perhaps members did not particularly like the automatic conversion by the web-based programs of the ASCII (standard character) symbols to a round yellow "happy face." The DDEBRP members also brought with them a practice from the DDEBs

of sending out "good luck vibes" to members who had job interviews or another important life event: (((((GOOD LUCK VIBES)))))[2]

Looking at CMC as informal written communication, more specifically as note-taking, both DDEBRP and MRKS members regularly used some of the established abbreviations (esp. for "especially," b/c for "because," info for "information") as well as those unique to CMC: btw ("by the way,") imho ("in my humble opinion,") or its variation imnsho ("in my not so humble opinion,") LOL ("laugh out loud,") rofl ("rolling on floor laughing"). Specific to fan-related threads were the use of initials for actors' names or shows: DD (David Duchovny), GA (Gillian Anderson), xf (*The X-Files*), PG (Paul Gross), CKR (Callum Keith Rennie). Lynn Cherny notes that in many instances, "economy overrides linguistic prejudice" in CMC (p. 90).

Efforts to approximate conversation or abbreviate/shorten, however, should not be confused with a lack of attention to accurate and effective language use, oral or written. To systematically gauge the use of the latter, I followed *A Canadian Writer's Reference* (Hacker, 2001) a guide recommended by many Canadian universities and one I used when I taught first-year composition. It is divided into six sections: "Composing and Revising," a "how to" for writing an academic essay; "Grammatical Sentences," covering topics such as subject-verb agreement, pronouns, adjective and adverbs, sentence fragments and comma splices and run-on sentences; "Effective sentences," covering topics such as parallelism, coordination, subordination and sentence variety. There were also sections on "Word Choice," "Punctuation," "Mechanics" (capitalization, abbreviations and spelling), "Documentation," and "Review of Basic Grammar."

Consider the following quotations from three DDEBRP and three MRKS exchanges:

1. After seeing that they hired Barbie (TM) as the new X, I fear that The X-files may be pandering more to the mainstream audience.

2. Hypocrisy would have been some false sentimental blather about how happy he is for her, and John Bartley, and Jeff Charbonneau, and so forth. At what point is he supposed to stop? Should he name all forty or so people connected with the show who got nominated while he got passed over? Best to do what he did and preserve a dignified silence on the subject while *Letterman* rubbed it in. Letterman was the fool for bringing it up at all, but calling Letterman a fool is an oxymoron.

3. Shall we spread the news of their nefarious deeds to all the XF lists around? If those guys are so keen to cruise the net in search of booty to plunder maybe they'll pay attention if they

see calm, well-measured posts warning people not to buy a book that egregiously violates your rights.

4. After meeting my brother's intended, a woman with a master's degree who teaches at an elite school here in my city and who can't follow a logic chain for beans or identify Abe Lincoln as the 'Emancipation Proclamation' president (and who comes from that "privileged" middle-class background,) I don't think it's a problem that society or public education is at all interested in solving. If we have a thinking electorate, after all, we won't be able to sell the American people a bill of goods and instill fear and thus obedience.

5. Any thoughts? Does there really seem to be a pervasive undercurrent of dissatisfaction with fannishness generally, or is it more likely that I'm imagining it?

6. I'm a mostly straight woman (so the Kinsey scale works in my favor *g*) who's actively and passionately committed to gay rights—my friend Brad draws the analogy of the white students in the late 50's and 60's who "got on the bus" and supported the black civil rights movement. They didn't need to be one of the group in order to recognize that injustice was being perpetrated against that group. People DO have personal attachments to the semantics, but strip away all the social and political connotations and "bisexual" just means "has sex with people of both genders".

These quotations all rely on a high level of linguistic capital. Not only do none contain grammatical errors but the sentences are accurate—no run-ons or fragments—and exhibit effective coordination and subordination. The second quotation makes use of rhetorical questions. Moreover, the word choices are sophisticated, and would be considered by Hacker to be adding color and vigor without being pretentious ("pandering to a mainstream audience," "false, sentimental blather," "egregiously violated your rights," "instill fear and thus obedience," "pervasive undercurrent of dissatisfaction," "strip away all the social and political connotations"). The choice of "intended" in the fourth quotation for the more common "fiancee" evokes a 19th-century literary sensibility, bringing to my mind Joseph Conrad's *Heart of Darkness* with Marlowe's references to Kurtz's "intended." Also to be considered are the neologisms in the fifth—the adjective "fannish" and noun for the state of being a fan, "fannishness," formulated according to the rules. There are only three minor punctuation errors, two of which appear in the last quotation: the dash connects two sentences and the period is outside the quotations marks. Some of the quotations also underscore the hybridity of CMC for the participants and as such cannot be taken as errors: *g* as modality play, the abbreviation "XF," as well as the inclusion of slang and colloquial expressions such as "rubbed it in," "can't follow a logic chain for beans" and

"cruising the net for booty to plunder." In the "Glossary of Usage," Hacker intones that "colloquialisms are expressions that may be appropriate in informal speech but are inappropriate in formal writing" (p. 83).

A search through the data samples of list interaction for my insertion of the Latin "sic" revealed the following "errors": missing apostrophes to mark possession or contraction ("a days work," "Its going to be interesting"); word choice ("it's hard to give something your not sure you love your all," "of perhaps CM [Cancer Man] just wanted her," "I love the really pissed look on here face") and spelling ("years of unrequeited love," "corosive," "I tend to prefet," "nonchanlantly introduced to your boyfriend's fiancee"). However, these errors need to be understood as typographical since they were not repeated in other messages sent by the same user. As Bourdieu notes, "the dominant class[es] can make deliberately or accidentally lax use of language without their discourse ever being invested with the same social value as that of the dominated. What speaks is not the utterance, the language, but the whole social person" (p. 653).

Nonetheless, members of both communities engaged in forms of verbal hygiene to shore up their status as competent users of the standard variety. Most examples were self-directed.

> **From: Drucilla**
> [Rhiannon wrote:]
> >I thought the scene of Scully doing CPR and trying to
> >get him to keep breathing was very moving.
> Me too. Daphne? Why haven't you spoke up? They finally
> had Scully trying to help people, like you've been
> wanting!

Upon noticing that she had used the incorrect form of the past participle, Drucilla immediately self-corrected in a follow up post: "Augh! SpokeN! Not Spoke. Someone's stealing my letters again." While making light of the error, she nonetheless was signaling to the other community members that she was a competent user of the valued standard variety. Sylvia did the same thing when she noticed that she had omitted a letter: "Um, that would be Canada Goose, not 'Canda'. That's what I get for not proofreading. <g>" Similarly, in commenting on forming meaningful relationships online, Liz noted that in the beginning, "everyone's staking out there positions." It was only when Daphne used that portion of her text in a reply that she noticed her error and provided the correct form in capital letters along with a self-rebuke: "*THEIR*! Course, sometimes they

are 'out there'! :-) I can't believe I did that :-)." In addition to making the correction, Liz provided evidence that she knew how to use the three words correctly by producing a wordplay. Daphne empathized ("heh, heh, heh. See how imperfect the English language is? ;->" but then teasingly suggested that Liz should in fact have known better: "Or maybe it's just user error :->." That these self-admonishing responses may seem excessive underscores the function of "good" grammar as a form of covert prestige in the community and the importance of demonstrating that one possesses the "write" stuff.

Beyond points of grammar and sentence structure, some members expressed doubts about their ability to express themselves in a focused, coherent, and clear manner: "Am I making sense?"; "I'm just rambling/babbling," "not sure if this is on topic." Megan concluded messages with phrases like "will stop rambling now" and "aw, hell, I'm just rambling now. I think its time for my coffee." In the context of the MRKS thread on elitism, Meghan stated, "I even went so far as to write a whole page about my theories on my blog, but deleted it as too much rambling on my part." Similarly, in a thread on a workplace shooting, Alain prefaced her comments with "ineffectual but short rant." Sonya made explicit the connection between writing well-developed papers in university and writing well-developed messages to a mailing list:

```
I can't believe I've written all this! I hope some of it
at least was understandable to someone. Where was all
this energy when I was writing papers last year in
school? I must be having some kind of post-traumatic
stress disorder, where all of a sudden I'm reliving
papers I should have written (but never did) in college.
```

On occasion, members corrected each other, using humor to avoid giving offense. For instance, Meghan had written in response to seeing an old photo of Callum Keith Rennie, "Ok, I had never seen this before. So sue me! I'm a bit behind on things dS since I woke up from my two year comma!!" Drucilla quipped, "And Phoebe calls *me* 'Commagirl' ;-D," to which Meghan responded, "Bleh. I'm a writer, not a spellir! <g>" The next sample is from the DDEBRP.

From: Rhiannon
So maybe that will peak your interest.

From: Mrs. Hale
pique!!! pique!!! This reminds me of the time I was
reading some erotica and the writer said something like,
"Mulder licked the pique of her breast". I was ROFL.

From: Rhiannon
Oh gawd, I can't believe I did that. And I only teach
English for a living!! I guess my only excuse was it was
the 130th post I was responding to…Thanks for the
humourous correction (BTW that's Canadian spelling this
time)

In making the correction, Mrs. Hale added another example with the "peak/pique" confusion. As others had done, I admonished myself but also stressed that I knew the difference between the two words. Lest there be any question of my linguistic resources, I clarified that "humourous" was spelled correctly according to Canadian usage. My response also contrasts the legitimacy of mimicking oral patterns ("oh gawd" instead of "oh god") with the illegitimacy of confusing words that sound the same but are spelled differently. This distinction is further highlighted in Megan's anecdote on the humor of sound/spelling errors:

I have a friend that was grading some papers for the
class she was TA for and one of the closing lines was
"the Greeks were able to take a peak into moden [sic]
science" (or soemthing [sic] like that). We were jsut
[sic] dying from images of all these men in togas trying
to carry a mountain :)

Ironically, in recounting the student's inaccurate word choice, Megan made three spelling mistakes, none of which drew any comment on as they were obviously the result of inaccurate keyboarding rather than a lack of linguistic capital. To echo Judith Butler, the performance of her middle-class identity was sufficiently "intelligible."

Not all participants were comfortable with the high community standard and its deployment in CMC. When Mrs. Hale pointed out what she perceived as incorrect use of the verb "recuperate" as a transitive verb ("we were recuperating 'gossip.'") by my co-researcher Lee Easton,[3] this member wrote me privately to speculate on why some of the new members from the other "brigades" might not have posted to the list yet:

From: [Name Withheld]
Another reason people might not be wanting to post is
fear that their grammar will be belittled. No reason to
pass this on to anyone...I just deeply resent someone
correcting grammer [sic] in a forum as chatty as email.

In examining this member's contributions to the list, her comments reflect her lack
of confidence more than her level of linguistic capital. Still, this post serves as a
reminder that even good-natured correction is still a form of policing that can have
a chilling effect on participation, producing an insider/outsider binary at those
moments.

Errors discovered offlist, on the other hand, were considered fair game to
mock, as the MRKS exchange below illustrates:

From: Drucilla
Next time you're feeling depressed and need something to
cheer you up...http://www.engrish.com/. I just about gave
myself an asthma attack trying not to laugh so hard that
I drew my co-workers out of their offices. ;-D

From: Penelope
Luckily for me, I was already home, where they're
accustomed to shouts of laughter. Did you see the bear?
"Recent Discoveries", scroll almost to the bottom. "I
was born in Cicago (sic). My mother is Barbara."

From: Alain
Like, uh, today? ;) It worked. These are hysterical!
Thank you so much!

From: Jeanne
Heh. Check out the 'Gum' page...there's a brand called
"Slash!" Its slogan is "Shock your mouth!" <g>

The site identified above is a repository of Japanese products, signs and advertise-
ments sporting English slogans that are unintentionally humorous to native speakers
because of the inappropriate word choices made from English-Japanese dictionaries
(a "propaganda board" instead of "information board" for example).[4] The examples
picked out by Alain and Jeanne have particular resonance for the community
because of *Due South* intertextuality.

Another indication of the prestige afforded by DDEBRP members to accurate and effective language use was the praise offered or questions asked of those who were seen as "expert" users:

```
From: Mrs. Hale
[Sonya asked:]
>What *is* the technical term for a <noun> of
><something>"?
The term is "collective noun", as in a pride of lions
(almost typed loins), an unkindness of ravens, etc.
There was a really neat book that came out years ago
listing all the known collective nouns. I don't remember
the title but I think it had swans in it.
```

Mrs. Hale then made a play on words with the concept, signing off with the line, "a synapse of nerves." In a different thread, Sonya complimented her on a play she made on the use of the pronoun "we" to speak for the three DDEB lists:

```
>We think it is a good idea, too, but then we have been
>speaking with the royal 'we' anyway for years. :D
Oh, Mrs. Hale, you have such a gift for words. :-)
```

While Sonya's question had been an open one, Daphne addressed a question on etymology directly to Mrs. Hale: "I promise I won't get on my high horse about judgmental thinking :->. BTW, where does the term high horse come from? Mrs. Hale, I bet you know." In one of the threads in which the concept of technology was being discussed, Mrs. Hale teased Daphne for being "a closet phenomenologist." In her reply, Daphne repeated the comment prefaced by "Mrs. Hale exhibits her superior vocabulary," and then said, "I'm sorry, that word isn't in my dictionary. What does it mean? Have something to do with scent glands perhaps??? Hmmmm??? Or maybe the reading of bumps on the head???" Although Daphne did not know the exact meaning of the word, her guesses were educated ones that implied that she knew the specialized terms "pheromones" and "phrenology."

Even Mrs. Hale was not above correction. In response to a message by Bel about a certain feeling that she had had that something was going to happen, Mrs. Hale suggested that it was clairvoyance, which she defined as "French, to hear clearly":

```
From: Hollis
Slight correction - clairvoyance is from the French to
*see* clearly. Clairvoyants see images in their minds
telepathically. Clairaudience is psychically hearing
something. I believe that just having a feeling like Bel
did is merely called intuition. I prefer the Scottish
term for it - kenning. :)So, does that make Barbie
psychic?
```

Similarly on MRKS, Alain asked about Drucilla's reference to receiving a "blort" of email: " [I]s that the scientific name for a group of mail? Like a herd of cattle, a blort of mail? ROFLMAO". The humorous reply included a DS allusion to the RCMP dress uniform worn by Fraser: "Oh yeah, didn't you know that? A spandex of bicyclists, a serge of Mounties, a clip of cops...and a blort of email. All those technical terms." In response to being "nominated" for "sainthood" along with another member for sharing a tape of a film starring Paul Gross which included a nude shower scene, Jeanne quipped that she preferred to be "an acolyte <g> Or perhaps an evil minion. Which pays more?" Another member asked if one could be a "holy minion" to which Penelope provided the correct terms: "I, um, think that's an acolyte. Maybe a disciple? Not big on theology. But I want me some minions." She is careful not to sound overly authoritative, switching to a non-standard variety.

There were other instances on both lists of nonstandard usages from other often devalued varieties. One example was Dani's response to Erin's comment that she really liked the "rumpled" Duchovny look: "Yep, he sure scruffs up real purty, don't he?" Here, Dani used an orthographic representation of a stigmatized variety of Southern American or rural English for humorous effect. In a post about medications she had been prescribed, Erin used the medical jargon, "one for my intercranial hypertension" and then "translated" by switching to her rendition of BEV or perhaps working class Irish: "fancy phrase dat means I gots too much spinal fluid in me head." An extended sample comes from a MRKS thread on a Canadian Inuit art-house film, *Atanarjuat: The Fast Runner*, which was being shown in selected cities in the US.

```
From: Drucilla
I got to see it in Denver, and it's really an amazing
piece of work.
```

```
From: Phoebe
>Eh, not enough car chases.
Or hockey fights, eh. Too many penalties called.
Phoebe, konsumer of kwality
```

```
From: Donna
And, you know, they actors were a bunch of mush-mouth
low-talkers. I couldn't understand a word they said
Donna, kontemplatrix of kwality
```

```
From: Jeanne
But…but…there was sex and violence and nakedness on the
ice! What more do you people want? Sheesh!
Jeanne, lending her support to the "go see it as soon as
you can!" contingent.
```

Those who responded to Drucilla pretended to spell phonetically, misuse possessive pronouns ("they actors") and lack the cultural capital to appreciate and make sense of the film. Yet of course, the misspellings, word choices and alliteration found in the tongue-in-cheek self-identifications were themselves displays of linguistic capital. Jeanne brought closure to the thread by switching back first to the standard variety and then her own "cultured" voice.

This practice of standard English users borrowing from a generally devalued variety can be thought of as a form of *codeswitching*, broadly defined by Monica Heller (1988) as involving "the use of more than one language in the course of a single communicative episode" (p. 1). Codeswitching, however, usually takes place between/among interactants who are proficient in the languages involved. Ben Rampton (1995) focuses on "code alternation by people who are not accepted members of the group associated with the second language [or variety of language] they employ" (p. 280). Rampton uses the term *crossing* to label the use of South Asian English (SAE), a devalued variety of English, and Punjabi by white working class youths in London, England. These youths were proficient in neither the variety nor the language and were not interested in becoming so. Rather, they picked up ritualized language forms to better fit into their peer groups, dominated by speakers of Punjabi and SAE. In the context of the DDEBRP or MRKS, members were not crossing as much as "slumming," my term for the linguistic equivalent of yuppies hanging out in a biker bar for an evening not to connect with bikers but to create group solidarity among themselves.

Humor as Linguistic Capital

Beyond possessing sufficient linguistic resources to write accurately and effectively, the DDEBRP and MRKS members placed high value on the use of language for humorous effect. Hints of this can be seen in the data samples presented in the previous section. Nancy Baym (2000) argues that the extensive reliance on humor among online media fans is part of the process of community making. On both lists, witty one-liners, quips, retorts and extended repartee were central features of interaction, functioning to establish and maintain community. However, it is also important to recognize that these practices involve performances of middle-class identity. After all, quickly formulating an adroit one-liner or coming up with a play on words during an email exchange with a fast server that approaches "real-time" conversation requires a high level of linguistic capital.

The first sample comes from a thread on how the existence of the DDEBs can be understood in relation to ICTs:

```
From: Daphne
Rhiannon wrote:
>I would argue that the technology that allows us to
>set up electronic lists and send email *is* an integral
>part of the DDEBs in that it enables the DDEBs to be
>without being them.
Well, now we're getting somewhere. At least today, we're
not BEING the medium. :->
```

Daphne had felt that my previous messages had emphasized technology at the expense of human relations. Her reply draws on Canadian theorist Marshall McLuhan's often quoted line "the medium is the message." It is clever because it links me as a Canadian researcher to a Canadian theorist. Then it was Mrs. Hale's turn to play on the word "medium":

```
Daphne wrote:
>At least today, we're not BEING the medium. :->
No, today, Mrs. Hale is being a Large.
Mrs. Hale XXL
```

The wordplay is underscored by the graphic representation of garment sizes found on labels.

Desire On (the) Line

A sizable (word play intended) number of the humorous exchanges on the DDEBRP involved expression of desire for David Duchovny. The context of the next sample was an expressed dislike of the acronym for the research list. Geneva quipped that it sounded like "DDE-BuRP." Drucilla noted that it sounded to her like "DDEB-RIP" as in "rest in peace." Erin, however, took Drucilla's association and changed its meaning, coming up with a narrative:

```
DDEB-RIP...

David suddenly finds himself surrounded by wonderful,
independent, non-patriarchal <g>, lusty women...he gets a
fearful look on his face and whispers quietly, "DDEB?"
Witnesses say that the next sound heard was the ripping
of his clothes.
```

Erin successfully shifted the image to a celebration reminiscent of a Bacchic ritual with women in the role of seducers. In another exchange, Mrs. Hale concluded a message on Duchovny with the one-liner, "Would like some DD Jelly." This led to an exchange of food metaphors:

```
From: Winnie
On white, wheat or rye?

From: Mrs. Hale
What else but...WRY bread? (ducking, running)
```

Sexual innuendo was used for humorous effect in exchanges on MRKS as well. One example began with a concluding off-topic remark by Penelope that hockey player Chris Chelios "is a major babe. Is there anything wrong with that?" to which Donna replied, "Nothing whatsoEVER, I assure you. Nose and all":

```
From: Penelope
Mmmm, I like a man with a distinctive profile. Don't
they say a big nose is indicative of...other things? (Like
big feet?)

From: Donna
I'm afraid that in hockey, it's only indicative of a
deviated septum, wandering bone fragments, and some
serious rhinoplasty bills after retirement.<g>
```

Expressing desire for an actor or sports figure can be risky business for female fans, even in a women-only or women-centered space where charges of "drooling" will not be made. A witty post thus functions to legitimate such expression, shifting the focus from "minus male" to "plus middle class."

The next sample concerns the gaze of objectification, an excerpt from a thread in which Phoebe uploaded some screen captures showing full frontal nudity of Paul Gross:

> **From: Jeanne**
> These are great! I'm sure someone out there in the world
> has a clean copy of the Euro-version of Aspen Extreme,
> but these clips from the compilation tape are the only
> ones *I've* ever seen. God knows I'd never been able to
> get as clear an image just by freeze-framing…Um. Not
> that I would ever have done that, of course. Because…
> that would have meant I was interested in…peckers. And
> that would be wrong. And…bwhahahaha!

> **From: Alain**
> I don't suppose anyone has any ideas on how to ask the
> DVD distributor for Aspen Extreme whether the DVD shows
> Paul's Penis, without using the words "Paul's Penis"?
> I'm not sure I'm willing to invest $10 for the non-Penis
> version. From my POV, the Penis is the major selling
> point.
> --Alain, who can still blush on occasion.

These participants coyly played with a normative feminine identity that stipulates both naivete and modesty around not only the spectacle of the naked male body but the naming of genitalia. That said, humor could also be used to perform a feminist identity which claims the right to look and objectify:

> **From: Drucilla**
> I keep getting this pop-up ad for a 'net nanny' type
> program that asks in huge letters "Is there pornography
> on your computer?" I keep wanting to say "I sure as hell
> hope so!" ;-D

Displays of linguistic prowess on MRKS could also be slash specific, involving the ability to write parodic *Due South* snippets on the fly. In the previous chapter, I discussed a thread in which the participants mocked the portrayal of RayK as a "slender blonde." Jeanne's response follows:

```
Drucilla wrote:
>Anybody here think that Ray K. is a 'thin' 'smaller'
>man with low self esteem?
"Ray. Ray. Ray. Ray. Where are you, Ray?"
"Down here!" squeaked Ray weakly from the pocket of
Fraser's jacket.
"Ah. Thank you kindly," Fraser said, patting his pocket
gently. "I thought I'd lost you for a moment."
"Never, Frase! You know I'll always be yours, even
though I don't deserve you."
"Pardon?"
The pint-sized blonde took a deep breath and screamed as
loudly as he could. "*I* *Said* *You* *Know* *I'll*
*Always* *Be* *Yours* *Even*…"
"Ray? Your high pitched wail is making Diefenbaker whine
in a most annoying manner."
"Sorry, Fraser?"
The Mountie bent his head closer to his jacket pocket.
"Excuse me?"
"I said *SORRY!* I suck."
"Understood."
```

Libra then quipped, "His jacket pocket? Just think how much more Ray could do in Fraser's jeans pocket!"

From: Donna
```
In FRASER'S jeans? Are you kidding?? Even poor little
tiny Ray would suffocate in there before he could do
anything else. He'd be able to chirp, "Help me, BenBen!"
And that's all he'd get out before he'd swoon and,
unfortunately, die.
```

In having "mini-Ray" refer to Fraser as "BenBen," the canonical naming convention was intentionally violated for additional humorous effect.

Funny Girl

Members who displayed linguistic dexterity often received responses, directly or indirectly praising their efforts. The final lines of Hollis's correction on "clairvoyance" ("I prefer the Scottish term for it - kenning. :) So, does that make Barbie psychic?"), for example, is a wordplay on the verb "to ken" and the name of the popular Mattel doll's male mate. Drucilla responded as follows: "***ggggrrrrrooooaaannnnn*** Go to your room, young lady!" Similarly, at the end of a "mock flame war" by two DDEBRP members (presented in Chapter 4),

Drucilla replied, "Oh, don't do this to me while I'm at work! People always look at me weird when I fall off my chair and roll around on the floor laughing!!!" Others sent messages containing only "laughter": "BWAHAHAHAHA" or the abbreviations "LOL" or "rofl," as was the case for the Jeanne's "mini-Ray" parody.

Although all members engaged in varying degrees of wordplay, quips and repartee, each list had its "star performer" who received the top accolades. On the DDEBRP, it was Geneva. The exchange below began with a playful search for an appropriate collective term for the DDEB members as admirers of Duchovny:

```
From: Drucilla
Daphne wrote
>Bet he'd [Duchovny would] just love the idea of having
>a passel of worshipful cyborgs.
A passel? Is that a technical term? Like a gaggle of
geese or an unkindness of ravens?   :-)

From: Winnie
Just what *would* the proper term be for a bunch of
DDEBers? A worshipfulness? ;-) A covy? A duchovny?
```

Drucilla quickly suggested "an assimilation" but it was Geneva who came up with "duchoven," a play on the name of the actor and a group of witches (coven):

```
From: Drucilla
PERFECT! :-)

From: Daphne
BWWAHAHAHAHAHAHAAAA! I read this as Dutch Oven. Please!
I don't want to be a cooking utensil. I just got over
being a computer!5 :->

From: Sonya
Geneva, this is *beautiful* I love it. I'm sure we'll
come up with all kinds of ideas here, but I love yours.
I don't know how the catholic sisters would feel about
it, but as a (sometimes) pagan, it's so cool.

From: Mrs. Hale
Geneva, you're a genius!!!! Even if you are blonde.
Mrs. Hale, brunette
```

Geneva then engaged in repartee with Daphne:

From: Geneva
But wouldn't you like DD [David Duchovny] to get all hot
if he were inside you? <vbg> [very big grin] For that
matter, he could be a lot of fun in the kitchen...

From: Daphne
For some reason, I see DD as a take-out man, myself...

On MRKS, Jeanne was the one who brought the house down, so to speak, with her deceptively friendly and helpful "reply" to a series of questions from a new member of the larger F/K list, Asylum. This person's post had been forwarded to MRKS by Vivian who used the subject header "oh my god" to express her frustration and incredulity that someone would try to write a story without having seen an episode of *Due South*: "Saw this on Asylum. Jesus H. tap-dancing Christ! <pounding head against table> Make it *stop*, mommy, make it *stop*." Others follow suit:

From: Donna
Now, now, dear. I feel that this approach makes for very
interesting characterizations. Would you care to join me
for my afternoon pick-me-up? <holding out a handful of
Thorazine>

From: Vivian:
<grabbing pills and stuffing them down throat> Erk. Ack.
Thanks. Ah. I feel *much* better.

From: Jeanne
You know, if you had a lick of simple human decency in
you, you'd answer the poor girl's questions, like this:

>I'm New to the Fandom and never saw the Show. So I have
>several questions on Canon. For a story.
>1. Did the Date RayK married Stella get mentioned? Or
>the Date of the Divorce?
Oh sure. In fact, there were a number of episodes deal-
ing with just these topics. Obviously Ray and Stella
were married on Valentine's Day in a church decked out
with pink and red hearts. Ray's choice, of course,
because that's the sentimental guy he is. We see this
kind of thing often in later episodes (like the party he
throws for Janet Morse's kids where he bakes the cake
himself and then dresses up like Barney the Dinosaur to
make them happy).

The divorce, well…you know, Ray was in the hospital
after taking a bullet trying to rescue a number of
kittens from a mad Cat Assassin, and Stella barged into
ICU and told him she was leaving. Then she disconnected
his tubes and laughed wildly before leaving. It was
very traumatic.

> 2. Did Fraser every mention a preference for a hand
>gun or did he use a standard Issue weapon? If So what?
One thing that's always bothered me about Due South is
how readily Fraser (we like to call him Ben-Ben, like
RayK does) goes for his weapon in dangerous situations
[sic]. I wish he were more like Ray and would try to
talk the criminals into surrendering first, but you know
what Mounties are like: shoot first and ask questions
later. Anyway…he carries a 357 magnum regularly, but
we've seen him with an Uzi and a colonial-era musket on
occasion.

The cleverness of these mock answers is likely lost on those unfamiliar with the
series, but suffice to say that each point portrays the characters completely at odds
with canon—Ray K. is not sentimental, his separation from Stella was never
dramatized, and Fraser does not even carry a gun. MRKS members were beside
themselves:

From: Phoebe
Oh my god.
Jeanne, for GOD'S sake. I need a new fucking LAPTOP now,
not just a keyboard.
Phoebe, still ROLLING

From: Kenzie
Oh my god Jeanne. Do it. Do it please. Sub under a
different name that nobody knows and then send it.
Please. Oh please.
Kenzie, shamelessly begging.

From: Donna
WOW. <admiring look> If you could bottle THAT…It'd go
great with Thorazine. I'm buying.:-)
D, who has a deep appreciation for Pure Evility

From: Penelope
Evil, evil Jeannie. I can actually *hear* your
ultra-reasonable Teacher Voice, you know. And I just
want you to remember that whatever you tell poor [Asylum
poster] will be remembered in BadFic for years to come.

```
Well, the stuff you didn't *get* from BadFic, that is.
Think what you're doing, woman! Ben-Ben? ::collapsing on
the floor again::
```

The thread continued well into the next day with more jokes being made on double-barreled nicknames as above:

From: Jeanne
```
Gosh VV and PP! I feel such a strong sense of personal
affirmation and love coming across from the two of you
now! I think I'm going to go post a challenge to Asylum
to write a story that explains the genesis of RayK's use
of the nickname BenBen...and how it never fails to make
Fraser weep with joy!
Hugs and kisses! -Jeanne-Jeanne
```

While clever play with language served to bring members together and create a substance of a university-educated, middle-class community, it has the unfortunate and unintentional effect of fostering competition and insecurity among members. The day after the "Duchoven" thread, the desire and pressure to display the "write" linguistic stuff became apparent. Sonya, who had acknowledged Geneva's play on words, attributed her "quietness" on the list to the fact that she was "just generally not too good at short, quick-reponse [sic] posts, at least not yet, on any list I'm on." Winnie named her new job and her young son as limiting her ability to start and join threads, and then admitted:

```
And I *so* want to write pithy, reasoned or just plain
glib responses. How about I admit that I was so pleased
with myself for coming up with "a duchovny of DDEBers"
that I was (ego ego) looking forward to strokes from the
group over it? Only to be upstaged by "duchoven"? I have
nothing to come back with. I'm just not that witty. Or
maybe I'm just tired.
```

It is interesting how Winnie modified her complaint that her contribution had been ignored by laying the blame at her own feet: it was not the others who had not met the community standard of supportiveness, but she who was unable to meet the community's standard of linguistic prowess.

Similarly, Alain's response, although praising Jeanne, acknowledged her inability to come up with a suitable "flame" to send the Asylum poster:

```
And I'll take my thorazine straight up, please. My
laptop's keyboard has suddenly ceased to function, and I
just got a rejection letter for a new job I thought I'd
nailed. Plus, my flame turned into sort of a condescend-
ing ramble. Damn. And I really tried. I did.
```

Like Winnie, she mentioned other factors which may have contributed to an inability to rise to Jeanne's level.

On occasion members of both lists expressed feelings of insecurity not directly related to a particular exchange:

```
From: Paula
OK, and I will admit it [downcast eyes, shuffling feet]
- I am intimidated by the famous folks on this list...some
of the most *hallowed names* [Hey! Don't laugh!! 'Tis
true!!] in Duchovnikdom are here, and I feel incredibly
shy about contributing my humble yatterings...yah, I know.
Pretty silly attitude for an adult, but there it is.
```

Although couched in playful exaggeration, as indicated by the "gestures," Paula was ashamed of her sense of inadequacy. To reestablish a sense of solidarity, Mrs. Hale, one of the "hallowed names," jokingly played down any suggestion of elite status, "Oh, Pooh. Drucilla puts her pink panties on one leg at a time, know what I mean?" Bel, although not a "hallowed name," also attempted to reassure Paula while poking fun at her own linguistic stock:

```
Ah, but Paula wasn't talking about Drucilla. She was
talking about me. Whaddya mean noone ever heard of me?
:). As to being shy, you get over that soon and start
babbling away and hope one or two words make sense to
your readers. Trust me on that one. :)
```

In the context of the MRKS thread on elitism, Meghan also made reference to the high community standard of wit and the pressure of trying to meet it:

```
I said perceived elitists because I think, in many in-
stances, it is the women who are being 'critiqued', for
lack of a better term, who see the critiquers as
elitist. I admit to a certain amount of intimidation,
myself, at times when some of the more erudite members
of MRKS begin a really good meta discussion and usually
just decide not to reply at all rather than not be able
to match the wit and sharpness of their posts. I
```

```
certainly wouldn't label Drucilla, Phoebe, M., or any of
the other many wonderfully insightful members elitist,
but, with an open mind, I believe I can see where that
might be a problem with someone struggling with their
own self-image. Face it…you do have to have a certain
amount of acerbic wit about you to fit into this group.
```

Just as displays of linguistic capital can bring members of an online community together, their divisive potential cannot be ignored. The investment of the majority of DDEBRP and MRKS members in cultural and linguistic capital might seem excessive, obsessive even, but it is perfectly understandable. In performing normative class identities, members are able to write off any deficit in cultural capital created by their investments in popular media fandom.

Notes

1. I have borrowed this heading from a book of the same title by Ivor Goodson and Peter Medway (1990).
2. A sample that includes the DDEBRP practice of "vibing" is presented in Chapter 4.
3. Lee was a member of the DDEBRP for the first two weeks of March 1996. We had co-authored a paper based on the preliminary questionnaires, and I had posted it to the list to get feedback. He never responded to Mrs. Hale.
4. The site's producers stress that they are not making fun of second-language speakers but rather commercial users who are not concerned with correctness, for their target market is domestic Japan, where even incorrect English carries overt prestige.
5. Daphne's reference to being called a "computer" came from a discussion of the co-authored paper Lee and I had posted to the list. Daphne had interpreted one of our statements to mean that DDEB members were inseparable from the technology that created them. We were referring to the communities, not the individual members.

↳ Chapter 4
Nice Girls Don't Flame: Politeness Strategies
On (the) Line

In this chapter I discuss a second set of communal practices—*etiquette* or *netiquette* in the context of CMC. There were no explicit codes of conduct or netiquette guidelines for either the DDEBRP or MRKS. Rather, the rules that govern politeness were commonsensical, a *true discourse* offering middle-class bodies in general and middle-class female bodies in particular, normative ways of attending to what sociolinguists call *face needs* when interacting with others. Expressing solidarity and avoiding conflict with others and quickly resolving differences were also critical to creating and maintaining a substance of community.

Politeness: A Short History

According to Laura Sutton (1996), the "courtesy manual" emerged at the same time as the bourgeoisie, who needed the normative behaviors of the aristocracy to be made explicit if they were to intermingle without inadvertently causing offence. In the 1920s, manuals such as Emily Post's *Etiquette: The Blue Book for Social Usage*, became popular in the United States among the *nouveau riche* who wanted to take their place among the old moneyed elites. Their efforts may or may not have been sufficient to gain acceptance, but they resulted in the entrenchment of a set of politeness behaviors that governed the middle classes themselves. While the specifics of Post's book may seem quaint and old-fashioned today, its general principles have become so naturalized that they, in part, define the middle-class subject.

The concept of *face* is used to make sense of the politeness strategies used in face-to-face interaction. Norman Fairclough (1993) sums up Brown and Levinson's account as follows:

People have "positive face"—they want to be liked, understood, admired, etc and "negative face"—they do not want to be impinged upon or impeded by others. [Brown and Levinson] see politeness in terms of sets of strategies on the part of discourse participants for mitigating speech acts which are potentially threatening to their own "face" or that of an interlocutor. (p. 162)

In any interaction, there are five strategies that can be deployed to deal with a potentially "face-threatening act" (FTA). Let's take the instance of me getting to the parking lot after class and discovering that my car battery is dead.[1] Having forgotten to renew my membership with the Canadian Automobile Association (CAA), I decide to ask for assistance from passersby. The first three strategies are clustered around going "on record." First, I can make no attempt to mitigate the FTA and make a "bald statement": "Bring your car over so I can boost mine." As I am unlikely to get any help as a result, I can try positive politeness ("You know what a drag it when your car won't start. Could I get a boost from you?") or negative politeness ("I'm really sorry to impose on you but could you give me a hand with this?"). The fourth choice is to go "off record" and hint at the FTA, implying but not directly stating it ("Oh no, I've left my lights on and my car won't start! What am I going to do?") The final choice is to not ask anyone for help and call the CAA to renew my membership.

Fairclough, quite rightly, criticizes Brown and Levinson's assumption that face is a universal concept based on psychological needs. He argues that "politeness conventions embody, and their use implicitly acknowledges, particular social and power relations…and in so far as they are drawn upon they must contribute to reproducing those relations" (p. 163). Hence, adhering to the naturalized rules of FTA mitigation is a means of performing a middle-class identity. Politeness strategies must also be understood as gendered. Etiquette handbooks prescribed specific "rules" for women, some of which dealt with speech. Women were expected to refrain from "gossiping" among themselves and to defer to the male head of the household (Cameron, 1995). Deborah Cameron quotes Emily Post as stating that "the cleverest woman is she who, in talking to a man, makes *him* seem clever" (p. 174). Just as "ladies" were supposed to dress modestly so as not to draw the desirous male gaze, they would have been expected to speak modestly so as not to draw unwarranted attention to their intellect.

A substantial body of evidence has been amassed by empirical sociolinguistic studies that women interact in mixed-sex groups in line with Post's advice. Women not only introduce more topics thus giving men the "floor" but provide "hearer

support" by asking questions and using minimal response markers ("uh-huh," "mmmm," "yes," "right," "I see") that enable men to keep the floor (Cameron, 1992). In addition to the undertaking of what Pamela Fishman (1983) calls "interactional shitwork," women are interrupted by men more frequently than vice versa when they hold the floor (Holmes, 1995). Robin Lakoff (1975) has claimed that women couch statements as questions and use "tag questions" ("nice day, isn't it?") and other forms of qualifiers that make assertions seem tentative and uncertain, a sign for Lakoff of their position of powerlessness relative to that of men in society. Cameron challenges Lakoff's conclusion that there exists an authentic but illegitimate "women's language" distinct from the powerful and valued style of men, arguing that "the meaning of a linguistic feature cannot be determined outside its context" (p. 52). A tag question, she explains, could be used to seek approval in one context but in another it could be a put-down, as when I look at my partner and say "You're not going to wear that shirt with those pants, are you?" Similarly, a continuous stream of minimal responses can also signal impatience on the part of the listener (Holmes, 1995). Nonetheless, in many contexts, using these types of linguistic features is an articulation of a discourse of self-effacement associated with normative femininity. Even today, women who speak assertively are likely to be dismissed as "aggressive" or "mouthy" (Tannen, 1990).

Some feminist sociolinguists such as Janet Holmes and Jennifer Coates (1989) have interpreted the above features of women's speech somewhat differently. Rather than being a sign of powerlessness, offering hearer support, supportive turns and expressing agreement are means of attending to positive politeness; hedging or otherwise qualifying an assertion or moderating disagreement are means of avoiding the violation of negative face. As Cameron says in regard to the latter, one "qualif[ies] the force of an assertion so as not to intimidate, offend or exclude other points of view" (p. 73). Speech among women is thus characterized as cooperative and contrasted with the competitive style used by men: "Girls and women carefully link their utterances to the previous speaker's contribution and develop each other's topics, asking questions rather for conversational maintenance than for information or challenge" (Gal, 1989, p. 11). Although politeness behaviors do not themselves create intimacy or a sense of community, they certainly facilitate it.

Politeness in Cyberspace

According to the disembodiment enthusiasts of the mid 1990s, politeness was a relic of face-to-face communication. In the introduction to his collection, *Flame Wars*, Mark Dery (1994) attributes the propensity for firing off vitriolic messages to "the wraithlike nature of electronic communication":

> When tempers flare...disembodied, sometimes pseudonymous combatants tend to feel that they can hurl insults with impunity (or at least without fear of bodily harm). Moreover, E-mail missives or "posts" seem to encourage misinterpretation. (p. 2)

The reason for the latter, contends Dery, is the lack of nonverbal clues. He quotes a nameless "net surfer" who states that "shit happens on the Net" and that "anyone who plans to spend time on-line has to grow a few psychic calluses" (p. 2). By resorting to technological determinism, Dery avoids questions as to who actually engages in flaming, how it became so widespread in the first place, and why "everyone" should just accept this practice as "the way things are." Yet he indirectly answers the first question when he describes flaming as "a less ritualized, cybercultural counterpart to the African-American phenomenon known as 'the dozens,' in which duelists one-up each other with elaborate, sometimes rhyming gibes involving the sexual exploits of each other's mothers" (p. 4). Similarly, Howard Rheingold (1993a) describes "sport hassling" as "vicious online verbal combat" (p. 62). Like Dery, he blames such behavior on the medium, specifically the "anarchic" structure of the Net and its lack of formal rules and regulations. These supposed "net" behaviors, however, are typical of face-to-face interaction among all-male interactants. One need never to have heard of "the dozens" to realize that the adjective that Dery fails to place in front of "phenomenon" is "male." Holmes makes the case that such behavior is not necessarily offensive; rather, it operationalizes a set of norms different from those of women (or middle-class professional men): "In some contexts, aggressive and competitive verbal behaviour appears to be experienced as thoroughly enjoyable, and mutual insults may even serve as expressions of positive politeness or solidarity" (p. 66). Cameron (1997) makes a similar point, noting the cooperative aspect of all-male interaction that nonetheless involves trading insults.

Despite the focus on flaming by the academics, the norms of middle-class politeness were being established in cyberspace, or at least, reinterpreted and rewritten to suit the hybrid form of communication. In addition to a full scale

handbook entitled *Netiquette*[2] (Shea, 1994), many public mailing lists, newsgroups and chats developed explicit rules or codes of conduct. Susan Herring (1996) did a content analysis of what she refers to as "netiquette statements" culled from seven professional or academic mailing lists. She classified them as prescribing both the observance of politeness (+N, +P), both negative (posting concise messages) and positive (supporting or thanking others) as well as the avoidance of violations of both forms—quoting previous message in its entirety (-N) and flaming (-P). Based on her comparative study of men and women's posting styles and preferences, Herring concluded that while both sexes are generally mindful of negative politeness, women are more concerned with maintaining positive politeness.

Politeness as Communal Practice

Typical of all-female face-to-face interaction, members of the DDEBRP and MRKS did not flame, and for the most part limited swearing; worked to avoid, minimize or mitigate disagreement; and supported others' turns. I will look at each of these features in turn to tease out the complexities.

"You Miserable Piece of @@#^&$#!!!"

During the data collection periods, there were no incidents of flaming on either list. In the questionnaire sent to the DDEB participants, I inquired about attitudes toward flaming:

```
I generally prefer not to reply to messages I find
offensive, both in email and on the newsgroups. I feel
it's immature to spam people and isn't likely to cause
trolls to change for the better. (Geneva)

I don't flame. Life is too short not to grow up. (Ardis)

I guess I tend to identify with the person who has
"inserted foot-in-mouth" and feel sorry for them I don't
feel I need to participate in harassment of that kind.
And it is juvenile and rude. (Paula)
```

It is interesting that the two participants who admitted to being or having been "flame throwers" saw this behavior as nothing to be proud of or to engage in lightly:

> When I first arrived online I used to state my opinion
> in a rather obnoxious manner. Since then, I've learned a
> lot about how other people see things. **(Dani)**

> Oh, yes. I don't suffer fools lightly. If someone
> disagrees with me, that's just fine, but *don't* tell me
> I can't hold an opinion or that I'm an idiot for not
> believing X. Also, I won't stand still for racist, sex-
> ist or other narrow minded bigoted statements. **(Liz)**

The next sample is useful in more precisely identifying behaviors that the participants associated with flaming.

> **From: Geneva**
> Well, we could start an example discussion here, just to
> see how it flows. How does everyone feel about the idea
> of skinning [conservative pundit Pat] Buchanan and feed-
> ing him to people on welfare who continue to smoke,
> drink, and breed indiscriminantly [sic] instead of
> spending their time supporting the IRA and growing vege-
> tables to send to Bosnians, and using Buchanan's skin to
> make a tent to house homeless nuclear physicists who
> formerly helped manufacture bombs that were used to nuke
> whales?

Obviously, Geneva's post, which included the line "living dangerously" after her signature, was designed to offend a range of people by asserting strong political views baldly. Daphne and then Liz picked up the "flamebait" and engaged in a parodic performance of normative masculine interaction:

> **From: Daphne**
> Geneva, the #^&#$, sez:
> <snipped>
> I am absolutely incredulized [sic] that you could even
> say the above #^&$#! You are an @@#%$# and an #%^##. I
> am an expert in this area, and your ideas are #%&$#Q!!!
> Get a life, you miserable piece of @@#^&$#!!!

> **From Liz:**
> Yeah! And the horse you rode in on, too!

The mock flame indirectly addresses the unacceptability of name-calling and swearing at others. Lars Andersson and Peter Trudgill (1992) divide swearing into four categories: expletive, which is used to express anger or frustration ("shit!");

abusive ("go fuck yourself"); humorous, used to tease others ("get your ass in gear!"); and auxiliary ("this goddamned computer"). Although what constitutes swearing has changed over the centuries in English-speaking societies, Geoffrey Hughes (1991) points out that it has been viewed as inappropriate since Elizabethan times. Indeed, it became the subject of numerous 17th century tracts that condemned it as a vice. Swearing was also seen as particularly inappropriate for women, who were deemed too "delicate" to hear, yet alone use such language. In 1619, John Fletcher lashed out at men who would "rack a maid's tender ear with dam's and Devils," and Defoe wrote that "the Grace of Swearing has not obtain'd to be a Mode yet among the Women; God damn ye, does not sit well upon a Female Tongue" (quoted in Hughes, p. 209).

Almost five centuries later, the prohibitions against swearing, particularly for women, are still in place. Daphne used symbols in place of the actual swearwords, the mode of representation commonly used in comic strips. Indeed, she added an explanatory closing line: "Had this been an actual flame, you would have been able to ascertain the actual swear words used herein." In another exchange Mrs. Hale joked about what she felt like saying, but would never actually say, to someone looking to join one of the DDEBs: "Usually I tell them they will never be worthy of the honor, and to fuck off." The insulting comment generated the following responses:

```
From: Liz
BWHAHAAHAHAHA!!! This could explain the letter bombs I
keep getting from time to time. :-):-)
```

```
From: Winnie
HAHAHAHAHAHAHAHAHAHAHAHA!!!!!!! <sound of Winnie falling
off chair>
```

```
From: Ardis
I see you're still striving every day to live up to that
degree you earned from the Saddam Hussein School of
Diplomacy.
```

Members clearly thought the unsent flame was extremely funny, as indicated by the orthographic representation of laughter, yet acknowledged that it was a gross violation of positive politeness. Ardis, with her reference to the former Iraqi leader, demonized in the American press since the 1991 Gulf War, positioned flaming as not only "unfeminine," but "un-American." In response, Mrs. Hale affirmed her

"credentials": "Magna cum loudmouth, that's me," yet she never sent and indeed never intended to send the face-threatening message. In this final sample, Erin differentiated between violating and attending to face needs when making a point:

```
Again, for me at least, it's a matter of language and
how it's used. If someone says to me "All people named
Erin are total fucking losers and I hate every last
person I've ever met named Erin," sure, I'm going to get
defensive. If they said, "man, I have a problem calling
you Erin. Every Erin I've ever met has ticked me off or
hurt me...can we come up with a nick name for ya?" it
wouldn't bother me at all. (sorry for the lame example -
I was trying to think of one that wouldn't offend anyone
<g>.
```

A few DDEBRP members occasionally swore during list interaction but not to direct abuse at anyone on the list. In an exchange concerning the arrest in April 1996 of the man known as the "Unabomber," Daphne denounced the media:"If the media caused the Feds to fuck up, I'd break the story over their heads…Who the fuck do they think they are?" Mrs. Hale used "fuck" to direct her frustration at the Fox network executives: "We're talking sharks here, some of the most venal and unforgiving (and inept) people in show business. They don't give a flying fuck about the fans."

A search of the MRKS database revealed more examples of swearing. The only abusive example, though not directed at anyone, came from one of Leah's signature files, a "quotation" from Brett Hull during the second game of the 2002 National Hockey League (NHL) playoffs: "Oh, go fuck your mother." Members occasionally used "fuck" as auxiliary. Phoebe, for example, thanked Angela "for all the fuckin' OT you put in on this thing, eh," referring to setting up the list with a new service provider. In expressing strong agreement with another member, Drucilla exclaimed, "Ditto, ditto, fuckin' ditto." Yet, she must have changed her mind and decided to replace the expletive with "frellin'," for the original text and this one-line response appeared twice in the same post as if the first were intended to be deleted and replaced. Indeed, members were more likely to avoid "bad" language altogether:

```
From: Jeanne
I saw this message this morning posted to Serge, and I
must admit to uttering the words "Eeek! Blech! Go away!"
(among other things).
```

From: Drucilla
Those being the more printable ones, no doubt. ;-D

"Fuck" was also used on occasion, not surprisingly in light of quotations from the slash stories in Chapter 2, to signify sexual relations. Another of Leah's sig files consisted of two lines of dialogue from *Queer as Folk*: Brian: "What kind of homosexual are you?" Emmet: "The kind that fucks guys." The next sample is also from Leah:

I just saw "couches" in the subject line, and since and
I had been discussing various Mark decorating styles...
whatever. I see "couch", I think "Mark on couch fucking
the hell out of Todd". One track, eh.[3]

Others responded by teasing her about the "very important" things on her mind. Yet in her reply, she switched to innuendo: "Mmm. Todd, what *are* you doing with that...oh. I see. Yum. Let's tell Mark about this one, shall we?"

Further insight into the general absence of swearing on both lists can be garnered by a meta-discussion on the topic:

From: Drucilla
I don't swear much, period. Only when I'm really FUCKING
angry. :-)

From: Liz
I generally swear quite a bit, but I'm trying to tone it
down now that I have a little language sponge living
with me. :-) I don't swear much in cyberspace simply
because it's a more formal form of communication than
speech. In general I do type the way I talk, but the
swearing just doesn't come out...unless... :-)

For Drucilla, swearing was reserved for expressing strong anger, and this message was the only one of hers to make use of the "auxiliary" category. Liz distinguished between oral and written communication even though she saw email as a form in which she generally tried to "write" in a conversational style. She also pointed to her role as a parent in limiting her use of swearing. Geneva was more circumspect about the process of self-regulation:

I started cussing when I was three years old and have
had to curb the habit at work. When I'm in academic

```
mode…I avoid cussing. As a [university ] employee, I
could be disciplined if another employee heard me
cussing and lodged a complaint. I also have to ride herd
on a grad student who yells "FUCK" all the time in the
lab, offending people, so I feel like I have to provide
a good example of self-control to him. Generally,
anytime I"m in a large group and talking to people I
don"t know well, I moderate my speech quite a bit.
```

It is interesting that Geneva used the colloquial term "cussing" to refer to swearing. She also pointed to the consequences, in her case being disciplined as an employee for breaching a code of conduct. Although she tried to set a good example, hoping the grad student in the lab would self-regulate, she ultimately had to instigate disciplinary action against him. Her message inspired Liz to send another message, noting how she was also careful to mind her language in the workplace. In direct response to Geneva's last point, she added, "Yeah, you never know who it's going to bother and it really is a minor thing to deal with. A small courtesy." Non-abusive uses of swear words are better thought of as violations of negative politeness—they do not make others feel hurt as much as they are impositions or signs of disrespect.

Beyond flaming and/or abusive swearing, what counts as an FTA is not so easily agreed upon. One person's honesty or directness can be another's rudeness or adversariality. In her study, Susan Herring found that the majority of male respondents valued candid discussion and debate over attending to positive face needs in contrast to the female respondents. Interestingly, I found a similar division *within* the women-only DDEBRP community.

Staking a Claim (Sort of)

Every proposition can be understood in terms of modality. "It's going to rain tonight" expresses a high degree of certainty whereas "I'm not sure but it might rain" is a low affinity statement. Using expressions like "I think," "it seems to me," or variations on the net acronym IMHO (in my humble opinion) are forms of subjective modality that clearly state that the opinion being expressed is not an "objective fact" and therefore lacks authority.[4] Adding modal auxiliary verbs ("may" or "could"), modal adverbs ("possibly") and adjectives ("it is possible"), verbs of perception ("it seems," "it appears") as well as qualifiers ("sort of," "kind of," "a bit of") also serve to weaken one's commitment to the claim. As Fairclough argues, modality does not necessarily indicate certainty but rather "a sense of affinity, or solidarity, with interactants" (p. 159). Thus expressing low modality, or *hedging*, as

Janet Holmes calls it, is also a politeness strategy. If I hedge, I am less likely to create conflict and I make it easier for others to take the floor to express their views. Holmes associates hedging with negative politeness in that it avoids threatening the authority of others. In the following exchange, Winnie and Erin speculate on why David Duchovny was not nominated for an Emmy award in 1996. I have italicized the modality markers.

> **From: Erin**
> [H]is work this season has been *a bit* lacking *(IMHO)*. I thought he deserved the nomination for second season, but sometimes this year his performances were very lack-luster.

> **From: Winnie**
> *I don't think* DD was given as much to work with this year as last, either. Mulder as a character *seemed kind of* stuck in a rut for most of the year. Though Emmy nominators are not known for their perspicacity in tell-ing the difference between performance one season to the next...*seems to me* that nominations are just as often given for the *previous* season's work, or for a *body* of work...*just MO, of course*...This is not to imply that GA chews the scenery, btw. [ellipsis mine]

> **From: Erin**
> No, but her perfomances [sic] are subtle with more en-ergy to them...*does that make any sense?*

> **From: Winnie**
> *Maybe* it's because Scully developed more as a character this year than Mulder, so GA just had more to work with...or *maybe* Emmy nominators just feel more comfortable with Scully because Mulder can be so *out there* -- anyone with only a passing familiarity with the show *could very well* have a tendency to pigeonhole DD based on the flake that Mulder is purported to be. *Or maybe I'm just babbling.* :-)

The use of modality markers facilitated the building up on consensus and avoidance of conflict. Although Erin disagreed with Winnie about the quality of Anderson's acting, she asked her to consider her perspective. Winnie still felt that Anderson had been nominated for other reasons than good acting, yet she repeatedly used the modality adverb "maybe" to avoid threatening Erin's face needs. Similarly, by dismissing her own views as "babble," Winnie avoided putting Erin

in a position to counter argue them. Her self-effacing reference to "babbling" prompted Dani to join the thread: "Not at all. You are right on the money."

Striking a Balance

MRKS members were particularly successful at finding the right balance between candid discussion and face needs. The sample that follows has already been alluded to in Chapter 2 as part of the "gay vs. bi" thread:

> **From: Marguerita**
> (All this from gay guys I've talked with.)If there's a
> hierarchy in gay guys' minds, at least some of them, gay
> men are equal to lesbians but bi's are way down at the
> bottom of the stack.(Or so it seems in [name of city
> withheld].)

This member qualified her opinion by placing specific limits on her claim. Positioning himself as a gay man, Orion expressed disagreement, arguing that any attitude of superiority came from bisexuals:

> I've never heard it expressed as a hierarchy--either in
> Canada or in [name of US state withheld]. In fact, the
> usual complaint about bis is that they consider them-
> selves better than gay folks. Bis are usually just not
> considered part of the gay community, mainly because,
> like straight people, they aren't. They are--along with
> gays, lesbians and a host of others--part of the queer
> community, however.

Like Marguerita, he was careful to locate his experience, thus avoiding a sweeping generalization. He also concluded with a statement that underscored unity not division. Marguerita responded by contextualizing her original comments. Yet Sylvia, who had technically begun the thread, clearly felt that she had created a conflict:

> I feel bad. I think I stepped into a political pothole I
> didn't even realize was there. I didn't mean anything by
> the bi-sexual comment, per se. I was just saying that I
> find it hard to believe that a guy who wants to suck
> another guy's cock is actually straight. I said bi
> instead of gay because, well, I don't know the guy,
> obviously, and he seemed to be asserting his straight-
> ness as a way to deny any gay tendencies, rather than as
> a way to indicate his attachment to/attraction for

```
women. I said bi, I guess, because that was kind of
halfway between gay and straight, and therefore meant to
give him the benefit of the doubt as to the female half
of the equation.

I definitely didn't mean to push any polictical [sic]
buttons the first time I participated in a discussion.
It's been about 6 years since I ran around with the gay
crowd I used to hang with in RL, so I'm obviously out of
touch. Again, I'm sorry. No hard feelings, I hope?
```

Her repeated apologies were deemed unnecessary by others. Drucilla reassured her with these words: "Hey, don't feel bad. Discussion is GOOD!! It's interesting to get all the different input and learn more about what people think and feel." Orion did the same, "No hard feelings here!" Upon rereading his post, he then began a new thread called "another apology":

```
Hey list-sibs!
I want to appologize [sic] to anyone who was offended or
took umbrage at my comments about bis in respone [sic]
to Marguerita's post. I expressed myself very poorly,
and I can see how it can be read in a way I really
didn't mean.
```

Orion continued with a longer, more detailed explanation of his original point. He in turn was reassured by Kenzie:

```
No apology needed, at least, not to me. And being bi, I
sort of fit into the group of people you were talking
about <g>. And, having said identification, I'm going to
go out on a limb here and assume I'm qualified to add my
opinion <g>.
```

Her investment in candid but nonface-threatening debate is indicated by the last sentence quoted in which she joked about her "qualifications" to take part in the discussion. She also used questions rather than statements to lower her affinity as follows:

```
And for me, that's really the crux of the matter. I
mean, commitment is commitment, isn't it? If I identi-
fied as het or as a lesbian and had made promises to my
partner I wouldn't expect my partner to doubt my sincer-
ity and think "oh, she'll change her mind as soon as
```

```
another man (or woman) comes along." How is it any dif-
ferent to assume that someone who's bi will "change
their minds" as soon as someone of a different gender
comes along? It makes no sense to me and seems to be
more about trust than about lifestyle.
```

Furthermore, her sign-off line "Kenzie, who loves talking about this stuff," emphasized the pleasure in discussing ideas. The rest of the thread consolidates a sense of community with convergence of opinion. It is in her reply that Drucilla accidentally "swore" and then rewrote her sentence:

```
Ditto, ditto, frellin' ditto. Frankly, it's all just
labels. And until we as a species can get *over* this
need to label everyone, the urge to identify as 'us' and
'them' we are never going to learn how to co-exist as
peacefully and as openly as possible.
```

The thread ended with Orion stating that identities and labels do matter, thus presenting a somewhat different view to Kenzie's. Again though, his conclusion served to build consensus: "But, bottom line, I have to agree with Kenzie that the real issue for any particular couple is one of trust and commitment between the partners, not one of lifestyle or orientation."

A Piece of Her Mind

Not every DDEBRP member had the same strong investment in hedging as a politeness strategy, or more broadly, in normative feminine discourses of modesty and deference. Daphne, Liz, Mrs. Hale and myself in particular were more likely to resort to bald assertions when expressing opinions, a strategy that sometimes upset the apple cart of community and necessitated the need for conflict resolution. Chapter 1 provided a glimpse of such an instance: Mrs. Hale's direct challenge to the views of those discussing Mulder's treatment of Scully in the *X-Files* episode "Herrenvolk." The sample I will present involves Daphne's previously mentioned "Unabomber" post. Here is the full text:

```
There's a couple of things about the unabomber stuff
that pisses me off. One is, is that the Feds were NOT
ready to [go] into that cabin yet, but the media got
wind of it and were going to break the story, so the
Feds had to go in early. Something like that could
SERIOUSLY jeopardize the trial, and if the media caused
```

```
the Feds to fuck up, I'd break the story over their
heads. I think the FBI should sue CBS for interferring
[sic] with a government investigation. The media has
alltogether [sic] WAY too much authority. Who the fuck
do they think they are?
```

Her key statements were bald assertions, emphasized with capitalization and swearing. Her only attempt to mitigate this potential FTA was her concluding "Just my $.02." Winnie was offended by this sweeping attack on the media:

```
And let me add that I'm tired of people bashing "the
media" when what they really mean is "the networks". "TV
news" is such a joke. How often it is I've seen lead
stories on TV turn out to be buried inside the first
section or even the second section of the newspaper.
Winnie
journalist by training
newspaper reporter in her heart
```

Winnie avoided challenging Daphne directly by using the generic "people" but also made bald assertions ("TV news is such a joke"), the "credentials" in her sign-off lines boosting the statement. Geneva's reply was more conciliatory, agreeing partially with Daphne but then pointing out the problem with the alternative in the form of a question:

```
[The media] can jeopardize people's safety and destroy
their privacy, but what can be done to stop them? It's
way riskier to try doing without freedom of speech.
```

The debate continued, Daphne apologizing both to Winnie and for "ranting." Nonetheless, she did not back down, relying again on bald assertions and mild swearing.

```
Yes, but you'd HOPE that they'd operated with a modicum
of respect. And, sorry, Winnie, but I find a lot of the
print media is just as bad about this as TV news. I
don't mind them giving us the cold hard facts, but most
of it is just crap and intrustive [sic] and unneccesary
[sic]. Sorry to rant about this, but it's a sore spot
with me. I stopped watching the news and reading the
newspaper long ago b/c 1) the whole thing is just too
depressing, and 2) it's too sensational.
```

Winnie then sent an impassioned rebuttal:

> Sorry, but it's a sore spot with me, too. I am tired of
> having the entire journalistic profession tarred with
> the same brush because of what a few have done. I con-
> sider myself an ethical, moral person, and everyone I
> ever worked with in the journalism field was ethical and
> moral. I'm tired of taking the rap. I'm tired of having
> to defend journalism as a profession. I'm just plain
> tired. I was a working journalist…and it still makes me
> bleeping angry.
>
> It's too easy to blame *all* journalists because you
> don't like what you see on TV or in your hometown news-
> paper. Do you go around talking about how sleazy other
> professions are because of one bad experience or a
> friend's experience? I'd even feel better if people told
> jokes about journalists like they do about lawyers or
> used car salesmen, but they don't tell jokes about
> journalists -- they just slam them unmercifully and
> blame them because the news is "depressing" or "sensa-
> tional". I'm sorry but it makes me blanking angry.
>
> And you wouldn't believe what one person thinks is
> unncessary [sic] and intrusive with what somebody else
> wants to know *all* the tiny details about. Not *one*
> person I've ever talked to outside the journalism
> profession has an inkling of what the job is really
> like. Not *one*. This isn't aimed at you personally,
> Daphne, but it's a blankety blank sore spot with me, and
> you happened to have pulled the scab off.

I have included the entire text of Winnie's message to demonstrate how she qualified her numerous expressions of anger ("I'm tired of" "it makes me angry") every few sentences with "I'm sorry but," "This isn't aimed at you personally, but" and so on. Unlike Daphne, Winnie was unable to bring herself to use actual swear-words but chose the substitute words "bleeping," "blanking" and "blankety blank." For her part, Daphne sent a conciliatory message, apologizing again to Winnie for upsetting her. This time, however, she tried to establish some common ground by including the parts of Winnie's message that she was able to relate to and agree with. For example, after the first paragraph, she explained that she understood what it meant to be in a maligned profession and then made a comment about the lack of respect accorded to secretaries. She concluded by retracting her sweeping generalization about journalists, blaming instead the few "bad apples":

```
Sorry again, Winnie. I guess there are good and bad
people in every profession, it's unfortunate that often-
times the bad ones are the noisiest.
```

When Ash joined the thread later that evening, she also worked to reestablish a sense of coherence and unity among members by focusing on the personal connection she felt with both parties in the dispute:

```
<Winnie's incredibly eloquent rant deleted.>
Thank you, Winnie. As a former journalist and one who
might be again, I was going to do a similar response,
but you did it better than i would have.

And Daphne, I'm currently working as a secretary as
well, so I hear you! Funny how i seem to gravitate
towards professions--secretarial, journalism,
writing--that people love to look down on, since they
generally don't know how ^&+$% hard it can be!
```

Having been both a journalist and a secretary, she was able to appeal to the positive face needs of both Winnie and Daphne. As with the "mock flame," she used the comic strip-style symbols to represent swearing. While it would seem that the conflict had been resolved, Winnie was clearly not comfortable with her adversarial role, as indicated by the message she sent the next day:

```
Thanks, everyone, for taking my rant in stride, for the
support, apologies, all of it. One day later, I'm embar-
rassed to have vented like that. I usually try to avoid
confrontation, but I guess I was just really tired and
my defenses were down. It's nice that everyone's been
sympathetic about it, and thanks also to everyone who
said I was passionate and eloquent! I guess I've been
holding that in for awhile.

Daphne, I sympathize with folks who look down on your
being a secretary. Their loss. I think anyone who looks
down on secretaries must either have never had a secre-
tary or never had to depend on one. Good secretaries are
worth their weight in gold! (And bad secretaries can
ruin you.)
```

As she had with Erin, she drew upon a discourse of self-effacement, referring to her defense of the media as a "rant" and herself as having "vented." At the same time, she thanked those who had supported her and connected with Daphne by

affirming the value of her profession, even if from the position of a superior rather than a peer.

The next sample comes from a thread began with Drucilla complaining that the poor characterization in recent *X-Files* episodes was the result of the loss of the two head writers, who had left to produce their own show, *Space and Beyond*.[5]

> **From: Rhiannon**
> Barf! How can you stand all that military jingoism? The
> sad thing is that that's a more accurate projection of
> the future than the Enterprise [the ship from *StarTrek*]
> blissfully trekking through space on missions of
> exploration and peace. BTW, by dissing the show, I'm not
> dissing you…different strokes etc.

Not surprisingly, my bald assertions drew some fire. Mrs. Hale in particular provided a "spirited" response, opening and closing with military metaphors:

> <Mrs. Hale straps on her six-guns.>
>
> I adore "Space: Above and Beyond" for the same reason
> people watch "Start Drek": the characters. You have an
> outstanding ensemble cast (really, James Morrison is
> just spectacular, and Morgan Weisser is *very* good)
> married to what may be the best team writing on televi-
> sion--or movies. Morgan and Wong don't know sh+t about
> the military and probably couldn't care less. They are
> doing what they do best: showing us how characters react
> in stressful situations. It's the real point of story-
> telling: how does a human (or a tank, in this case)
> react to crisis? What can I learn about human nature
> from this story? What we find is that humans are humans,
> with recognizable human reactions, even though the
> technology and the environment have changed…
>
> I wish people would stop focusing on the irrelevant
> details of "Space" and pay attention to the storylines*!
>
> <unbuckling six-guns>[ellipsis mine]

Mrs. Hale never attacked me personally, and as Winnie had done, she stuck with the generic "people." She also drew on a discourse of criticism to discuss what she perceived as the show's strength, the development of the characters. I rebutted some of her points, noting that portrayal of the alien enemy was one dimensional and racist. Mrs. Hale in turn retorted that she was "*so* tired of the PC [politically

correct] crap that portrays every enemy of the United States now and in the past and in the future as being the victim of oppression." Had she concluded there, I could well have taken offense. However, in her next paragraph, she tried to appeal to my reason and apologized for the "rant":

```
Think about it, Rhiannon. Is it realistic to think that
every time we go to war it is in order to further an
imperialist agenda? When you are attacked by a merciless
enemy, who not only won't negotiate but won't acknowl-
edge your fellow humanity, would you prefer to sit
quietly and die?

I'm no militarist, and I don't like violence, but I *do*
admire the courage it takes to go out and die for one's
nation or people. That level of sacrifice is totally
unknown in this self-indulgent culture.

Excuse the rant, I really am NOT G. Gordon Liddy. I
marched against the Vietnam War and the Gulf War, but I
am no friend to the VietCong or the Iraqis, both of whom
proved themselves over and over and over and over again
as no friend to human rights.
```

I remained comfortable with the debate, and indeed over the course of the year, regularly engaged Mrs. Hale on sociopolitical issues. This was not the case with Bel:

```
You know, I don't understand why people have to come
down on (belittle? right term) shows they don't like. I
don't watch Space but I know a lot of people that do and
enjoy it. I don't watch Soap operas either but I try not
to come down on them or the people that watch them.
```

From her perspective, my criticism of the show was a criticism of those members who liked it. I responded by expressing concern that fear of starting a flame war could effectively shut down any meaningful discussion. Bel then distinguished between constructive criticism and rational debate and provocation:

```
True, I'm sure I critique far more than I realize.
However, most of the time I try to give reasons for my
comments that hopefully aren't hurtful. You dislike
Space because of its language/jargon. That's fine and I
think comments like that are helpful. Others dislike
Star Trek because of its lack of strong female
```

```
characters...

But your "Space. Barf!" and Mrs. Hale's "Stark Drek"
aren't very constructive, IMO.I understand that the
speakers obviously don't like the shows, but I don't
know why they don't like them. Those are the kinds of
comments I was referring to when I said people were
coming down on the shows. Sorry if I didn't make myself
clear. It happens all the time. :)[ellipsis mine]
```

Bel's discomfort with debate came up in another thread on sexist language. When Drucilla suggested forwarding messages (with permission) from her list on the topic, Bel stated that she would just delete them unread "because I didn't feel like 'listening' to the debate." Indeed, she made explicit a strategy specific to CMC for coping with communal practices in which one does not wish to take part. Prompted by Drucilla's somewhat pointed reply, "I'm sorry that you feel that way. I didn't think we were boring people," Bel elaborated:

```
Not boring, making uncomfortable. I don't like arguments
at the best of times, and the beginning of the discus-
sion seemed very close to arguing. It did evolve into a
debate, which, IMO [in my opinion], is just a civilized
argument. I almost jumped in a couple of times, but
realized that "taking sides" was not a good idea and
would possibly lead to more confusion.
```

Like the female respondents in Herring's study, Bel associated any type of debate with argument, a threat to the coherence of the community. These comments inspired Daphne and Liz to come to the defense of the practice. Daphne acknowledged that "there was some misunderstanding going on, but we worked thru that." In response to Bel's reluctance to get involved, she wrote, "I was actually hoping that more people would jump in and we could have a free-for-all. :-> I like lively discussion." Similarly, Liz asserted:

```
That's the nature, IMO, of any meaningful discussion -
if you're talking about anything deeper than the days
[sic] activities, you're going to have a period at the
beginning when everyone's staking out there [sic]
positions and making sure you're using the same terms in
the same way and all. Toss a bit of passion into it and
it can heat things up a bit. :-)
```

Daphne reinforced Liz's last point and linked not just her own identity but that of her DDEB community with the emotion that fueled these discussions: "Yeah, and if anything, we're a passionate bunch. :-> Hormones to spare." In drawing on a discourse that links women with emotion and passion, Daphne effectively "feminized" the practice of debate, traditionally associated with rationality, thereby making it a legitimate practice in the creation and maintenance of a community based on feminine values of politeness and supportiveness. For her part, Geneva tried to find a balance between the push of candor and the pull of politeness:

```
To some extent, you have to monitor your speech in any
group to avoid offending someone, not just in an e-mail
group. When I'm hanging around with my friends IRL, I
know I can't talk about sex in front of one who's a rape
victim, can't talk about female complaints in front of
most of the males, can't criticize a certain person's
religion even jokingly, etc. Everyone has a button or
two that any polite person will try to avoid pushing,
and everyone has certain topics they're squeamish about
discussing. It is a little maddening sometimes not to be
able to state a strong opinion without risking offending
someone else, but that's a small price to pay for
belonging to a group.
```

As Geneva made clear, the potential for conflict is always present in communal relations when strong views are expressed, and while they cannot be eliminated, they can be minimized through following n/etiquette ("everyone has a button or two that any *polite* person will try to avoid pushing"). Thus, the coherence of women-only communities like the DDEBRP ultimately depends upon politeness strategies and some degree of self censorship. In the end, though, there was no consensus on the right balance to strike between candor and politeness.

Truth and Consequences

The tensions that developed out of differing views could and did have lasting effects on membership in the community. The "fangirl" thread, discussed in Chapter 1, was a case in point. The discussion criticizing the DDEB member who in my words "slavered" over Duchovny clearly struck a nerve:

```
From: Kimberly
Ok, I have to say something here, I've been seething
over this all night…First of all the "she is also very
```

```
young, and it shows"--are you implying that she is
immature? Or do you believe that younger people just
can't control their "slavering drool"? Well, she's older
than I am, so what does that say about me? I for one, am
not a heavy drooler, but I also don't presume to judge
(or silence) those that enjoy that sort of thing,
"reputation" or not...This brings me to my second point -
this account was written for the DDEB3, and in the
context of our friendship with this person, I think it
was appropriate. I read it over again just now, and
personally, I found it quite funny and HONEST. I enjoyed
sharing in her excitement and nervousness, and appreci-
ate the fact that she didn't edit her account to appear
more "mature".
```

Erin indirectly accused the participants of the thread of inflammatory posting behavior.

```
I'm sure I've done things that have embarrassed my
fellow ddebers (ie - allowing the Leno post to be put on
a ddeb web page?).If they want to call me on it in
private and tell me, I'll reconsider my actions. I see
no need for this sort of name calling and finger
pointing to happen in public. Perhaps I just have a
different mind-set on this than others. If I do have to
speak out about something it [sic] public, I usually try
my best to put things in such a way that it would not
hurt the feelings of the people involved or their
friends. I'm not always successful at this, but I do
try.
```

On the surface, the conflict was resolved. Those who had expressed the strongest criticism of such behavior apologized or qualified their original stances. In her next post, Kimberly added, "feeling much better about getting this off her chest...phew..." She also reached out to Hollis, explaining that she understood the fear of being dismissed as a fangirl. Yet, only three weeks into the data collection period, Kimberly never posted again. She unsubscribed from the list the following February citing too much work as a university student. Erin continued to participate actively on the list. In October, a discussion on the most appropriate way to turn down requests to join one of the DDEBs (the context for Mrs. Hale's "I tell them they will never be worthy and to fuck off" joke) found Erin once again more concerned with face needs than others. The next day I found an "unsubscribe" notice from her in my inbox. At the time I was surprised—in relation to the data

samples presented here, the discussion bore few markers of direct disagreement. When I emailed her, she told me that she felt her views were not valued. Nothing was ever directly said onlist about Erin's abrupt departure. The silence, however, was not golden. Several members of Erin's brigade told me after the data collection period ended that they had felt excluded henceforth:

```
After that incident I felt like the odd man out & was
not really comfortable with sharing myself with the
others. If the overall conversations hadn't been so
interesting, I probably would have left as well.
```

```
I did feel like the discussions tended to be carried on
a lot by the DDEB[number withheld] members. I know there
were times that I felt like comments I made in 'their'
discussions were ignored.
```

One member was more forthcoming:

```
The lack of response to her departure just appalled me.
The fact that it was never publicly acknowledged by the
group ticked me off…It makes me clench my teeth to think
about it still.
```

```
I almost quit DDEBRP myself because of it -- the only
reason I didn't is because I didn't want to just
unsubscribe, and I didn't know how to explain it to you
without yelling at you for "allowing" it to happen. I
guess I kept waiting for you as listowner to step in to
mediate. Of course, I realize that as a researcher you
didn't feel you could do that.
```

Only Ardis made an indirect reference to Erin's departure on the list, implying that the community was responsible for failing to adhere to the values of politeness and supportiveness upon which its legitimacy was based:

```
Offense is in the eye of the beholder. We have to
remember there's the unknown variable of the person
receiving the message and all the filters he/she has…All
sorts of weird spins get added [in cyberspace] that we
don't intend -- and we have to live with that, whether
we like it or not. And considering we just chased one of
our own out of here, I'd say we're all a little more
familiar with this than we think. :(
```

I have not mentioned MRKS in the previous two sections because there were no instances of overt conflict during the four months I was on the list. There were a few minor flare-ups, one of which arose out of the thread listing author's notes that were supposed to be indicative of poor-quality fanfic. Deirdre was the one who intervened to express her unease with the thread, yet she avoided confrontation or accusation by employing the "off record" strategy ("I'm glad I didn't fess to anything too massively stupid in my notes. Yikes!") It served its purpose, Drucilla and Jeanne shifting the discussion to the sharing of inspirations for stories to build solidarity. That said, several discussions indicated that the participants were well aware of the price to be paid for candor. The first sample comes from the "fannish ennui" thread, part of which was presented in Chapter 2.

> **From: Phoebe**
> Still and all, as I told you and Drucilla yesterday,
> after three years I'm very un-inclined to get involved
> in discussions, especially those that might result in
> contretemps, esp on public lists. Most of the time I
> bite my tongue and confine the discussions to private
> email. OTOH I miss the free and easy exchange of ideas
> about *any*thing (or so it seemed) that we had onlist
> when I came into the fandom. So I'm not sure how much of
> this disinclination to speak could be combatted [sic] by
> simply speaking - but you know when you've been through
> the "you hurt my feelings" wars it gets pretty old to go
> through them again and again and to explain again and
> again what the concept of "free speech" really means. I
> see stuff that happens in areas other than fandom online
> and it shocks me how insulated we've become or made
> ourselves to 'negative' opinions IN fandom - as in all
> societies, there's a very strong movement to have every-
> one agree with everyone else, but it seems to reach an
> extreme in fandom, and, being that I'm not willing to
> fight those battles any more, I can't blame other people
> for being unwilling to fight them too. So this isn't a
> "someone DO something" kind of statement, just an obser-
> vation.

Phoebe was not specifically referring to MRKS but the general lack of disagreement can be, in part, attributed to a reluctance on the part of the flame-weary to raise controversial views. She observed negative politeness by couching her claims as personal experience and reassuring the others that she did not expect them to take action, or even a position ("Just an observation."). In her reply, Deirdre also typified

her "other fandom" as "fucked up and war torn," although she did not specify whether she was referring to public and/or private lists. A week later, a similar discussion took place. This time Phoebe made the distinction between public and private lists in relation to candor:

```
I know that I really have to be upset or pissed to get
into something in public now (to disagree on a public
list) that two years ago I would have been ranting about
without a second thought. It's just not worth the
effort, especially when you have to explain basic stuff
like the implications and responsibilities of free
speech over and *over* and *OVER* again. I just tend to
hang out more here instead where some things are just
understood without being reiterated. I mean, for me what
I love about the members of this list, whether or not I
agree with them or whatever (Chelios??? Puh-LEASE! <G>)
is that they can all follow a goddamn fucking logic
chain. It's such a *haven* in fandom in that sense.
```

Hence, it was not disagreement that was a problem but the way in which it was managed. Although Phoebe stressed rationality, the importance of attending to face needs in debate cannot be ignored. Her message also gestured to the coherence of MRKS ("some things are just understood"). Indeed, as illustrated in Chapter 2, Phoebe and others expressed strong views on the "slash for fun" vs. "slash as craft" debate several times, but were likely comfortable in doing so knowing that the majority of members took the former position

In the next paragraph, however, Phoebe admitted that she did not speak her mind even on MRKS when it came to "the technical aspects of writing. And I don't know if that's just cowardice or just being tired or what." Drucilla joined the thread to agree with Phoebe on the fear of speaking out even among like-minded fans:

```
I think that's a lot of it, yeah. After a few times when
one has stated an opinion onlist and ended up starting a
frickin' firestorm, one tends to…not say things as much.

Like the fandom ennui thing. I've been avoiding saying
what I think may be contributing to the problem, because
I feel like I've ticked off more than my share of people
lately and I should just keep my big opinionated yap
shut before any MORE people stop talking to me, ya know?
```

The self-deprecating comments served to add humor to the thread, prompting Jeanne to respond: "All right, that's *it*! I refuse to talk to people who won't open their big opinionated yaps onlist! I'm never talking to you again! Bwahahahaha!" She signed her post Jeanne, Making Trouble Since 1996. In Chapter 3, I discussed humor as a form of linguistic capital but in the above sample, it can also be understood as a politeness strategy, functioning to diffuse concerns around conflict and to create solidarity. Indeed, the thread continued with good natured teasing of Jeanne by Donna: "Are those flames I see licking at the hem of your jeans? Cause baby, I'm betting you made trouble *long* before 1996."

An Electronic Kaffeeklatsch

Although I have focused on disagreement and its management in the previous two sections, particularly on the DDEBRP, I wish to emphasize that the violations of face needs were far outnumbered by efforts to support others and make them feel both respected and liked.

When the DDEBRP became operational, members made a special effort to get to know members from the different "brigades" and to share everyday life experiences. The first post to the list was the following:

```
From: Mrs. Hale
*clearing throat* Tap..tap...is this thing on?
Hi. My name is [Mrs. Hale]...I am short, loud, partial to
tie-dye, and drink my whiskey straight up, no soda. By
day I am a mild-mannered secretary in a[n]...engineering
firm which investigates things that break (like the
Exxon Valdez) or blow up (like the Oklahoma City bomb-
ing). At night I write...and tend to the care and feeding
of my large husband and two small daughters. [ellipses
mine]
```

Mrs. Hale began by introducing herself rather formally as if at an AA meeting, and then presented a series of personal "facts," some of which were self-deprecating but included for humorous effect ("short, loud, partial to tie-dye"). The next members to introduce themselves took their cue from this post, sending humorous descriptions of aspects of their background, age, jobs, hobbies, marital status, and so on. Mari used a similar opening ("Hi everybody! test, test, test"), and Caprice directly echoed Mrs. Hale's "by day/by night" structure but connoted a Jekyll and Hyde split—Assistant Professor of Medicine by day but at night "a brainless zombie

that lays on the couch and maybe watches television if I can remember to point my head in the right direction."

Members of different DDEBs, Mrs. Hale and Caprice set about establishing a connection (the former's original text is included in the latter's reply):

```
From: Caprice
>Hi,Cap. (Do you like that term or do you prefer
>Caprice?)
Cap is fine.

>Can I pick your brains (metaphorically speaking) when I
>need medical info for an X-Files [story]?
Sure, if you can find them when you need them. ;-)

>What kind of cancer are you researching?
Uh-oh. Don't get me started! I am basic scientist
working in a nest of hematologic oncologists.

> Mrs. Hale
> nosy
No problem!
Cap
```

Mrs. Hale started out by using a standard abbreviation of Caprice's real name, but then checked to make sure that she had not violated her negative face needs by being overly familiar. Caprice reassured her and responded favorably to Mrs. Hale's request for medical information for her story. Mrs. Hale even described herself, albeit tongue-in-cheek as "nosy" in case Caprice felt that she was again not respecting her negative face needs by asking too many questions.

Erin also responded to Caprice's introduction but identified with her "Hyde" side:

```
Cap...we are so much alike here that it's frightening. :D
Except that you do brainy work at day and I'm part of
the brainless government bureaucracy at night...I too have
forgotten hobbies since the net has taken over my life,
am single and have 2 cats. [second ellipsis mine]
```

The self-deprecating style of humor found in all the above samples is itself a politeness strategy linked to a discourse of normative white middle-class feminine modesty. Members did not wish to be seen as arrogant or self-absorbed, that is, looking after their own negative face needs at the expense of others' positive face.

More evidence of this self-effacement can be seen in the way in which some DDEBRP members spoke of their accomplishments. When Erin received praise in an online magazine for a website that she had designed, she immediately emailed the list both excited and apologetic: "Sorry too [sic] toot my own horn a bit...the site was the first one I designed and made all of the graphics for by myself...I'm still glowing from the description of the page :)." When Winnie mentioned that she had written half a novel based on the film *Alien* and its sequels, Mrs. Hale asked her if she would send a copy to those interested in reading it:

> **From: Winnie**
> If you'll overlook the fact that it's unfinished,
> unpolished, and has some contradictory plotlines that I
> never decided how I wanted to deal with...umm...sure! Can
> you take it by email? In one piece or broken into parts?

While she hesitantly agreed to the request, she also provided an "out" for Mrs. Hale to refuse it by mentioning all the story's supposed flaws. The tag line after her signature, "digging toe in dirt," describes a physical act used to signify bashfulness. In contexts such as the above, self-effacement is also a strategy that encourages supportive turns from others, therefore affirming their membership in the community. Mrs. Hale, not surprisingly, expressed her interest in receiving the story. Hollis similarly reassured Erin that she had every reason to "toot her own horn" over the website:

> No problem. It's nice to hear of someone getting praised
> for doing a good job, especially when that person is one
> of our own. And that site *is* damned impressive! :)

DDEBRP members also made excuses for not saying enough or anything on the list when I asked how folks were doing during "lulls" in list activity:

> **From: Megan**
> Mari's reason:
> >I'm busy getting ready for my May 4 concert. Sound
> >system, background tapes, what to wear, memorizing
> >stuff. That's my excuse...lately I haven't been
> >_anywhere_, cybernetically.
>
> My excuse:
> Well, I don't really have one other than a really crappy
> weekend and Monday, so I haven't really felt like

```
sending out mail...but since I'm writing this one, I guess
I've gotten over it. :)
```

Both Mari's and Megan's replies can be understood as supportive turns meant to attend to my face needs as the researcher and "hostess" of the meeting "space" by making it clear that their silence did not signal a lack of interest in participating. Not surprisingly, direct requests to share "real life" experience or other information always generated a response. After several days of tensions caused by the "fangirl" and the "Space and Beyond" threads, Mari took the floor to change the topic and build on the commonalities that were beginning to form out of the introductions from two weeks previous:

```
I think we all need a break from all this serious
discussion - a lot of us don't even know one another
yet! So when searching for a topic, I decided to go with
what I know - music.

1. What kinds of music are y'all into?

2. Does anybody know what ambient music is, exactly? I'm
gonna be on an ambient comp[ilation] and I'm not even
sure what it is. :)
```

Judging by the explosive response—several hundred messages that spanned almost a week, the rest of us were only too happy to explore common interests in music.

Supportive turns were not only generated by self-effacing posts or requests. Indeed, celebrating good news, wishing others luck and commiserating around bad news were communal practices on the DDEBRP. The following exchange revolved around Hollis's announcement (offered in response to one of my requests for news) that she had finally quit her job as a secretary at the university:

```
Well, I just quit my job from hell last Friday. Silly
me, I waited until the very end of busy season to do it.
Now I've got so much catching up to do in my non-work
life that I haven't been able to start unwinding yet.

Anyway, I have this deal going with my husband whereby I
stayed in a job I loathed for a couple of extra years so
he could get half-price tuition while he was in grad
school (I worked at a universiy [sic]). In exchange, I
get to take a couple of years off while he supports me
now that he's got his M.B.A. (also last Friday)...
```

> Aside from learning to dance and getting a lot of sex,
> my big plans for the summer are to do some renovations
> on my house and to refinish furniture. I've done some
> minor upholstery work, and I'm itching to try something
> more complicated. [ellipsis mine]

Hollis received praise and kudos from members who could identify with being trapped in a job that they hated:

From: Erin
Wooohoooo! You are free! What a wonderful feeling that
must be!!! I'm playing hooky from my job from hell
tonight...too bad I have to go back tomorrow...Kick back,
relax and enjoy. You deserve it for surving [sic] that
job!

From: Megan
Happy Happy Joy Joy!!!! I hadn't seen the countdown
lately, but I knew it was getting close! Almost exactly
a year ago, I quit a job from hell, so I know how you
feel...Enjoy your time, and the sex! ;) [ellipsis mine]

Other connections were made as well. Her mention of refinishing furniture generated a response from Liz who was planning to buy an unfinished dresser for her daughter's room and stain it herself. She highlighted the sense of connection that having shared plans provided by adding, "We may be furnituring together this summer :-)." Megan sent another message in which she exclaimed, "Me too!" She went on to describe her project to restore a deacon bench that her mother had built a number of years ago.

In the next sample, Erin mentioned as an aside that she had a job interview the following Monday:

From: Megan
Cool! Was it for the web job? You might want to take
along that write-up that you passed along. GOOD LUCK
VIBES!!!!

From: Moll
Good luck on that job interview. Of course you have a
lot of vibing support behind you which should make it go
that much better.

In joining the thread, Mrs. Hale elaborated on the effects of the practice of sending "good luck vibes" in the context of her brigade:

```
And I can *personally* attest to the power of DDEB
vibing. It accomplished outright miracles for me last
month--the new job was only a tiny part of it! I'll be
thinking of you on Monday.
```

Both Erin and I, who had not heard Mrs. Hale's news, then posted messages offering our congratulations. I also added that my partner had finally been accepted into a multimedia course for which he had been waitlisted, and in turn, was congratulated by a couple of members. The next day, Erin sent a long message to the list with details of her experience:

```
Since so many of you were so nice as to wish me good
luck on my job interview, I thought I [sic] post the
tale of my day here.

I got up way too early after too little sleep...I was
nervous. Better yet...I'd started my period and had major
cramps going. Bleah. I got ready and left the apt.
Luckily, it was overcast today, so the car hadn't quite
reached it's usual steering-wheel-melting-tempurature
[sic]. The air-conditioning actually kicked in a bit and
I wasn't a total puddle by the time I got there.
```

She had arrived ten minutes early, feeling confident in the new outfit she had bought for the occasion, but almost immediately was caught off guard by the interviewer:

```
She took a folder with my name on it out of a big stack
of folders with names on them. :/ To make matters worse,
Her first set of questions had me squirming in my sleep.
She said she was supposed to ask me if I was familiar
with these software programs: Webweaver, BBedit and
Pagemill...I'd never heard of any of them except webweaver
and that one only in passing! I was feeling like an
idiot. At just that time, Kay's assistant walked in to
tell her something and on her way out she looked at me,
introduced herself and then tucked one of those
white-strings-for-wide-necked-dresses-so-they-can-stay-o
n-the-hanger-thingies under my collar and said, "Thought
you might wanna know that was hanging out". I was now
ready to admit defeat and crawl under the table.
```

While Erin felt the rest of the interview had gone okay, her anxiety and nervousness were obvious, and others provided in-depth responses. Mrs. Hale, who had lived in the same state, shared her memories of suffering in the summer heat and then assured her that not knowing the programs that the interviewer had mentioned should not have been a problem:

> Isn't WebWeaver brand new? You'd have to be a genius to
> be an expert at it. At which point you'd be too
> expensive for her. PageMill is Adobe's new web editing
> software and it sucks.

As for the dress loop hanging out, she retorted:

> Nah. Don't worry about it. I interviewed a guy for a job
> today who came in with no tie. I don't care how he
> dresses as long as he can code HTML. As long as you are
> not interviewing for a meet-the-public position, like a
> receptionist, why would they care? Besides, real
> programmers (of which web coding is a subset) dress like
> geeks anyway.

Once Mrs. Hale learned that Erin's interview had been with an agency that hires for companies, she gave her a detailed account of how the system worked based on her experience. She concluded her message with some advice, based on a personal experience:

> Good luck! Even if you don't get this opening, that
> agency has your resume on file. They *do* call back. My
> mom, who has been retired for four years, is currently
> getting phone calls from job-shoppers pulling her resume
> out of their files from five years ago!! They hang on to
> those resumes forever. And you can always send them an
> "updateda' resume in the future to remind them you are
> around. They have called me from time to time asking for
> an updated resume.

Others responded in kind, sharing their own experiences and thus forming a supportive community around Erin in an effort to build her confidence and self-esteem:

From: Bel
Don't get discouraged. It is a letdown to see stacks of
resumes, but remember *your* resume was one of the ones
that made an impression and *you* got the interview. I
know how shocked I felt the first few jobs I interviewed
for and found out they received *hundreds* of resumes.
It helps you appreciate getting the interview - and the
job! - that much more. Good luck.

From: Hollis
Good luck, Erin! It would be foolish of them not to hire
you just because you've never been *paid* to do that
before. The web pages you've written for fun blow away
the ones I've written for my old job. I also hope they
aren't too sticky about being familiar with those
particular web editing programs. It's not like most web
editing programs aren't easy enough to pick up on, and
like you said, a lot of the time it's almost easier to
write code without them. I'll be keeping my fingers
crossed for you! :)

On MRKS, there were far fewer supportive turns based on the sharing of
personal experience. I only came across one thread in which Angela mentioned a
shooting at her office in a message about getting the new list software up and
running:

There was a shooting at the main office today, so I
might be standing around for hours waiting, but I have
to be there at 1:00 AM I wonder if it made the national
news. Three dead - and the shooter blew himself up.
Happened in Providence and Warwick RI at the Journal
Bulletin in the printing press room. Anyone hear
anything?

Several members responded, expressing shock and anger and then developing the
topic by making connections to their own experiences.

From: Phoebe
Oh Angela! That's awful. I didn't hear anythign [sic]
but then if it's not on thesportingnews.com or mentioned
during intermissions, I don't hear much in the way of
news. Sad but true. I'm so fucking pissed about the
government that I avoid national news as much as
possible.

From: Alain
Angela, what a nightmare! I'm sorry. Something like that
has to be disturbing. I need to catch up with you off-
list about Providence -- I spent four years there in the
late 80s. Coming from the southwest, it took me a *long*
time to understand the culture of RI, but it grew on
me.:)

[Ineffectual but short rant: The increase of workplace
violence in this country scares the hell out of me. I
wish we could somehow get a handle on it and/or
destigmatize our attitudes about mental health care.
And, while I'm making wishes, it would be nice if the
fucking assholes of the world would stop tormenting
other people for the fun of it. /rant]

It is interesting that Alain felt it appropriate to support Angela's turn by
expressing political views about workplace violence but not share personal
experiences about living in Rhode Island. As noted in the Introduction, MRKS has
been deliberately set up to be fan-centric. As a result, members usually added "OT"
(off topic) to their subject headers when raising a non-DS fan-related thread. Doing
so is negatively polite behavior as it avoids imposing on others. Yet many of these
posts were picked up and ended up being some of the longer threads. In the above
sample, Angela did respond onlist, picking up a number of Alain's points:

Providence…four years…let me guess. Brown? PC? RISD?
J+W? I did my freshman year at Brown in 1987. Then I had
to get away from RI. I should have stayed at Brown. But,
what did I know at 17 ???? After living in San Francisco
for 10 years, coming back to RI was almost a culture
shock, but at least I was prepared for it by growing up
here <G>. I couldn't imagine coming here after growing
up in the southwest! Everything you hear about New
England being a strange place is very, very true. I
come by my prickliness and suspicion of strangers
honestly, at least.

The last sample comes from a thread on the DVD *Torso*, a made-for-Canadian-
television movie starring Callum Keith Rennie (RayK):

From: Lisa
One observation: as I told someone offlist, I like
Callum in soft, wavy or tousled hair. Not necessarily as
formal as in a 1940s slicked back style, but he looked

fine with that too. I like the vulnerable, boyish aspect
of the softer hair, at least upon occasion, as much as
the spikey "bad boy" image…I apologize for introducing a
hair discussion in fandom - (covering face) Oh, the
cliche. But it *is* a slow news period. <g> [ellipsis
mine]

From: Jeanne
Okay…if Lisa can introduce a hair discussion (which I'm
fully expecting D. to jump right into <g>), then I can
continue it. Or rather, I can post a link. Anyone who
hasn't seen Callum's "real" hair (via his grade twelve
school photo) should really take a gander (scroll down a
quarter of the way).

Lisa's (tongue-in-cheek) apology attempted to mitigate the potential FTA of introducing what she perceived as an off-topic thread. Jeanne's response is an example of positively polite behavior; not only did she accept the topic but developed it. A number of members joined the thread, discussing their preferred hairstyle for Rennie as well as their own hairstyles and colors, past and present. Although the behaviors that constitute politeness were not always agreed upon, particularly on the DDEBRP, their regular and consistent deployment by the majority of members were major contributors to the *substance* of both communities

Notes

1. I have modeled my example after Fairclough (1993), p. 163.
2. In line with Holmes's perspective on competitive male interaction as positive politeness, it makes sense that Shea would dedicate an entire chapter to the "art of flaming."
3. Mark and Todd are minor *Due South* characters.
4. Holmes points out that in some texts subjective modality is not a hedge but a "booster," which strengthens, not weakens, one's assertion.
5. *Space and Beyond* was a short-lived television series produced by Glen Morgan and James Wong, the writing team from *The X-Files*. It ran on the Fox network during the 1995–1996 season.

⩊ Chapter 5
Cyberspace as Virtual Heterotopia

In this chapter, I shift the focus from the social relations afforded by ICTs to spatial relations. Specifically, I will discuss the three David Duchovny Estrogen Brigades and the Militant RayK Separatists as *heterotopia* or alternative spatial orderings. As I argued in the Introduction, community and space are not mutually exclusive categories. One informs/is informed by the other, although each raises distinct concerns. In the first section, I set out to explore the ways in which the DDEBs blur the boundary between public and private space. As feminist scholars are keenly aware, this division of social space runs along the fault line of the gendered body and is highly problematic. In the second section, I focus on the disruption of normative spatial relations when American fans embrace a Canadian television show. Through discussions of Canadian national symbols, news and culture intertextually linked to *Due South*, the MRKS members produced a quaint, white, gay-positive Canada amidst a vast virtual territory dominated by American media culture.

Spaces of Their Own: From the Convent to Cyberspace

To properly contextualize the formation of women-only online spaces like the DDEBRP, it is critical to provide a *genealogy* of the ways Western women have been officially relegated to the realm of the private as well as the ways in which they have also been able to create spaces that disturb the public/private binary. Michel Foucault (1980b) describes this approach as producing "the union of erudite knowledge and local memories which allows us to establish a historical knowledge of struggles and to make use of this knowledge tactically today" (p. 83). I examine the historical regulatory function of this division in Western culture as well as

examine historical sources for glimmers of the alternative orderings and in-between spaces created by women.

The Birth of the Public

Women's association with the private sphere in Western culture can be traced back to ancient Greece. Jurgen Habermas (1989) summarizes the relationship between public and private as follows:

> The sphere of the polis, which was common (koine) to the free citizens, was strictly separated from the sphere of the oikos...The political order, as is well known, rested on a patrimonial slave economy. The citizens were thus set free from productive labor; it was, however, their private autonomy as masters of households on which their participation in public life depended...Status in the polis was therefore based upon status as the unlimited master of an oikos. The reproduction of life, the labor of slaves, and the service of the women went on under the aegis of the master's domination. (p. 3)

With the collapse of the Roman Empire, the distinction between public and private disappeared. What constituted the public in medieval times was the representation of power, organized into a hierarchy, the highest level of which was that of the sovereign in the absolute monarchies of Europe and Parliament in England.[1] As a result, argue Marilyn Boxer and Jean Quataert (1987), a noble woman enjoyed a certain amount of power through the administration of her husband's estate, duties which included overseeing serfs, collecting rents, etc. That said, she had no rights as did the English "freemen" whom the *Magna Carta* of 1215 specified could not be "arrested, or imprisoned, or dispossessed, or outlawed, or exiled, or in any way ruined, except by lawful judgment of his peers or by the law of the land" (Corrigan & Sayer, 1985, p. 35). Moreover, she was subject to regulation, primarily through marriage:

> Under common law all her property passed to the husband on marriage: her chattels (personal property) for his absolute use and disposal; her real property for his use (including alienating its fruits) for the duration of the marriage, or, if children were born, his lifetime...A wife could not sue or be sued at common law in her own name alone, she could not sue her husband...Murder of a husband was petty treason (as was the murder of a master by his servant), not simple homicide, until 1828. Petty treason carried the penalty of death by burning. (Corrigan & Sayer, 1985, p. 36)

There existed, however, a few spaces in which women could congregate together outside the boundaries of the court, the manor and the household. For the daughters of the landed gentry and wealthy merchants, joining a religious order was the only means of access to a space not dominated by a father, husband or master craftsman (Boxer and Quataert, 1987). As for women from the lower echelons of society, the growing urban centers provided alternatives to normative social relations. For instance, it was possible in the 12th and 13th centuries to join the predominately male guilds and train as an apprentice, and in certain northern European cities, women were able to become master craftsmen and operate their own workshops. According to Merry Wiesner (1987), the local markets of many English and northern European cities were also spaces in which women, the predominant buyers and sellers of produce, fish, meat, dairy, bread and household items, could gather, exchange information and discuss current events. In addition to small shops, inns and taverns, women also ran smaller hospitals and pest-houses with the assistance of other women hired to do the cooking, nursing and laundry.

By the late middle ages, these potentially heterotopic sites were increasingly subject to regulation. A series of laws were passed, in both England and on the continent, against vagrancy in an attempt to restrict the movements of those persons considered "masterless." By the 16th century, Wiesner notes, the guilds began to place strict limitations on women's participation in any capacity, even as widows of master craftsmen. In addition, domestic servants were forbidden to leave one household for another more than once a year or stay in public inns between positions, places where they could come in contact with the women who ran those inns or other women like themselves looking for a better life. A number of German cities tried to exclude unmarried women from selling in the markets. Yet such laws, argues Wiesner, were not particularly effective. The demand for cloth required the larger households and workshops in the cloth centers of Augsburg, Ulm or Strasbourg to hire young women as day laborers to card and spin wool for the male weavers. Thus, it became possible for single women to eke out a living despite the poor wages, and in the process, "to congregate with others of their own age, to discuss religion and politics, to compare employers and experiences" (p. 68).

The women who had joined religious orders faced similar attempts to bring them into the patriarchal fold. Olwen Hufton and Frank Tallett (1987) highlight "a long tradition of hostility toward the uncontrolled presence of large numbers of women...circulating freely in the community, immune from control" (p. 78). The result was to impose enclosure and a code of discipline on orders such as the

Ursulines. Finally, no discussion on the regulation of the "deviant" would be complete without mention of the witch hunts of the mid-to-late Middle Ages. Four-fifths of those accused and found guilty of witchcraft were women and of those, the majority were older, single or widowed. The prevailing attitude is summed up by Philip Corrigan and Derek Sayer (1985): "Daughters of Eve were dangerous; women not under patriarchal authority were particularly dangerous" (p. 65).

With the end of feudalism and the rise of the nation-state and a national economy, "the status of the private man combined the role of owner of commodities with that of head of the family, that of property owner with that of 'human being' per se" (Habermas, 1989 p. 28). The public of the ancient Greeks also reemerged at the beginning of the 18th century. To have a public existence, in part, was to frequent the coffee houses that were rapidly becoming fixtures of the larger urban centers. According to Habermas, there were 3,000 in London alone by 1710. There, literature and art as well as political and economic affairs, were discussed by an expanding bourgeoisie that included landowners and merchants, doctors and lawyers as well as more successful craftsmen and shopkeepers. These emergent "public" spaces were of course off-limits to women. Indeed, Habermas points out that "the women of London society, abandoned every evening, waged a vigorous but vain struggle against [this] new institution" (p. 33).

European salons, on the other hand, not only included but were run by women. Originally, they were an extension of court life where the aristocracy, old and new, mingled with the intellectuals, but by the eve of the French Revolution, they had been adopted by the bourgeoisie. However, women were likely valued most for their role as hostesses. That they were in a public sphere contained within the private home would certainly have given them more legitimacy than any coffee house could afford.

If an upper-class or middle-class woman could not be said to have a public existence, neither could she be said to have a private one in the way that a man did. As Habermas points out, "the independence of the property owner in the market and in his own business was complemented by the dependence of the wife and children on the male head of the family (p. 47). Moreover, little of the domestic space could be considered the domain of women. In her study of 19th-century house design, Daphne Spain (1992) notes that only three rooms were identified as being for women—the drawing room, the breakfast or morning room and the boudoir off the bedroom—of which only the latter was exclusively for the lady of the house. In contrast, six rooms were designated for men's use, including "the

library, billiard room, gentleman's room (for business transactions), study, smoking room, and gentleman's odd room (where young gentlemen could 'do as they like')" (p. 114). With some of these having adjoining bathrooms and cloakrooms, they formed an isolated male "sanctum." It is small wonder then, that bourgeois women would literally long for "a room of one's own," as Virginia Woolf (1977) titled her famous essay.

The process of suburbanization that began in the industrialized cities of mid-19th-century England also served to reinforce the home as domestic sphere with which women were identified. Janet Wolff (1990) describes the new suburban homes outside British industrial cities as being built on the same model of separate spheres. It goes without saying that the notion of privacy is also suffused with class. The emerging working class homes, like those of the tenant farmers and cottagers, offered little in the way of personal space for any family member. Even so, the male breadwinners had access to the informal social space of the pubs in which to spend their leisure time at the end of the working day.

Industrialization and the Power of Dirt

If an alignment of state and capital served to contain bourgeois women in the home, the alignment of capital and the technology that produced the Industrial Revolution blurred the public/private binary, enabling the formation of potentially heterotopic spaces for many working-class women. The new relations of production can be thought of as wielding the power of dirt, to borrow a phrase from John Hartley (1992b), in that they had the power to disrupt normative social and spatial relations. Manufacturers came to hire women and children to be in charge of the spinning jenny and the power loom in the cotton mills of England and the United States. There is no doubt that the conditions of employment were appalling: long hours for low wages in poor lighting and ventilation performing tasks with machinery that was often dangerous. But for the first time in Western history, significant numbers of single women were able to support themselves, and married women were able to help support their families. According to Friedrich Engels, one of the evils of the capitalist mode of production was its power to destroy the traditional family order based on patriarchal authority:

> The wife supports the family, the husband sits at home, tends the children, sweeps the room and cooks. This case happens very frequently: in Manchester alone, many hundred such men could be cited, condemned to domestic occupations. It is easy to imagine the wrath

aroused among the working-men by this reversal of all relations within the family. (Quoted in Massey, 1994, p. 196)

Engels was correct about the first part of the equation but wrong about the second. Men did not take over the domestic responsibilities; rather, other women were hired to do so.

Moreover, in working collectively in the space of the factory, women were able to form their own communities. In Lowell, Massachusetts, for example, the female workers had access to a circulating library as well as informal education. Spain discusses the formation of "Improvement Circles" in which they "talked about current events and shared their original essays and poetry" (p. 185). The Lancashire "mill-girls" formed their own trade unions, as they were barred from joining the existing ones, "and it was from this base of organized working women that arose the local suffrage campaign of the early twentieth century" (Massey, 1994, p. 197).

In light of the above, it is not surprising that what Massey calls a "coincidence of interests" undertook to regulate and ultimately eliminate the presence of women in the factory. In Lowell in 1828, 98 percent of textile workers in Massachusetts were female; by 1848, female employment had declined to 69 percent, and by the end of the century, it was 41 percent. The boarding house system of Lowell and other centers "lasted less than three decades in an entire century of production," replaced by a "family" wage paid to a male breadwinner (Spain, pp. 186–7). It is important to stress that it was not the fact that women worked that upset the social order but *the fact that they worked collectively and had access to other non-domestic spaces*. As Massey observes, nobody objected to women turning out piecework from within the confines of the home, often under conditions no better than those found in what William Blake called the "dark satanic mills."

The Pink Collar Ghetto

If industrial technologies temporarily disrupted normative spatial practice,[2] the typewriter and the telephone were to permanently redraw the public/private binary and enable another set of potentially heterotopic sites to open up. Until the 1870s, the office was the domain of male clerks. With the completion of the continental railroad in the United States in 1869, the demand for business correspondence, record keeping and general office work exploded (Baker, 1964). With large numbers of men enlisting to fight in the American Civil War, the federal government began to employ women to fill the vacancies. In the 1840s and '50s, women copied

business correspondence but on a piecemeal basis at home. According to Carole Srole (1987), the first government office to hire women to perform their duties in the workplace was the Treasury. This change in policy occurred solely because it was felt that money could not be counted in an unsupervised environment. In this particular context at least, the need for surveillance overrode the need to police the public/private binary. In 1870, 16 percent of all US government clerks were female; thirty years later, this percentage had doubled. In private industry, the number of women in the office went from 2 percent to 30 percent in the same time span (Spain, 1992). Why then was the disruption of normative spatial practices accepted in the office? One argument made is that women could be paid almost half the wage of a male clerk, a practice justified on the basis that typing was mechanical and did not require the same level of education or skill as clerking. While this was an important factor, it was not the whole story, for female factory workers were paid less than organized male workers. Srole suggests a more fundamental reason:

> Some [men] employed them because they sought to acquire the personal attention that women appeared to offer. Women were expected to bring flowers, cheerfulness, and beauty to the office...Others employed stenographers and typists as symbols of authority. Hiring a stenographer meant that the employer was truly a boss, one who "dictated" and told others what to do...A female in the office was always the inferior; the male, the superior...And finally, male employers found women appealing because they were not potential competitors. (p. 92)

Similarly, the advantages to hiring women as secretaries, according to Perrin's Monthly Stenographer, were that they were "more contented with their lot as private secretaries, more cheerful, less restless, more to be depended [upon], more flexible than young men. [She is] more willing to do as asked, more teachable" (quoted in Srole, p. 95). In other words, domestic relations of power could be reproduced in the space of the office. It is no coincidence that the function of the secretary has always been twofold: to assist her employer in the realm of private enterprise and in the realm of the private familial sphere, when she undertakes some of the "wifely" duties such as bringing him coffee, arranging personal appointments and buying gifts on his behalf for family members. Moreover, the majority of women filling these "pink collar" jobs were young and single, and thus were expected to return permanently to the domestic sphere when they married. The supposed temporary nature of their employment thus appeased concerns and, not surprisingly, justified low wages.

As in the factory, women were able to interact with each other, providing an opportunity to form their own communities. This was especially true in areas in which large groups of women worked together in the secretarial and typing pools as well as in the telephone exchanges. At the turn of the 19th century, for example, the operators in a number of American cities formed reading and gardening clubs (Baker, 1964). A hundred years later, the office retains its informal designation as "pink collar ghetto," as indicated by current statistics that show that the majority of Western middle-class women make their living performing clerical work (Probert & Wilson, 1993). Yet, the office remains potentially heterotopic. The demand for pay equity in Canada, for example, has come out of organized office spaces of the federal government and the telecommunications giant, Bell Canada. Juliet Webster (1993) conducted a study with a group of typists working in a large British office who decided to play to their male employers' assumptions of their lack of skills, by typing up exactly what had been dictated—asides, hesitations and revisions: "So, some of them came back and were furious about this and said 'This is absolute rubbish'. We said, 'Well, that is what you dictated, so we typed it'. They wouldn't admit that they had done it" (p. 52).

Meanwhile Back at the Ranch

Despite the number of women who did work outside the home and had the opportunity to form their own communities in/through the workplace, even larger numbers of middle-class North American and European women remained entrenched in the domestic sphere until the 1970s. Daphne Spain notes that between 1890 and the First World War, the bungalow became the ideal American family home, "in which a pleasant living room with a cozy fireplace, bookcases, and a cupboard or two would serve the combined functions of library, parlor, and sitting room" (p. 127). At the end of the Second World War, the ranch house "carried the interior informality of the bungalow one step further. Most rooms in the ranch house could serve multiple purposes—a study-guest room, living-dining room, kitchen-laundry. This was also the era of the "family room," where children and teenagers could play and hang out (p. 128). While these changes to the floor plan may have reduced the gender segregation typically found in Victorian homes, these spaces were hardly gender neutral. The kitchen-laundry was still a place for wives and mothers to prepare meals for the rest of the family and wash their clothes. Similarly, the living room-dining room was primarily a place for the male head of

the household to be served in and then afterwards to relax in his La-Z-boy with his newspaper while his wife washed the dishes.

Given the dirty power of technology, the potential existed for women to invert/subvert/resist their isolation in the suburbs. Although Jane Jacobs (1961) does not interpret the design of city space from a feminist perspective, her comments on (sub)urban planning are interesting and revealing:

> Most city architectural designers and planners are men. Curiously, they design and plan to exclude men as part of normal, daytime life wherever people live. In planning residential life, they aim at filling the presumed daily needs of impossibly vacuous housewives and preschool tots. They plan, in short, strictly for matriarchal societies. The ideal of a matriarchy inevitably accompanies all planning in which residences are isolated from other parts of life. It accompanies all planning for children in which their incidental play is set apart from its own preserves. (p. 84)

What Jacobs interprets as the "curious" exclusion of men in a "matriarchal society," I interpret as the deliberate containment of women in the devalued domestic sphere. Nonetheless, in pointing out this segregation, she is alluding to the design and use of spaces such as shopping centers, supermarkets, parks, playgrounds and even the houses themselves. These spaces afforded women the opportunity to fulfill their roles as housewives and mothers, but also to potentially form their own communities in these spaces.

One key domestic technology that actively enabled the maintenance and extension of these social relations forged in the heterotopic spaces of the suburbs was the telephone. According to Valerie Frissen (1995), it was intended to be used by men for business matters and by women to order services related to the upkeep of the home as well as to arrange social engagements for the family. What in fact happened was that women began using the telephone for their own social purposes, often having lengthy conversations with friends and relatives. In a study of a group of women in a small midwestern American town, Lana Rakow (1992) concluded that the telephone was integral to maintaining a sense of local community as the demands of the women's lives were such that their opportunities for getting together in a physical location were restricted. If men could not stop women from subverting the intended use of "their" technology, they could certainly denigrate it, dismissing it as frivolous "gossip." According to Carolyn Marvin (1988) endless jokes and anecdotes in the journals of "electrical experts" positioned women as "parasitic consumers of men's labor" (p. 24). With the development of fiber optic

and cellular technologies in the past ten years, telephone talk has become a legitimate, not to mention very profitable, activity. Advertisements for these services, though, almost always depict women making and receiving the calls. One cell phone company ran bus shelter ads in Toronto trumpeting, "Attention teenaged girls! Free evening and weekend calling!"

Women Get Wired: The Case of the DDEBs

Like the technologies described above, ICTs possess the power of dirt, enabling the formation of heterotopic cyberspaces and online women-only communities. Given women's historical connections with the typewriter/computer in the office and the telephone in the home, male-dominated cyberspace was ripe for reordering. As mentioned in the Introduction, interaction on the DDEBs was described as "shooting the breeze in someone's kitchen." This virtual kaffeeklatsch was for the most part produced from the space of the office, where all but four participants worked. Of this group, four identified themselves as professionals working in their field: two in computer science, one in astronomy and one in information science. Two others held liberal arts degrees but worked as professionals in computer support and in fundraising for a large institution respectively. Of the remaining ten, all worked in various administrative support positions ranging from temp to executive secretary. Only two had not completed at least one university degree. Even Daphne, who liked her job because she had a fair amount of independence and responsibility, was keenly aware of how undervalued office work was:

```
I'm a secretary. I'm a good one, and I care about my
students and try to give them the best service possible.
Yet, secretarial work is looked down on, jokes are made
about "government employees" etc.
```

One reason that the office was the preferred point of entry into the virtual kitchen was the easy access to email:

```
I blip on to check my e-mail frequently throughout the
day while I'm waiting for queries to run at work. Then I
also usually log on in the evening to check my mail
again. (Hollis)

Actually, my job is pretty great, b/c my boss is absent.
She's a faculty member who has an office on another
floor, and I see her prolly [probably] once a week, and
```

```
that just to pass paperwork back and forth. So, as long
as I run the office in a decent way, the students get
the attention they need, and I get my work done, nobody
seems to care how much I'm on my computer for personal
stuff. (Daphne)
```

```
First thing in the morning when I get to work, then I
check mail periodically throughout the day. I'f [sic]
I'm overloaded with work, I'll log on from home around
8:00 at night to read my mail.(Geneva)
```

```
Gawddess, this is embarrassing. I leave my work computer
on-line all day and check it periodically. I don't know
if that counts as being on hours a day. *Actual* time
spent on-line is much lower, probably an hour to two
hours, counting time in the evenings when I log-on from
home. (Drucilla)
```

The DDEBs also inverted/subverted normative social and spatial relations because members indulged in an activity that Michel De Certeau (1984) calls *la perruque* (literally translated as "making the wig"). This activity involves the use of work time to produce "work" of one's own: "the worker who indulges in la perruque actually diverts time…from the factory [or office] for work that is free, creative, and precisely not directed toward profit" (p. 25). Interacting with her DDEB "sisters" was for Daphne a deserved break for her efficiency. For others like Hollis, who had what she described as "the job from hell," it was a necessity:

```
My job is high-stress and I depend on the DDEB lists as
my lifeline to sanity. The worse the job gets, the more
I feel a need to be on the 'net, and the less time I
have that I can afford to be there.
```

The above comments point to the function of the DDEBs as heterotopic sites of resistance to both denigration and isolation in the realm of work. Similarly, almost all posting on the DDEBRP was done on work time, sometimes to air work-related complaints and receive support and advice from the other members.

The Limits of the Heterotopic

Using the office as a point of entry into DDEB (and DDEBRP) cyberspace, however, was not just contingent upon internet access at work, but *restrictions* to it in domestic space. By restrictions, I am not referring to a lack of access—all the

DDEBRP members had service at home. However, only the six who were single and lived alone claimed to have no constraints that limited the amount of time that they could spend online at home. This was also the case for the three who lived at home with their parents and had their own computers in their bedrooms. In Moll's house, where there was only one computer, she found it "impossible to get my boyfriend or my brother off it." In contrast to the single women, none of the married or divorced women with children had sole access to a computer even though two stated that the computer was in their office. The others named shared locations such as the bedroom, study, and in Mrs. Hale's home "in the corner of the dining area." That said, several participants indicated that they were the primary users:

> All members of the family use it. After me, the most frequent user is my 4 year old daughter, who plays CD games on it…After that comes my 7 year old, who is well into writing her first novel…then comes my husband, who uses it almost exclusively for games…finally, my mom uses it for letters and mailing lists for her flower clubs. **(Mrs. Hale)**

> My husband uses it fairly often, when he can pry me off it ;) I'm the one who actually goes out and spends my money on the computer equipment, so I get first dibs. **(Hollis)**

> My children use the word processor. My husband is computer illiterate. **(Dani)**

In terms of constraints, several members mentioned family responsibilities:

> I have things to do with/for my family and non-virtual friends. I also write, so a lot of my free time is taken up doing that. I used to spend much more time on the net, but it was interfering with my life so I cut back some. **(Drucilla)**

> My daughter and my job must come before my net activities. That doesn't mean that there aren't times when I log on while she's awake or that I don't read mail while I'm sitting on hold waiting to talk with Microsoft support or something. **(Liz)**

Although I do not have children, I almost never checked or sent email in the evening either, generally setting aside that time to prepare meals and spend time with my partner, who worked during the day. The only participant in this category who did not feel her home access was restricted was Mrs. Hale, but it is clear from her comments that she had conflicting feelings:

```
It should be, but it isn't. :) I admit I neglect some of
my work responsibilities, and sometimes my home
responsibilities as well. I rationalize the latter by
reminding myself I am actually earning money by working
on the Net.
```

In a similar vein, the unmarried women in relationships cited these as priorities over being online with friends. Geneva, for example, noted "I'm generally too busy with my fiancé and my pets to read mail on the weekend." Moll joked that her online time outside of work was limited "by the fact that the modem lines are always busy when I try to dial in from home. And my boyfriend keeps insisting on taking me out." Of course, not all time spent offline can be interpreted as time that one would prefer to spend online if given the opportunity, but one cannot dismiss the historical construction of the domestic sphere as one of work for women and one of leisure for men. In this context, the DDEB spaces were unable to permeate its boundaries, their heterotopic potential neutralized. Compare these experiences to that of self-proclaimed cybernaut, Howard Rheingold: "'Daddy is saying 'Holy moly!' to his computer again!' Those words have become a family code for the way my virtual community has infiltrated our real world. My seven-year-old daughter knows that her father congregates with a family of invisible friends who seem to gather in his computer" (1993b, p. 1). Indeed, if we visualize the setting—the writer at his computer screen, his back to his daughter who seems to be calling out to another unidentified family member (the child's mother?) who is not even in the picture at all—it would seem that relationships with virtual friends take precedence over family.

Fortress DDEB

The final point I wish to make about the DDEBs as heterotopia concerns the consequences of self-imposed boundaries.

Heterotopia always presuppose a system of opening and closing that both isolates them and makes them penetrable. In general, the heterotopic site is not freely accessible like a public space. Either the entry is compulsory…or the individual has to submit to rites and purifications. To get in one must have a certain permission and make certain gestures. (Foucault, 1986, p. 26)

Entrance to the DDEBs, as mentioned in the Introduction, was originally open to all interested female *X-Files* fans. All three were set up as private lists and as such, listserv software served to easily and effectively monitor and regulate entry. Messages to the list by nonmembers were automatically referred to the list "owner." As the number of requests grew, a decision was made to close each list in turn to new membership. According to the original DDEB FAQ

```
The list was threatened by extinction if we didn't keep
the volume of mail down. We were able to find a new
mailing listserver with no such restrictions, but we
kept the list closed as each member figured that 100 to
200 messages was about all they could handle from one
list.:-)
```

Beyond technical and personal limitations is the desirability of a smaller space:

```
From: Liz
[Closed lists] tend to be relatively small, about 30-50
members. In general, after the first flurry of
discussion about whatever topic brought them together,
threads drift and the group becomes less a discussion
group on a certain topic and more like a group of
friends sitting around someone's kitchen shooting the
breeze about whatever comes to mind. Members talk about
their lives and their problems and, in sucessful [sic]
groups, a valuable support network begins to develop.
```

Thus it seems that a list can only function as a community based on values of intimacy and support when it places boundaries around itself and restricts its spread. So while unwanted male participants were not permitted to enter DDEB spaces, also excluded were other women who may not have been in the right "public" space at the right time when the formation of the lists was announced. Excluding others who might also have experienced marginalization and exclusion on the open, mixed forums was clearly problematic for some DDEBRP members:

From: Mrs. Hale
Judging from my mail, there are a LOT of DD fans out
there trying to join fan clubs, probably for the same
reason I did (to talk to other women without male
harrassment [sic]). There are no open groups, and some
of them sound pretty desperate. I wish someone WOULD
start up a new group. I sympathize with these ladies
deeply.

Other DDEBRP participants expressed a desire to help those excluded to form
their own groups. Bel suggested that she would consider starting up a group, though
assuring the other DDEBRP members that "it would NOT be a DD-named group,
although I'd let people talk about DD if they really wanted to :-)." Others offered
similar suggestions:

From: Liz
You know, it might not be a bad idea to come up with a
little one or two screen FAQ that pretty much tells
people *how* to go about setting up their own lists. Not
the nitty gritty details (go ask your ISP would satisfy
that bit) but just the "Well, you decide if you want to
run a list, you either think up your own unique name or
let your members decide on one after you put it
together, you announce it in the appropriate places and
start talking. Maybe add some insights on the kinds of
things to avoid or to be prepared for or something.
Mainly just a slap in the head for the clueless (or the
honestly ignorant).

From: Megan
If you get something up, let me know and I'll add it to
the DDEBX site and pass it on to the DDEBY. If I come
across a good reference page about setting up mailing
lists, I'll let you know.

Policing these boundaries turned out to be an act that came with a price to the
DDEBRP community. Indeed, it was this thread that triggered Erin's departure
from the research list (discussed in Chapter 4):

From: Sonya
The AOL DD forums may have changed since two years ago
(when I did some lurking and they were *really* bitter
about the DDEB, but on the other hand, I think on some
levels, no matter how polite or non-elitist we are, some
people might be po'd [pissed off] anyway.

From: Erin
People will think what they want no matter how we go
about doing things. As long as we are polite, not
condescending and friendly, we've done all we can do
about it. I do think it also helps to encourage people
to form their own groups…but I may be wrong as that
might emphasize the idea that "you can't join us."
Ideas?

While Erin wanted to find ways to avoid conflict and appease those who were upset with the DDEB members for not letting them join, Sonya felt that such efforts would not make any difference. Most of the participants in this thread ended up agreeing with Sonya, Mrs. Hale adding, "practically ANYTHING you say that isn't 'yes, we'd be delighted to have you join' will be put down as evidence that we are snobbish jerks, anyway."

On the other hand, members were not sympathetic to those who refused to respect their boundaries and threatened to appropriate the name to create their own DDEB space. Listserv technology may have made the three DDEB spaces impermeable but it also facilitated their (albeit unauthorized) reproduction:

From: Mrs. Hale
Much as I despise AOL, I will go surf the folders there
this weekend and see what's brewing. If the group is
seriously concerned about this, we can send a message to
Deb Brown (Mrs. Spooky)…If R. or someone of equal
authority can tell her we are trademarked, registered,
locked and loaded, she might back down on this. Since
it's her job to monitor the playpen, if she says no AOL
DDEB, there won't be one. At least not publicly. Of
course we cannot help what people do on private mailing
lists. [ellipsis mine]

Discourses of ownership drawn on by Mrs. Hale functioned to position the DDEBs not simply as the intimate private spaces of women but as *private property*. Her references to being "locked and loaded" echoed the amendment of the American constitution that gives its citizens the right to bear and use arms to defend their property. Possession is also implied by use of the terms "trademarked" and "registered." The DDEBs were also imagined as a form of *intellectual property* whose protection depended on copyright and/or patent legislation. As such, the alternative ordering based on feminine values of intimacy and inclusiveness has itself been disrupted by a normative ordering based on relations of capital.

Standing on Guard for Canada in Cyberspace[3]

As every first year Mass Communications student knows (or should know), American media culture dominates world markets. In the 1980s, the United States accounted for 75 percent of all exports of television programming yet only imported 2 percent, the lowest of any country (Martin, 1997). US borders in the context of media flow thus function like "open door" exits deployed on some subway systems: they expedite the passage of large numbers of people out of the system but slam shut and sound a loud alarm if anyone tries to enter—only the very fleet of foot stand a chance of slipping through. Chris Barker (1999) adds that 80 percent of the American exports go to seven countries: Australia, Canada, France, Germany, Italy, Japan and the United Kingdom. Of those, Canada is by far the largest importer and consumer. Citing a report made to the Canadian Radio-television and Telecommunications Commission (CRTC), Jeffery Simpson (2003) claims that while American programming comprises 43 percent of the total broadcast in Britain and 56 percent in France, it is almost 75 percent in Canada. Another CRTC (2003) report, using Bureau of Broadcast Measurement (BBM) statistics, states

> Viewing to foreign television drama, virtually all from the U.S., outstrips viewing to English-language Canadian drama by a factor of 9 to 1. In 2002, 89% of all viewing to drama on English-language television, which includes conventional as well as specialty and pay services, was to foreign programming. [4]

The main reason for this situation is that the large American networks (ABC, NBC, CBS, Fox) are permitted to broadcast directly into Canadian homes from their border affiliates.[5] Moreover, the CRTC permits what is called "signal substitution." An example would be the Fox feed of *The X-Files* being replaced with the one from Canwest Global being broadcast simultaneously (*"The X-Files*, Global's got it" was the slogan used to promote the series). The result is that Canadian stations have the entire local audience tuned to their commercials, giving them little incentive to produce expensive and far less popular (and therefore less profitable) Canadian dramas. (Austen, 1996).

All Canadian broadcasters nonetheless are mandated by the CRTC to provide some Canadian content. From the 1960s to the mid 1990s, the state-owned and funded Canadian Broadcasting Corporation (CBC) produced the bulk of Canadian drama: *The Beachcombers*, *Anne of Green Gables* and its numerous spin-offs, *North of 60* and *Street Legal* were the most well known and long lasting. Although the CBC

has chosen to no longer air American drama, years of government cutbacks to its budget have reduced its current production of one-hour dramas to two: *DaVinci's Inquest* and the 2004 courtroom drama, *This is Wonderland*. As for private broadcasters such as CTV and Canwest Global, to name the biggest multi-station owners, the CRTC stipulates that they must provide 60 percent Canadian programming measured between 6 am and midnight and 50 percent from 6 pm to midnight. In addition, they are required to provide a minimum of eight hours per week of "priority Canadian programs" between 7 pm and 11 pm. However, these regulations have always been met with resistance. Simpson puts it bluntly: "Audiences lap up U.S. imports. And that suits the private broadcasters just fine. They skate at the margins of their existing CRTC obligations, Canwest Global being the most inventive skater." Morever the CRTC has been criticized for further reducing these obligations in 1999, "eliminating minimum expenditure requirements and specific quotas for drama" (Atherton, 2003). This policy enables cheaper programming such as reality shows and lighter information/entertainment fare to receive the same "credits" toward the eight-hour priority programming. Coupled with federal government cuts to the Canadian Television Fund, the number of Canadian one-hour dramas has been reduced from twelve in 1999 to *five* by the 2002–2003 season (Atherton, 2003). Antonia Zerbisias (2003) points out that with less demand, independent producers such as Alliance Atlantis Communications have cut their dramatic programming hours from 326 in 1999 to 78 in 2003, 43 of which were dedicated to CSI, produced for CBS. What's more, ratings for the remaining dramas are lower than average (650,000 viewers), whereas ratings for American dramas remain at more than two-thirds of that figure. To compare, the Canadian edition of "Who Wants to be a Millionaire," aired in September 2000, captured 4.17 million viewers (Brioux, 2002.)

 This unilateral media flow effectively enables the expansion and reproduction of American space beyond its borders. If the media, as Doug Kellner (1995) argues, has become "a primary vehicle for distribution and dissemination of culture" (p. 35), then fears of cultural imperialism or colonization in Canada and around the world are justifiable. Moreover, if we accept that nations are "imagined communities" and that no essential national identity exists, then the increasingly restricted opportunities for Canadians to see and hear their own narratives could lead to a diminished sense of "Canadian-ness." That said, it is important not to overestimate the role of Canadian drama series in the project of nation building and to authorize and fix the meanings of its texts. Anecdotally speaking, I've watched little Canadian

drama over the years and do not think my sense of national identity has been effected. Indeed, the much stronger sense of identity and patriotism found in America (and seen as problematic by many Canadians, including myself) can hardly be directly linked to highly rated dramas like *ER, Law and Order* and *The West Wing*! Chris Barker argues against the notion of a global monoculture (American culture) in favor of hybridization. Rather than seeing local cultures and meanings erased or overwritten by the "consumption" of imported programming, it is better to see them as overlaid, allowing for disjuncture, not just similarity. Recalling Chapter 1, the ways in which television texts get interpreted in different contexts cannot be predicted.

Due South and Back

Barker also makes a case for *reverse flow*, although "trickle" might be a more apt term. While he is referring to one from east to west, I will concentrate on *Due South*'s disruption of normative spatial relations, even if only for a brief time and on a very small scale. A co-production of Alliance Atlantis Communications and CBS, the two-hour pilot aired on CTV and CBS in April 1994. In Canada, the series was an immediate success, and during its four-season run, regularly garnered over one million and a half viewers, ratings that the CRTC deems "a major hit." In the US, it had solid ratings in the first season: The Nielsen ratings for the week of September 26 to October 2 1994, for example, placed it at 27 (*The X-Files*, in its second season, was 65th). Nonetheless, it was not renewed by CBS, apparently because of the departure of a top executive who had supported it. As the network's fall 1995 lineup faltered and fans flooded its offices with mail and email to protest the cancellation, CBS first picked up the eight episodes produced for CTV and in January, ordered thirteen more to complete the season. As a result of supposedly low ratings, CBS declined to renew the show a second and final time. The series remained in limbo for months as Alliance looked for and finally secured funding from the BBC and a German production house, Pro Sieben Media AG. Twenty-six more episodes were made. CTV showed them as two seasons from September 1997 to March 1999. In the US, they were picked up for distribution by Polygram and shown in syndication as a single full season from September 1997 to May 1998—a small irony that the withdrawal of American funding resulted in American viewers seeing 13 episodes half a year ahead of Canadians. *Due South* lives on in syndication

on both sides of the border. The specialty channel BBC Canada shows it as I write in March 2004.

The series is set in Chicago, although, with the exception of a few location shots, the cityscapes are invariably Toronto in disguise. Some scenes from "Hunting Season" (CTV, 11 March 1999) were filmed across the street from my house in a building that once housed a branch of the Canadian Imperial Bank of Commerce, the sign over the portal reading "Chicago Commerce Bank." On its own, this reconfiguration of space is highly normative—Canadian locations are presented as American in countless Hollywood productions, including *The X-Files*. Moreover, Benton Fraser appears to be a Mountie cliche in the American tradition of Dudley Do-Right (Jay Ward's cartoon) and Sergeant Bruce (Nelson Eddy in *Rose-Marie*[6]). He is regularly seen on duty in the full dress uniform of red serge or at the very least with his wide-brimmed RCMP-issue hat on head or in hand. "Thank you kindly" is his motto, a phrase he offers up several times an episode, even to the Chicago officer who issues him a parking ticket in "Witness" (CTV, 14 December 1995). In the same episode, he is seen unable to steal a pack of Milk Duds as part of an undercover operation and when imprisoned shows the incredulous tough-looking inmates in the cell block how to make a bed properly and offers up reading choices such as Marcel Proust as the book monitor. While a "do-gooder" and a "goody goody," Fraser is also well read, well spoken, loyal, and not as naive as he appears to be. Unlike his partners (Ray Vecchio and Ray Kowalski), he never uses a gun, despite being an expert marksman, and often uses his skills of tracking, smelling and tasting, learned at a young age, to solve crimes and otherwise save the day. Finally, Canada as the "great white north" is played up in the series. In the first season, the opening and closing credits begin with a panoramic shot of snow-capped mountains which then zooms in on Fraser and his wolf, Diefenbaker (named after a Canadian Prime Minister) trekking through deep snow. There are numerous references to Fraser growing up in the northern wilderness, his father an RCMP officer stationed in the Northwest Territories.

The heroic, stoic Mountie and Canada as a vast, northern wilderness are not mere Hollywood creations but myths of identity and nationhood that Canadians draw on to make sense of our own history. I use the term "myth" in Roland Barthes' sense, not to suggest that they are false as much as they function, like discourse, to naturalize history (Fiske, 1990). According to novelist and poet Margaret Atwood (1972), who has studied the themes of identity in early Canadian literature, it is survival in a hostile landscape that makes Canadians out of the British

settlers.[7] They are ultimately portrayed as victims, both helped and hindered by aboriginal peoples who have no identity in their own right. The myth of survival is closely associated with the "benevolent Mountie myth," which according to Eva Mackey (2002) represents a Canadian "heritage of tolerance" (p. 2), specifically in regard to the treatment of native peoples in the 19th century. A 1912 chronicle of the Northwest Mounted Police, the predecessors of the RCMP, claimed that they had brought about "civilization" without bloodshed to the 30,000 aboriginal peoples and whites already in the region. The fairness and impartiality of the force supposedly created trust and gratitude among the aboriginals. While it is true that they did not slaughter Indians to clear the way for expansion and settlement, they had no need to—disease, famine and the "uncivilized" whites had sufficiently "pacified" the population. The mythic bond between Mountie and Native is drawn upon in the series. According to the "Fraser FAQ" compiled by MRKS members and distributed to new members, Fraser was conceived in an Igloo, grew up with Native friends and guides, hunted caribou and learned native languages including Inuktitut. In "The Mask" (CTV, 18 January 1996) his old friend Eric arrives in Chicago to help him recover two Native masks stolen from the Museum.

Ironically, it is the "mythic presence but real absence" (p. 86) of aboriginal peoples which provides legitimacy to white colonization and ownership of the land. "O Canada," begins the national anthem, "our home and native land," but it should more accurately be "our home *on* native land." Native art and artfacts (e.g., masks, totem poles, soapstone carvings) are routinely circulated as representing Canadian culture. In "Seeing is Believing" (CTV, 12 October 1997), a gift from Canada presented at a Chicago shopping mall is an Inuit sculpture. "The Mask" also deals with issues of cultural appropriation, but as a result, the bond between Mountie and Native is severed, Fraser seeking to return the masks to their "rightful" owners, the French and Canadian governments, and Eric to return them to his people whose ancestors created them. Eric succeeds but only because Fraser chooses to remain silent and not pursue him when he realizes his old friend has switched the masks in the tradition of the Native "trickster." The Trickster is ultimately dependent on the good will of the Mountie.

The function of the myths outlined above is to allow Canadians to feel distinct from and morally superior to Americans. This contrast can be traced back to the Constitution Act of 1867, when the Canadian Parliament was given the power of "peace, order and good government" by Great Britain, hardly the revolutionary "life, liberty and the pursuit of happiness" of the American Declaration of Independence.

In *Due South*, both Rays find Fraser naive and exasperating, but at the end of each episode, they come to see the superiority of his polite, honest and quirky Canadian ways. Furthermore, each partner in turn is given the opportunity to become Canadian. In the appropriately titled "North" (CTV, 9 November 1995), the second season premiere, Fraser and Vecchio are on vacation in the Northwest Territories to rebuild Fraser's father's cabin. The bush plane they charter turns out to be commandeered by a drug smuggler and the ensuing crash leaves Fraser blind and at one point unable to walk. The American urban cop is now in charge of their survival, threatened by both the wilderness and the drug smuggler. At first he is hopeless, but in the end, out of ammunition and desperate, he uses Fraser's Inuit weapon, essentially a sack of rocks, to cause an avalanche that buries the smuggler (who was firing on them at close range). Like a *coureur du bois*, Vecchio cuts down trees and lashes together a raft, which he then steers down river with the injured Fraser and the wolf aboard to safety. His earlier ineptitude and dislike of the wilderness have turned to competence and enthusiasm: like the early settlers, the landscape has transformed him into a Canadian, if only momentarily. The series finale, "Call of the Wild" (CTV, 14 March 1999), has Fraser and Ray following Muldoon, a notorious killer and arms dealer, to the Yukon. Forced to jump from a prop plane when discovered as stowaways by Muldoon's henchmen, they must survive in the wilderness. As with Ray Vecchio, RayK's experience of hardship "Canadianizes" him. The final scene shows Fraser and Ray on a dogsled with Diefenbaker in the lead heading due north "to find the hand of Franklin reaching for the Beaufort sea/Tracing one warm line through a land so wild and savage/And make a Northwest Passage to the sea."[8]

Due South offers American viewers the opportunity to take up a Canadian identity but without the unpleasantness of roughing it in the bush.[9] The appeal of such an identity is suggested in an interview with Paul Gross: "Americans are really worried and scared right now about crime—they think the US is falling apart" (Lock, 1996). Moreover, many Americans support gun control despite their constitutional "right" to bear arms, say "please" and "thank you," and do not agree that supporting invasions of foreign countries is an act of patriotism. The quaint, white, mythic Canada of *Due South*, quite understandably, presents a desirable alternative.

The Canadian Heterotopia

MRKS needs to be understood as heterotopic because it is produced both within American offices and homes and within the vast terrain of cyberspace organized around American media culture. Although I have no quantitative data to prove this point, my search of the alt.tv section of Usenet revealed very few non-American names (the few exceptions were Canadian (alt.tv.due-south) and British (alt.tv.absolutely-fabulous). More significantly, I surmise that the majority of the participants are American. Based on conversations with DDEBRP members, each DDEB had at most 4 Canadian members out of 50. The same was true of MRKS. Whether on a fan site or an academic list, I inevitably feel like a tourist in the US.[10] When I "meet" other Canadians, it is unusual enough to sometimes lead to an offlist exchange ("So, you live in Toronto too? Whereabouts?") I do not visit sites for the HBO series, *Six Feet Under*, for fear of having plotlines "spoiled" by American fans who are almost two seasons ahead.[11] On the generically titled WMST-L (Women's Studies list), the discussions on suffrage are always specific to the American context. As with whiteness and middle-class-ness, an American nationality is the unmarked norm. Of course, there are "national" cyberspaces organized around American programming—I came across a site for Dutch *X-Files* fans—but these are marked as such, often quite obviously by discussions in languages other than English. Through discussion of Canadian symbols, current events, and culture (books, television, film and music), the MRKS participants effectively produced a heterotopic Canadian space.

The Canadian Test. One means through which nations authorize citizenship to those born outside its borders is testing various aspects of history, geography, economy, government, emblems etc. National identity is thus assumed to be based in part on a collective knowledge. In this sample, the MRKS participants took a "Canadian-ness Test" discovered by Drucilla on the web.[12] Below a large Canadian flag "flying" in the virtual breeze are 18 multiple-choice questions about stereotypical Canadian politeness (apologizing "for things that are not your fault"), sporting and beverage preferences (American vs. Canadian beer, NFL vs. CFL[13]), pronunciation ("about" vs. "aboot"), word choices ("pop" vs. "soda"), and even perceptions of Canadians abroad ("If you were in a foreign country, would people dislike you if they saw your national flag sewn on your backpack?"). The final question even suggests that Canadians are more environmentally conscious than Americans (The environment

"should be taken advantage of commercially" vs. "It should be protected, and saved so its beauty can be always admired").

As with the last question, the correct answers are often obvious by their implied positive value. This was acknowledged by Drucilla, who exclaimed, "Hey, I can't even get above 61% Canadian unless I *lie* on the test. ;-D (But I can get up to 83% if I lie!)." The results were also questioned by Marguerita who announced a score of 94 percent even though she claimed to be half Canadian. Although the results were not taken seriously, the desirability of Canadian identity was illustrated by expressions of admiration for high scores and disappointment over low ones. Drucilla, for example, replied to Marguerita, "Wow, she said admiringly ;-D" and Leah, who also had a near perfect score, boasted, "94% baby." At the other end of the scale, Lisa confessed, "Heck, I can't even get the test to load, what kind of rejection is that?" Donna sympathized and emphasized, "Oh, no! And I thought 44% was bad. Good thing I like hockey and Canadian beer." Donna also teased Leah that she must have cheated, "Oh, come on. You can't make me believe you call a hat a toque." Leah's retort further confirmed her Canadian "heritage":

```
The "hat" that they showed was a toque. Because a hat is
a piece of headgear that has a full brim. And a cap has
either a bill or no brim. And a toque is what you wear
in the winter time, unless it's a stocking cap or a dead
animal. My father, who lived in BC for 17 years, is very
fussy about his sartorial semantics.
```

Penelope joined the thread, linking the test results to *Due South* with her addition to Leah's list of winter headgear: "Or what*ever* the hell that was Ray was wearing in CotW." According to Drucilla and Leah, it was long johns, a playful positioning within the series narrative of Ray's status as an outsider who has yet to master appropriate Canadian winter headgear.

The National Bird of Canada. Part of the mythic fabric of the modern nation state is its emblems and symbols. They are expected to be not only recognized but meaningful to the citizenry. A desire in taking up Canadian identity is signaled by familiarity with these emblems. In this first sample, Sylvia, in the process of writing a Fraser/RayK story, asked the list about the "tradition or legend or back story to the names of the $1 and $2 Canadian coins, which I know sound like, but are certainly not spelled, I'm sure, 'looney' and 'tooney'." Adhering to the politeness

behaviors discussed in the previous chapter, she emphasized that she did not expect others to give her the information but just to give her suggestions of how to find the information:

```
I think several people on this list are Canadian, so you
know more about resources, and legends, than I do. If
you guys can't help, that's no problem, I'll just ask
the question on Asylum. Buit [sic] don't worry, I won't
cross-post. Or at least I won't make it obvious that
I've already asked the question here. Thanks for the
help.
```

It was not a Canadian member but Drucilla who explained that the "$1 coin is called a loony (or looney) because it's got a loon (the bird) on it. A $2 coin is called a twoney because it's worth twice as much as a looney. ;-D" Without correcting her, Orion, a Canadian noted that "the loonie story really isn't that interesting a story so maybe it's perfect for Fraser. <g>" Sylvia thanked both and then asked why a loon would be on the coin, wondering if it was the country's national bird. A member not part of the MRKS project and not Canadian stated (incorrectly) that it was and provided details about the bird, including its Latin name, habitat and distinctive call.[14] Signaling an identification with Canada, she stated a preference for a bird over the dead politicians on American coins. Jeanne provided a gentle correction: "As an honorary Canadian (i.e. "raised in Minnesota"), I can only agree. But hey, K…we *do* have that bird/money thing going on here, too—or have you forgotten the eagle? <g>" If K. had effaced her American identity, Jeanne's performance can be described as hybrid. In her reply, Sylvia identified as American but expressed concern about displaying undesirable national characteristics, ones in direct opposition to those of the "modest" Canadian:

```
Yeah, animals are better than profiles of 200-year-dead
guys, I agree. I guess, being American, I get used to
thinking of the eagle as a really cool looking bird and
comparing other birds to it. So, I'm obviously more
egocentric about my nationality than I thought. <g>
Sylvia, (who really doesn't want to sound like an arro-
gant American, honest.)
```

National Costume of Canada. Let me begin by stating that there is no national costume of Canada. However, the way in which one was imagined by a Miss Universe beauty pageant contestant and the reaction to it by MRKS participants reveals the differing

ways in which Canadian identity is understood. As with the Canadian test, a link was sent to the list to the photo of Neelam Verma, Miss Canada 2002, wearing the "national costume" on the Miss Universe website. Neither Ms. Verma nor her costume design were legible in terms of Canadian mythology. First, she is a visible minority of South Asian origin. Second her costume is a flamboyant creation, consisting of a gold lamé bikini layered with bright orange tulle with yellow and green accents. The top has a back piece that rises six inches or so above her shoulders and she is wearing a tall headpiece adorned with the same fabrics. The general list reaction was incredulity, as indicated by the capitalized subject header "WHAT th'...??? (OT)." What is interesting is that participants not only saw it as ridiculous but *un-Canadian* on several counts:

From: Donna
Yeah, I see people from Canada wearing stuff like that
all the time, don't you ever go to the Mall Of America
and people-watch? And ain't that Hudson Bay in the
background??

From: Drucilla
Hmm...the costume designer seems to have gotten Canada
confused with one of those other places that starts with
a "C"...like Costa Rica.

From: Deirdre
WTF's she supposed to be? A Thanksgiving centerpiece???

From: Jeanne
>It's, like...a secret code, K. CA-rme-N mi-A-n-DA
Darn...where are the dumb-post beta readers when you need
them. That would be: CA-rme-N mir-A-n-DA, of course.

From: Vivian
Yeah, of course, K. Where were you when the memo went
out? I've ordered mine in an extra-large. Somehow I
don't think it'll look the same. Can't wait to see
Fraser in this.

Image 8 The National Costume of Canada
Credit: ©2002 Miss Universe L.P., LLLP

```
From: Penelope
Aha! After much thought, I have figured it out - this is
the costume of the traditional Autumnal Equinox Festi-
val, where the celebrants are first dipped in maple
syrup (Grade A, of course), and then rolled in a large
pile of maple leaves that have been ceremoniously, uh,
raked.
```

Donna's first comment implied that the Canadian costume would be something subtle that would not distinguish the wearer from an American. Of course Fraser's "costume" of red serge certainly marks him out, but in a way that is recognizably Canadian. In imagining Fraser in the outfit, Vivian also distinguished the legitimate RCMP dress uniform, which could also be read as camp and outlandish, from this illegitimate and illegible costume. Drucilla extended the drag scenario, joking that he would wear it in a dance competition with Ray. Vivian's reply described Ray's getup: "And Ray will be in a matching orange polyester leisure suit. With a lemon-yellow ruffled shirt. Open at the neck. With an Italian horn pendant nestled in his almost non-existent chest hair. And orange-tipped spikey hair." Her closing comment "'Scuse me. I think I'm gonna barf" affirms the illegitimacy of the scenario.

Donna's second comment reaffirmed Canada as the Great White North with her reference to the beach in the background of the photo as the shores of Hudson Bay. Furthermore, the colors of the costume were singled out by Deidre and Penelope as problematic. The national colors of Canada are red and white, but bright orange is prominent in South Asian culture. As *Due South* did not mobilize the myth of the multicultural mosaic, in which a national identity permits traces of the "other" to remain with hyphenation (Indo-Canadian in the case of Ms. Verma), these participants had only familiar symbols of autumn, maple syrup, and Thanksgiving, celebrated in both countries but at different times, to make sense of the dress. Indeed Ms. Verma's ethnicity combined with the style of the costume and the head piece in particular is misread as Latin American. Drucilla makes a reference to Costa Rica and Jeanne to the Brazilian-born entertainer who become a fixture of 1940s American popular culture with her exotic outfits and "fruit-laden" hats. Yet despite the mockery, Miss Canada's campy "un-Canadian" costume was seen as superior to the American contestant's by this member:

```
From: Libra
The national costume" of the American entrant is a
firefighter's outfit. I'm disgusted.

L. (guessing that she could only wear one plea for a
sympathy vote at a time and so went for the Bravest
instead of the Finest uniform)
```

Extra. Extra. Read All About It. In addition to discussion of national symbols and characteristics, some MRKS participants made an effort to keep up with current events in Canada. Jeanne, for example, mentioned subscribing to the e-newsletter produced by the Canadian Consulate in her home state—the kind of service aimed at ex-pats living abroad. Others, Drucilla in particular, sometimes forwarded newspaper articles from various online sources, including canoe.ca, canada.com and the sites of large newspapers like the *Toronto Star* or the *Globe and Mail*. Estraven, who had visited the northern territories, forwarded stories from the Northern News Services Limited (NNSL). While I have no data on the types and numbers of stories read and with what frequency, the stories forwarded and discussed on MRKS were generally those that extended the primary text by reproducing a quaint, white Canada. One example was an article entitled, "When Croquet Goes Bad Canadians Wield Mallets." Found on an American news site, it tells the story of a brawl that erupted between a croquet team and a softball team in a Calgary park. Several players were arrested and some taken to hospital to treat injuries sustained from blows from the wooden croquet mallets. The humor is of course based on the "violations" of the myth of polite peaceful Canadians, yet it is the choice of "weapon" that makes the perpetrators "quaintly" Canadian. Had the violence involved guns or even baseball bats, the story never would have been published. Drucilla also forwarded a story about the town of Banff, in the Canadian Rockies, authorizing an RCMP officer to "patrol" the streets in dress uniform five hours a day during the summer tourist season. Donna quipped, "Hey, I'd photograph the guy. I might even run down the street to do it.<g> Of course, I photograph *everything*." Drucilla replied, "I think it would help a lot if he was cute—do you suppose they'll have to submit a portfolio before volunteering? ;-D"

Serious stories were also relayed to the list, all having an intertextual relation to *Due South*.

From: Drucilla
```
You know, if they ever did decide to do a dS movie or
something of that ilk, not that they would, of course,
but if they did, something like this could provide a
backdrop. In fact, there even appears to be a little nod
to dS in the text of the article.
```

The article was about a post-September 11 security consideration to have NYPD detectives posted in Toronto. The *Due South* "nod" was a mention that the officers would *not* perform guard duty at the US Consulate, one of Fraser's duties at the Canadian Consulate in Chicago.

While MRKS participants did not challenge the unmarked whiteness of Canadian identity, they advocated for a queer- and gay-positive Canada. Drucilla forwarded a story from canoe.ca on the passage of a bill giving same-sex couples in Quebec the right to adopt children. Her subject header was "Yet another reason to move to Canada." When a similar law ran into trouble in the Yukon territorial legislature, Estraven forwarded the story from NNSL. Members reacted with outrage to comments by a dissenting member:

> "We are putting these children in a situation where they can be an orphan early," said North Slave MLA Leon Lafferty.[15] Lafferty said he had medical documentation that showed gay men typically have lifespans 20 years shorter than heterosexual men, and wanted to know if the government had any plans to protect adopted children from diseases like AIDS. Lafferty did not produce any documentation to support his assertions (*Full rights expected for same sex couples*, 2002).

From: Leah
```
I'm sorry, but file this under "shit I don't need
bringing me down." It's bad enough, okay? It's bad
enough. I don't need to get furious about yet another
way bigots are trying to keep people from living their
lives. "Won't someone think of the children?" Up yours,
you fucking homophobic prick.

::pantpant::

Okay. I'm done. I'm going to return to my hot lemonade
and think of Brett Hull 'til the urge to kill passes.
```

I also replied, describing a similar homophobic reaction to the decision of the Vancouver Anglican diocese to bless same-sex unions (not marriages). Estraven added that the article demonstrated that "there were goofballs even in Canada,"

as if she had higher expectations. Two days later, she forwarded the follow-up NNSL story that the amendment had passed. Several members expressed pleasure and relief. Given their investments in queer identity, it should come as little surprise that MRKS members wanted and indeed expected their Canada to be tolerant of and inclusive to gays, lesbians, bis and queers.

Seeking Canadian Culture, High and Low. Admittedly, the above articulations of Canadian identity in terms of symbols and news are few and far between, and on their own do not make a strong case for an understanding of MRKS as a heterotopic Canada. As I suggested in my introductory remarks on this community, however, threads on both "highbrow" and popular Canadian culture were more common than those on slash.

The imbrication of culture and identity is underpinned by the mission statement of the Federal Department of Canadian Heritage, which has direct responsibility for the CRTC, mentioned earlier in the chapter. Its "strategic objectives toward a more cohesive and creative Canada" are fourfold, three of which are directly applicable to policies grouped under its Arts and Culture section:

> Canadian Content: Promoting the creation, dissemination and preservation of diverse Canadian cultural works, stories and symbols reflective of our past and expressive of our values and aspirations.

> Cultural Participation and Engagement: Fostering access to and participation in Canada's cultural life.

> Connections: Fostering and strengthening connections among Canadians and deepening understanding across diverse communities. (Department of Canadian Heritage, 2002)

If Canadian identity is linked to cultural heritage, it is fair to say that significant numbers of Canadians are "failed" citizens, rarely taking or getting the opportunity to watch Canadian television, see Canadian films or art, attend Canadian theater, or read Canadian books. MRKS participants, on the other hand, demonstrated extensive knowledge of various forms of Canadian culture, and in the context of Heritage's goals, are model Canadians.

Not surprisingly, threads with direct intertextual links to *Due South* were the most numerous. Of these, the most prevalent were on the subject of films and television series starring or featuring Canadian-born and Canadian-based actor

Callum Keith Rennie.[16] One Canadian feature that came up on several occasions was *Flower and Garnet* (Behrman, 2002), in which Rennie plays a father of two children still coping with the death of his wife. In this first post, Alain (mistakenly) referred to it as a made-for-TV movie, having learned about it on an online segment of "Movie Television," a entertainment-cultural affairs program produced by the Toronto network Citytv:

> A nice short promo with [Canadian radio and television personality] Terry Mulligan interviewing our boy. Even on my horribly slow dialup connection, he looks and sounds delicious. Callum, that is. Not Terry. ;) I don't know when this film will be aired. Has anyone heard? This is one I'm really looking forward to.

No one was able to answer her for over a month until Drucilla forwarded the description from the Toronto International Film Festival (TIFF) website. The next day, Alain forwarded an excerpt on the film from an article on TIFF from canada.com. As the opening dates of both the Vancouver and Toronto film festivals approached, Canadian press coverage increased and Drucilla was able to forward three more links providing information on both *Flower and Garnet* and the festivals:

> As long as I'm on the topic of film festivals, I thought I'd pass along this link to the F&G page for TIFF…If you happen to be in Toronto two weeks from now you can catch it Sunday, September 08 at 07:00 PM (CUMBERLAND 2), or on Tuesday, September 10 03:00 PM (UPTOWN 2). [ellipsis mine]

A regular TIFF attendee in the past, I explained that none of them would be getting tickets to these screenings at this late date even if they decided to make the trip: "To get the shows one wants is akin to planning a military assault."

Indeed seeing this film or any of the actor's other Canadian features was difficult to impossible for MRKS participants. The distribution and run of *Flower and Garnet* was typical of a "highbrow" Canadian film. After making the rounds of the film festivals, it only played at "art house" movie complexes in major cities. In Toronto, it ran for two, perhaps three weeks in the spring of 2003. It has never been distributed in the US. Of the other films brought up on the list, only two, *Last Night* (McKellar, 1998) and *Hard Core Logo* (McDonald, 1996) had US releases. As a result, announcements of DVD release dates and/or sites from which to purchase DVDs

were common. Alain, for example, passed on information about the release of a DVD (Region 3) and VCD (Asia) of *Suspicious River* (Stopkewich, 2000), a film that had received a lot of "buzz" on the festival circuit because of the critical acclaim and reasonable box office of the director's first feature *Kissed.*

> If you want to try it, I found mine at http://us.
> yesasia. com (North American customers).They also have
> an international site. As I am apparently of a suspi-
> cious nature, and I have never heard of a VCD until now,
> I am paralyzed with indecision.<G> My DVD player will
> apparently play one, though. Does anyone have any info
> to add?

No one at that time in May 2002 had anything to add. In July, Drucilla announced, "SR is now out in Canada on DVD. I just got my copy in the mail today from AB Sound in Vancouver. I imagine HMV also has it. Haven't watched it yet, but I *have* it. :-)" A member not part of the project added a few more details. Given that I, a self-described Canadian film buff, had yet to see it while Drucilla already owned it on DVD, I jokingly nominated her for "honorary Canadian citizenship." I also commented on her choice to buy from the Vancouver-based A&B Sound: "they're independent *and* Canadian rather than just another multinational with a Canadian division."

A similar discussion ensued around *Torso: The Evelyn Dick Story* (Chapple, 2002), made for and shown on CTV. As a postscript to a reply on a thread on a photo of Paul Gross with British comedian/actor John Cleese, Jeanne noted that she had "just found a copy of Torso on the way home and is now going to watch it and…oh…was Callum in that?…really? What a pleasant surprise! <snerk>"

> **From: Drucilla**
> Wait-- you *found* one? Just lying in the gutter or
> what?

> **From: Jeanne**
> Okay, I admit that this was the kind of "finding" that
> involved turning left into the open door of an HMV on my
> way from the subway to the bus and kind of looking under
> "T" in the DVD section, but, um, I didn't really think
> they'd *have* a copy, so it was finding of a sort :)

Donna went online to get a copy as well only to find it not available on the HMV website.

From: **Drucilla**
SHe got hers at a US HMV. It's not for sale in Canada.
But I have a link to a place where you can get it:
http://www.uln.com/cgi-bin/vlink/619935405332IE.html And
I think Jeanne said Amazon has it--and you can go
through the MRKS link to donate money to website upkeep!

From: **Donna**
I found it! whee!

From: **Drucilla**
I enjoyed it -- it's not going to win awards but it was
an interesting story and I gotta say, CKR looks
fabulous in 1940's style clothing and wire-framed
glasses. :)

Lisa was not as lucky as Jeanne in her attempt to secure a copy of the film.

Warning. If you search for "Torso" on Amazon you
will get the list of four films with that word in it.
The first one is the CKR film "Torso, the Evelyn Dick
Story". Click on that link and indeed, the listing is
for CKR's movie. The "Shop" box on that page indicates
it's available in DVD. DON'T ORDER IT!

What you get is not CKR's film at all. What I got
shipped was the second film in the former list: the 1973
Italian film entitled "Corpri presentano tracce di
violenza carnal,I", which was titled "Torso" for the
subtitled US distribution back then. That film is a
bloody slasher film. At least from the reviews when you
click on its page. Luckily I could tell from the cover
of the box it wasn't the one I wanted and sent it back.

Lisa emailed MRKS two weeks later to say that the error had been corrected and that she had received the right DVD.

In addition to Canadian features, MRKS members also reported on sources and view dates for Rennie's appearances in Canadian television series (e.g., *Bliss*) as well as his supporting roles in American films and television (e.g., *Dead Zone*). The following sample illustrates another Canadian/American "reversal":

From: **Alain**
Callum is starring in a thriller entitled THE BUTTERFLY
EFFECT. It started filming in Vancouver, B. C., Canada,
on June 3, 2002 and is due to wrap on July 31, 2002. The

film also stars Ashton Kutcher, Amy Smart, Ethan Suplee,
William Lee Scott and Elden Henson...

A few weeks ago, Dan Savage ("Savage Love") remarked
that his sexual fantasies involve coming all over Ashton
Kutcher's face, so my mental image of A.K. is a bit
squicky. I think he's a teen idol of some sort. I have
absolutely no idea who anyone else is. [ellipsis mine]

For Alain and others, the star is Rennie—Kutcher is a "no name" teen idol only
recognizable as the sexual fantasy of the syndicated advice columnist. The irony
of this reversal has intensified with the release of the film in early 2004 accompanied
by a typical Hollywood marketing campaign. Even after seeing the trailer, I had no
idea Rennie was in the film until I reread Alain's post when writing this chapter.
The Internet Movie Database lists Rennie as 15th in the cast overview.[17]

The Canadian cultural landscape of MRKS extended to include Canadian actors
who had appeared with either Gross or Rennie in films or television series. I knew
that members were familiar with Don McKellar, the star of the CBC series, *Twitch
City*, in which Rennie had a reccurring role. When I saw the actor on a Toronto
street, I sent a message announcing this sighting. Native-Canadian actor Adam
Beach was discussed several times. Here is one sample:

From: Drucilla
Speaking of favorite Canadian actors guesting on The
Dead Zone, in a 6 Degrees of Callum moment, I'm pretty
sure I saw Adam Beach in the preview for the next one.
He was in "Last Stop" with CKR, and also in the
unreleased "Now & Forever" with CKR. AND he had a Bliss
ep, though a different one from CKR. Hmm... that's a
shame. Ahem. Not to mention he was in "Dance Me Outside"
with Hugh Dillon...Anyway, when I went to the IMDB to
check and see if DZ was listed yet for Adam Beach, I
noticed that "Now & Forever" now has a 2002 date on
it--which it didn't used to if I remember right. I
wonder if that means maybe it will actually get released
sometime this year?

Drucilla's in-depth knowledge of Canadian film is truly impressive. While I knew
of Adam Beach and had attended the Toronto Film Festival premiere of *Dance Me
Outside*, I did not know that Hugh Dillon, the lead singer of the Canadian punk band
the Headstones, and star of *Hard Core Logo*, had a role in it. When I asked for details,
she told me that she had yet to see the film but "seem to recall reading that HD

played some sort of a 'thug.'" This was confirmed by another member. I also had never heard of the first two films mentioned in her post.

Finally, the Canadian cultural landscape of MRKS was produced by an intertextual chain only loosely related to *Due South* thematically. At the heart of several threads was *Atanarjuat: The Fast Runner*, produced, directed, written and acted by Inuit. It had received international acclaim, winning numerous awards, including the Camera d'or at Cannes for best first feature in 2001. Here is an except from one thread:

From: Estraven
I was trying to explain to a co-worker why I could not wait for July 12th, when Atanarjuat opens in Albuquerque. He said I should try to see what I could find on an early 70's film called "The Idea of North" by Canadian artist Glenn Gould…Found it, a radio broadcast, musical piece first performed 12/28/1967…

On the way I found a newly published book, "Canada and the Idea of North" by Sherrill E. Grace, which looks very good featured in the catalogue of books in the McGill-Queen for Arctic and Northern Studies. I want one of everything in this list. [ellipsis mine]

From: Deirdre
Speaking of Glenn Gould…our pal Don McKellar co-wrote the acclaimed "Thirty-two Short Films about Glenn Gould" (directed by Francois Girard, who also co-wrote and directed "The Red Violin" with McKellar.) And Val, yeah, you especially since you've *been* there -- are just gonna love Atanarjuat.

The intertextual chain led from *Fast Runner* to a composition and performance by Glenn Gould to a film about Glenn Gould starring Don McKellar directed by Francois Girard to *The Red Violin*, also starring McKellar and directed by Girard. A second chain led to series of academic books by an esteemed Canadian university press.

Estraven started another thread by forwarding two articles about the difficulties facing filmmakers in the territory of Nunavut. The first mentions Igloolik Isuma Productions, the company who made *The Fast Runner*, and the second John Houston, a producer trying to make a film with an Inuit cast called *Snow Walker*.[18] Drucilla extended the chain, speculating that "this John Houston must be the son of James Houston, who wrote Confessions of an Igloo Dweller, and who helped

create the Inuit folk arts movement." Just as the Canada of MRKS included Mounties, it also included Natives and the North, both as part of a normative Canadian identity but also, as these last threads demonstrate, as an alternative, distinct culture and landscape.

Notes

1. Corrigan and Sayer (1985) make the case that England functioned as a constitutional monarchy by the 1530s.
2. North American women were to return to the factories during both World Wars, only to be sent back to the home when the servicemen returned to civilian duty.
3. This heading is an echo of the final stanza of the Canadian national anthem: "O, Canada/We stand on guard for thee."
4. The situation is different in Quebec where French-language Canadian programming is generally well supported by audiences. In 2002, for example, it reached a record high of 52 percent, compared to 11 percent for English-language Canadian programming in the rest of Canada.
5. It is ironic that the CRTC does not allow satellite or cable providers to bring in specialty networks like HBO or Showtime, claiming that this would create unfair competition to fledgling Canadian specialty channels, very few of which produce original dramatic series.
6. A direct reference is made to the Nelson Eddy character in the first season episode "Letting Go" (CTV, 1 June 1995) with the ghost of Fraser Sr. in full dress uniform floating in a pool singing "Rose-Marie."
7. Margaret Atwood's long poem "The Journals of Susanna Moodie" (1970) based on the diaries and books by the English settler, demonstrates the process of becoming Canadian through survival: "Susanna Moodie has finally turned herself inside out, and has become the spirit of the land she once hated" (p. 64).
8. These lines are from "Northwest Passage," written and performed by the legendary Canadian singer/songwriter Stan Rogers. The first stanza and refrain are played during this scene and over the closing credits in place of the *Due South* theme. The "hand of Franklin" is a reference to the doomed Franklin Expedition.
9. *Roughing It in the Bush* is the title of Susanna Moodie's book about her experiences as a settler. See Note 7.
10. The one exception is air-l, the list of the Association of Internet Researchers.
11. At the time of writing, only the first and second seasons have been aired on analog cable in Canada. Seasons Three and Four have only been shown on *The Move Network*, only available as part of the premium cable package.
12. The link to the "Canadian-ness Test" is no longer active. It is archived at <http://web.archive.org/web/20020205113753/http://absolutek.com/canadiantest/>. Accessed March 10, 2004. Results from taking the test, however, cannot be accessed.
13. "CFL" stands for Canadian Football League.
14. Canada has no national bird that I know of and none is mentioned on the official Government of Canada website. According to the site, the beaver became an official emblem in 1975. Similarly the maple tree became the official "arboreal emblem" in 1996. Please see <http://canada.gc.ca/acanada/acPubHome.jsp?lang=eng>. Accessed June 2004.
15. MLA stands for Member of the Legislative Assembly.

16. The fact that there were more threads on Rennie than Paul Gross had less to do with a preference for the actor and more to do with the amount of new information about screenings and DVD releases of films and TV series starring or featuring the latter during the data collection period. Gross's *Men with Brooms*, a film that he also directed and produced, had already completed a highly successful run in Canada but was not yet out on DVD. Gross also does far less Canadian television or film work and no longer acts in American productions.

17. For more information on the filmography of actor Callum Keith Rennie, please visit the Internet Movie Database website: <http://www.imdb.com/>. Accessed June 2004.

18. The film was released in Canada in March 2004. I checked a number of online sources but found no mention of John Houston's name as a producer.

☱ Conclusion
Lessons from the Virtual Kitchen

In the final section of the Introduction, I noted that the practices associated with the David Duchovny Estrogen Brigades and the Militant RayK Separatists were specific but that the processes of identification, community making and spatial ordering were cautiously generalizable. To wrap up, I will discuss these generalizations as they apply to both Media Studies/Mass Communication and Cyberculture/Internet Studies as distinct areas of study. I then suggest a set of shared interests and reasons to pursue the study of fandom.

Lessons on Fandom

Still No Respect?

Almost 25 years after the recognition that media could not be talked about solely in terms of "consumption," the text remains at the heart of critical studies of media. For instance, most of the articles published in the venerable *Screen*, a journal that positions itself as having "maintained its position at the cutting edge of research and scholarship in film and television" over 45 years, are textual analyses. Even *Popular Film and Television* focuses primarily on film and representation, despite a reference to *Buffy the Vampire Slayer* in its promotional website blurb. Thirteen years after Henry Jenkins put media fandom on the academic radar, it largely remains what he called a "scandalous" category. Polite, puzzled smiles are the rule not the exception when I mention that I do research on female fandom. Like the MRKS participants, I find myself retreating to the "slash closet," sticking with the generic "fanfiction" when explaining the MRKS project. "Oh, good," said one former colleague when I noted that I did not write such fiction myself, as if doing so would be irreconcilable with or taint intellectual activity.[1] Yet, I am regularly approached by female grad students and scholars after conference presentations

my work not only captures but legitimates their experiences as fans. After interviewing for a tenure-track position, my name was given by a member of the search committee to the Chair of another department to serve as an external examiner of an MA thesis on slash fiction. He had been unable to find anyone capable and/or willing to take on this role in one of the largest communications departments in Canada.

To be fair, there are legitimate concerns that audience-oriented approaches can overemphasize the "power" of the viewer or assume that fan practices are necessarily acts of resistance. The DDEBRP and MRKS data clearly demonstrate the push of text and pull of viewer in the process of negotiation. The text may be polysemic, but as John Fiske (1987) acknowledges, certain meanings are preferred. For fans with investments in bourgeois aesthetics, these are not lightly dismissed or casually reworked. Although committed to a liberal feminist discourse of equality, DDEBRP members were unable to fully rewrite the script to have Scully directly challenge Mulder when he made decisions without consulting with her as his partner. Yet, when the writers sanctioned such a response from her, it was wholeheartedly embraced. Moreover, the queering of straight(ish) primary text by the MRKS participants was a highly resistant act, yet not a wanton one. Many self-identified as queer and embraced a gay politics, as indicated by their reaction to homophobic attitudes. Yet, they admitted feeling constrained by the *Due South* canon, most reading both Fraser and Ray as bisexual rather than gay. What is needed is more ethnographic audience research that underscores the complexity of the text-reader, discourse-subject relationship. Perhaps then those media and communication studies scholars who focus on ideological critique and representation would be more open to including work on reception in their undergraduate and graduate courses.

The Fan as Invisible Fiction

Throughout this book I have talked about fans and fandom, so my next point may come across as odd: there is no such entity as a fan. The category of fan is what John Hartley (1992a) calls an "invisible fiction"—there is no homogeneous group of people that lie "beyond its production as a category" (p. 105). John Fiske (1989) makes a similar point when he describes himself as a different "audience" when he watches a football game by himself, a cartoon with his son or a soap with his wife. What he is suggesting is that the arrangement of identities that coalesce into a subject position will shift according to the text being viewed. Henry Jenkins did the indispensable work in *Textual Poachers* of mapping out fandom and identifying

common practices, but, as with the universal category of "woman" constructed by second wave feminists in the 1970s, the time has come to deconstruct the category and acknowledge difference.

As I have illustrated, fan practices cannot be analyzed separately from gender, class, sexuality and nationality. As female fans, the DDEBs and the MRKS read the primary texts paradigmatically, focusing on relationships in general and romantic relationships, straight or queer, in particular. The same was true of their reading and production of secondary texts. Female fandom in general, and slash fandom in particular, are minority fandoms. Not only are they marked out as different/deviant but they also actively mark themselves out as such in relation to male and/or heterosexual fandom. The marginality of feminine and queer fandoms, however, does not indicate shared concerns and practices. After reading a draft of one of the chapters, Geneva from the DDEBRP asked me what MRKS stood for. She and Drucilla were both members of the same DDEB and yet Drucilla never talked about her DS slash list. Geneva reasoned that this was because she knew that the DDEB members were not interested in slash.

As middle-class, university-educated fans, both sets of research participants engaged in critique of the primary and secondary texts, drawing on bourgeois aesthetics. They were not interested in interacting with fans or reading fanfiction produced by fans not concerned with or not capable of accurate and effective expression. Moreover, the intersection of gender and class unquestionably affects fan practices. A number of DDEBRP members were concerned about being dismissed as "fangirls" and therefore did not condone behaviors such as excessive displays of emotion or "drooling" over celebrities. Yet a visit to public but *de facto* women-only message boards dedicated to popular male celebrities such as Orlando Bloom, Johnny Depp and Keanu Reeves reveals a multitude of female fans quite happy to participate in threads with subjects such as "you know your [sic] obsessed when..." and "what would you do if you found yourself in an elevator alone with [name of celebrity]." DDEBRP members also cautiously read the historically devalued romantic storyline into *The X-Files*, the resulting pleasures ambivalent at best. As for sexuality and class, the pleasures of slash for MRKS participants were not exclusively queer. Erotic m/m romance needed to be both well-written and adhere to "canon." If each quality—erotics, writing, canon—is seen as a circle in a Venn Diagram, the center of overlap is the pleasure zone.[2]

Finally, fans are positioned differently vis-à-vis the primary text depending on their nationality and location. We cannot expect Canadian fans of American shows

to make the same meaning out of them as Americans. Proportionately, *The X-Files* had consistently higher ratings in Canada than in the US. Speaking for myself, part of the pleasure of the text was its Vancouver and Lower Mainland locations passed off as just about every American state over the five seasons it was shot in Canada. On the DDEBRP, I often added background on not only these locations but also Canadian actors in episode-based discussions. In this way, I "Canadianized" the text. Similarly, Americans cannot be expected to interpret the few Canadian programs that they have the opportunity to watch in the same way as Canadian fans. Rather than "Americanize" *Due South*, as would have been the normative practice, MRKS participants enthusiastically took up the Canadian myths on offer, evoking a desire for a Canadian identity founded on quaintness and politeness.

Absent from work on fandom, including my own, is an examination of race and ethnic identity. Statistics on general internet demographics and my admittedly small samples indicate that media online fandom is overwhelmingly white. Only one MRKS member who gave me permission to include her list contributions but did not complete a questionnaire was African American. I only know her racial identity because I met her in person. Only two major works on audience research center on issues of race/ethnicity: Hamid Naficy's (1993) study of Iranian television and viewers in Los Angeles and Marie Gillespie's (1995) study of South Asian television and viewers in London, England. Mary Ellen Curtin presented a paper at the 2002 Popular Culture Association conference in which she studied fanfiction archives to discover that black characters appeared far less in both het and slash fiction than white or even Latino/a characters. This academic silence on the whiteness of fandom and the dearth of research involving fans of color is puzzling and disappointing, especially in light of recent critical work done on race and ethnic identity in the emerging area of cyberculture studies.

My final point on the generic category of fan is that "fans" themselves are not likely to find it any more meaningful than scholars. MRKS participant Phoebe made this clear in the "fannish ennui" thread:

```
I also don't know what the profile is of the 'average'
fan but I suspect, because I can't just slash two guys
for the hell of it, or for the aesthetics of it, that
perhaps I wouldn't even be in the sample to begin with.
DS was pretty much a lightning bolt for me and I
haven't to date felt the need to explore any other
universe on paper the way I felt (feel) a compulsion to
expore [sic] the dS universe and characters on paper… In
```

```
that sense I don't feel that I'm any kind of profes-
sional - fan or writer or whatever - because I'm not
able to do that and I don't identify with fans in
general or with fandom. But then I wonder what the
definition of 'fan' really is. (That's an open ended
question, not a statement. <G>)
```

Phoebe began by distinguishing herself from the "average" fan, which she implied is someone who does not pay close attention to canon and accurate characterization or who casually changes fandoms. She then pondered the usefulness of the category itself. As her next set of comments indicate, "fan" is only meaningful when it is associated with specific identifications, in Phoebe's case, an educated, queer-positive female fan:

```
In terms of what I found valuable about "fandom" then as
opposed to now, it's the same thing - it's this group of
incredibly intelligent and articulate women who share
the same interests as me, and that's something guess I
don't want to give up or won't give up without a fight,
so if "fandom" is the common thread that binds us, I'll
put up with the snags in the upholstery. <G>
```

The category of fan, as Diana Fuss (1989) argued for that of "woman," is therefore best understood as strategic, not essential. To this end, it continues to serve a vital function—to distinguish those who have a more intense emotional investment in a text than that of the casual reader. After all, as the data demonstrates, the pleasures of the primary and secondary texts are not *just* a result of the quality of acting or writing. Jeanne of MRKS detailed the emotional attachment that lies at the heart of all fan practice:

```
We're fans. We have great admiration, love, dare I say
'obsessiveness' for specific things (Due South, in our
cases…or at least one or more of the actors who were
involved in that show). This is pretty much how fen are
recognized, for heaven's sake - they have that look of
fevered infatuation in their eyes <g> (n.b.: when I say
"they," I'm certainly including myself, of course) Am I
arguing that we *shouldn't* have these strong loves and
loyalties and allegiances to people (both real and
fictional) or ideas? Hell no. I'm not even certain it
would it's possible to erase those kinds of responses. I
spent years laughing at people in Highlander who seemed
to consider Duncan MacLeod, for example, their long lost
son or something and who berated people that dared to
```

```
say anything critical of him. Yet now, here I am, feel-
ing similarly needlessly (and irrationally) over-
protective of the DS characters. While it's true that I
haven't yet yelled at anyone for being 'mean' to Fraser
or RayK, sometimes I fear it's just a matter of time.
[ellipsis mine]
```

Fans, Communities and Everyday Life

Jeanne's last point reinforces another important claim made by Henry Jenkins, namely that fandom is ultimately about relating to other fans, for better in the case of communities like the DDEBs and MRKS, and for worse in the case of the derision directed at the female fans on alt.tv.x-files and the flame wars between Ray Vecchio and Ray Kowalski fans in public DS slash forums. My research underscores the relationships that can develop among fans *beyond* the shared interest in a text. Admiration for David Duchovny and a love of *The X-Files* may have brought the DDEB members together but it is not what has kept them together more than 10 years after the lists' formation. Indeed, many members claimed to have lost interest in the series by the fifth season. Sarah Stegall gave up writing reviews after the fourth season, citing the poor quality of the writing and character development. Ardis likened the series to a dog crippled by an auto accident that should have been "put out of its misery" instead of being renewed season after season: "The show had become just plain stupid, and I felt betrayed because its early brilliance was, you should pardon the expression, a fluke.[3] Time to move on." Thus it would seem that the pleasures of taking "stories for boys" and making them into "stories for girls" were ultimately subsumed under the larger practices of community making among female friends. MRKS, however, has not enjoyed the same longevity. While the list remains operational, it is effectively defunct. Phoebe told me that a number of members had drifted off to other fandoms, the WB network's *Smallville* in particular. Drucilla felt that MRKS did not thrive because of the decision to restrict discussions to DS-related topics. Given the lengthy and enthusiastic responses to the "OT" threads during the data collection period, her assessment makes sense. A commitment to a show or an actor is not necessarily enough to sustain a community, particularly once that series is no longer in production.

Finally, fan practices are but *one* set of practices bound up with everyday life. William Shatner may have told the Trekkies to "get a life" on *Saturday Night Live* but like all fans, they already have one. As the DDEBRP and MRKS data indicates, they are mothers, daughters, girlfriends, wives, administrative assistants, fundraisers,

computer analysts, doctors, students, quilt makers, costume designers and technical writers to name but a few roles/identities. The unintended and perhaps unavoidable consequence of focusing exclusively on fan practices can be to further fetishize and ghettoize fandom. The DDEBRP data in particular offers gleanings into the lives of its members beyond their interest in a television text.

Lessons on Virtual Living

In the introduction, I made the case that poststructuralist theory enables the internet researcher to tease out the complexities of virtual identity, community and space. The data from my two case studies demonstrate the intricacies of such theory in motion.

Identity

While much research has primarily focused on the difference between online and "real life" (RL) identity, the DDEBRP and MRKS studies demonstrate their *sameness* and contiguity in terms of both gender and class. Members performed a range of identities associated with RL femininity whether making sense of *X-Files* episodes (DDEBRP), offering advice and support, avoiding and managing conflict as well as engaging in politeness behaviors. Similarly, RL middle-class identities were extended into cyberspace through various articulations of bourgeois aesthetics, deployed to assess the quality of both primary and secondary texts. Moreover, members displayed high levels of linguistic capital in list interaction, using language accurately and effectively, particularly for humorous effect. The idea that the gendered, classed, raced body is extended into cyberspace rather than left behind led A. R. Stone (1995) to coin the term *prosthetic communication* as a more precise alternative to "computer-mediated communication."

That said, my data points to one major difference between RL and online identity. In cyberspace gender becomes more akin to RL class or sexuality, not immediately intelligible to others. Interactants, at least by today's standards of technology, cannot be instantly pinpointed and identified as men or women by the power of the gaze. Over time and depending on what is said and how it is said, femininities (and by extension masculinities) will seep through as has been demonstrated. On the other hand, class, as far as it is imbricated with linguistic capital, becomes more akin to RL gender. Because of the centrality of language in today's virtual/textual environments, one's stock of linguistic resources is instantly

on display to be judged by other interactants. As Drucilla put it, "I want to see good grammar, spelling, syntax, and a grasp of the language. I don't want to see the boys going on 'steak outs'." At the first sign of these types of errors in slash, Drucilla and the other MRKS participants "hit the back button."

Sherry Turkle (1995) argues that a "disjuncture" exists "between theory (the unitary self is an illusion) and lived experience (the unitary self is the most basic reality)" (p. 15). Prosthetic communication supposedly enables interactants to experience the multiplicities of identity as prescribed by postmodern theory. While I am unconvinced that Turkle has distinguished role playing from gender performance, online interaction does enable the researcher, even if not the participant, to recognize and document the complexities of the identification process, including the differing levels of investments both among and *within* subjects in the discourses on offer. The DDEBRP discussions on Mulder and Scully presented a range of performances including radical and liberal feminisms and normative femininities. Similarly, the MRKS questionnaire responses to the sexual orientation of Fraser and Ray and the fiction produced by MRKS participants revealed a range of queerness from a closeted bisexuality to an out-gay identity. Moreover, gender and class identifications are not necessarily performed in tandem. Tensions between the two surfaced on the DDEBRP around the value of debate as a community practice. While some members embraced the frank exchange of ideas that could lead to disagreement, others saw this practice as rude and/or unnecessarily divisive.

Community

As with identity, the studies do not support an epistemological break between RL communities and online communities. All communities are produced through some form of interaction and require a commitment to establishing a set of commonalities. The term online community, therefore, is not synonymous to or interchangeable with electronic mailing list, newsgroup or chat room. The onus is on the researcher to identify those practices that give such a formation its substance. The majority of DDEBRP and MRKS members regularly engaged in a series of gendered and classed practices involving the interpretation of primary and secondary texts, as well as clear, clever and polite expression. In the case of the former, the sharing of personal experience also constituted a communal practice. Sustaining an online community involves a sizeable investment in time and energy. A testament to that commitment and investment is the continued existence of the DDEBs, as

mentioned above. While some members have left permanently (e.g., Mari, Dani) and others have left for personal reasons and returned (e.g., Liz), the ties that bind these communities together have outlasted their interest in Duchovny and *The X-Files*. As for MRKS, a number of members remain close friends and continue to have close contact through private email, telephone calls and visits.

It is imperative to recognize that communal practices do not just bring people together but end up functioning as norms that lead to insider/outsider divisions within the community. The data samples provide glimpses of this function: The one DDEBRP member's dislike of the critical discussions of the episodes, Bel's dislike of debate, Winnie's feelings of inadequacy in formulating short, witty replies. On MRKS, Deirdre and Meghan expressed concern with attacking other fans who write slash "for fun" and mocking "bad" writing. I am not suggesting that these members were always outsiders; on the contrary, the insider/outsider division shifted with the ebb and flow of interaction. Moreover, these were the few members who positioned themselves as outsiders in those instances. Others were likely to have simply remained silent rather than risk a potential face-threatening act or conflict. Silence in these situations enables communities to maintain their coherence.

The issue of silence raises an important difference between RL and online communities—the ability to recognize participation and interpret silence without the benefit of vision. In face-to-face communication, participation in a community can involve nonverbal communication to signal interest and involvement (the nodding of the head, a smile) or the sole use of minimal responses ("uh-huh," "yes," "mmm") to signal listener support. In cyberspace, participation requires actively taking the floor on a regular basis. Those who do fail to do so fall into the undifferentiated category of lurker." In the DDEBRP study, I followed up on the practice of lurking. Three members sent less than a total of a dozen messages, most of those in the first two months. Two remained on the list until the end of the project and the third unsubscribed two months before the end of the project, citing time constraints. When I asked the two who remained, Lynn explained that she had been ill for an extended period of time as well as busy. Even on her own brigade, she described herself as a lurker who read the mail several times a day but usually only sent messages to other members privately. In the case of the DDEBRP, she claimed that she read the posts once a month. Clearly the research list was a low priority for her. In explaining her lurking habits, Paula also cited RL responsibilities as well as her personality: "I am normally rather quiet and careful of my speech in groups where I have no intimate friends." Even on her own brigade, she only sent

a few messages a month. She suggested that long-term silence could have a negative effect: "In a 'real world' group one member's silence is noticeable and usually dealt with; in cyberspace the silent ones become invisible and are quickly forgotten by the group :/." From the perspective of the active members such as Mrs. Hale, lurkers were regarded with some suspicion, "eavesdroppers" rather than community members, who drew on the community's resources but gave nothing of themselves. Jeanne implied a problem with lurking in her "fannish ennui" message; "Then, too, unless you're going to lurk all the time, to be really involved in fandom almost 'requires' expressing your feverish ideas and interests, at least among a small group of people if not to the larger fannish culture." Thus in cyberspace, listening/reading does not register as a form of community involvement.

Space

The discussion of the DDEBs and MRKS as virtual heterotopia in Chapter 5 demonstrates the rewards of taking the discussion of space beyond metaphor and symbol to examine the spatial relations afforded by ICTs. *Pace* Howard Rheingold, cyberspace was never a "frontier" waiting to colonized but one in which the normative orderings of RL space were reproduced the moment the first cybernaut logged on. As my genealogy of public and private space indicates, spatial arrangements have long histories that are not easily displaced. Similarly, the normative media flow established in the 20th century originates with the American cultural industries and now moves across almost every national border in the world, raising the specter of a *pax Americana* on a cultural front. The oppositional space of the heterotopia also predates ICTs by hundreds of years, though the virtual context provides unique opportunities to disrupt normative orderings and/or produce alternative ones. The space of the office, whether private or public/broader public sector, can be overlaid with that of the kitchen, a private collective space of women. The American territory of media fandom can be transformed into a Canadian cultural landscape. That said, one must be careful not to overestimate the power of ICTs and/or their users. A few women-only or women-centered online communities do not disrupt the domination of the public and corporate spheres by men or world market domination by American cultural commodities.

Where the Fans Are Headed and Why You Should Care

I am going to address the last part of the section title first. Specifically, I want to encourage Media Studies/Mass Communications scholars and students to pursue issues in CMC, and cyberculture/internet studies scholars and students to take an interest in media fandom. As I noted at the beginning of the book, fans were among the first groups of people to extend their bodies into cyberspace. The internet has become an integral part of fandom and if the situation arose, they would be the last ones left to turn out the lights on their way out. Thus, anyone who studies audience reception and/or media fandom today in a North American context must account for online fan activities and formations. Moreover, fandom provides a prime vantage point from which to study forms and processes of prosthetic communication, identity, community and space. Determining where the fans are, what they are doing and how they are doing it is in essence taking the virtual pulse of the North American white middle classes.

Although the DDEBs and MRKS are representatives of a small subculture of fandom, they too can offer a sense of the trends in internet practices. The more recent MRKS data, for example, gestures to the increasing popularity of the blog, an abbreviation of weblog, and the LJ or Live Journal. As the names suggest, programs are available for those who wish to post their daily thoughts and have others comment on them, thus affording the possibility of dialogue. More popular blogs/LJs with regular respondents offer the potential for communities to form. In the "fannish ennui" thread, all the participants—Jeanne, Phoebe, Libra, Marguerita and Deidre—mention reading or keeping blogs or LJs. The appeal of this activity is implied by Marguerita:

```
Fandom is an escape, but some things can't be escaped
from so, since people can't change them they complain or
change what they can control, which includes fandom
interests. My own fannish contributions continue to be
writing, beta-ing for people and writing the blog, with
occasional appearance on a very few discussion lists
now; however, I'm seeing a lot less traffic on all my
lists. I'd hate to think we're all outgrowing these
interests, but maybe we're just in a holding pattern for
a while.
```

Given the history of flame wars in fandom, a blog or LJ may well provide a better sense of control and autonomy while still providing a form of interaction with other fans. Looking at the MRKS website and following the links, almost all the

participants have a LJ and most are reasonably current as I write. It would seem that the members prefer to direct their limited time and energy toward blogging rather than interacting on the list.

In light of the above, is the "blogosphere" or LJ "continuum" posed to be the next destination for millions of internet users seeking to speak their minds and to make connections with like-minded others? How are blogging practices gendered, raced or classed? How do they reinforce or transgress the public/private binary? As with any other online practice, why not follow the fans and find out.

Notes

1. This colleague would no doubt have been shocked to learn that one of the MRKS participants was a tenured professor at a prestigious Canadian university.
2. I am grateful to Lee Easton for this conceptualization.
3. Ardis's choice of the term "fluke" is a reference to the second season episode "The Host" (Fox, 23 September 1994) in which Mulder and Scully encounter the "Flukeman" living in a New Jersey sewer system.

⩔ Appendix

DDEB Questionnaire

Name:

Mailing Address:

Phone # During the Day:

Phone # in the Eve.:

Fax # (If Applicable):

Email Address:

Brigade Number: 1 2 3

Part I: Computer and Net Use

1. What kind(s) of computer(s) do you own or have access to?

2. What kinds of software applications do you use on a regular basis?

3. If you have a computer at home, where is it located?

 Do others have access to it? Please elaborate.

4. How long have you been an internet user?

 If you have been a long-term user, what major changes have observed?

5. Do you tend to go to specific sites of interest or do you prefer to browse/surf/cruise? (Please select the term you like best.)

6. How much time on average do you spend online each day?.

 At what time(s) do you tend to go online?

 Is the time you spend online constrained by work/family responsibilities?

7. Could you tell us a little about the lists you subscribe to aside from the DDEB?

8. Do you ever use an alias(es)? Why or why not?

9. Have you ever been flamed?

 If so, describe the incident(s) and why you think it occurred.

 Have you ever been party to a flaming? Why or why not?

10. Have male users harassed, threatened and/or made you feel uncomfortable in any way?

11. Do you feel that cyberspace is a predominately male space? Why or why not?

Part II: Popular Culture

1. Would describe yourself as an occasional, regular or heavy reader?

2. What types of reading materials do you tend to read regularly?

_____job- and/or school-related materials

_____newspapers (please specify)

_____news/informational magazines (e.g., Time, Harpers)

_____fashion/women's magazines (e.g., Vogue, Cosmo)

_____lifestyle magazines (e.g., Vanity Fair)

_____tabloids (e.g., National Enquirer)

_____entertainment magazines (e.g., People, Us)

_____computer magazines (e.g., Personal Computing, Macworld)

_____fiction (novels, short stories, poetry, romance, mysteries, science fiction, fantasy)

_____auto/biography

_____nonfiction (philosophy, music, psychology, science, technology etc.)

_____comics

_____erotica

_____other (specify)

3. Could you name a few of your favourite authors/books/magazines?

4. Would you describe yourself as an occasional, regular or heavy TV viewer?

5. What types of TV programs interest you?

_____comedy

_____drama

_____talk shows

_____soap operas

_____news

_____made-for-TV movies

_____mini-series

_____foreign programs

_____music videos

_____other (specify)

6. Could you name a few of your favourite shows aside from *The X-Files*?

7. Would you describe yourself as an occasional or regular moviegoer?

8. Do you rent videos on an occasional or regular basis?

9. What are some of your favourite films?

10. *The X-Files* has spawned a host of crossovers into other media. Do you collect/read any such paraphernalia?

11. Many fans attend conventions, write (slash) fiction and produce artwork. Are you involved in any of these activities?

Part III: Fandom

1. When would you say you became an *X-Files* fan?

2. Were you a member of any other *X-Files* fan clubs or lists before joining the DDEB?

 If so, are you still a member?

 If not, why not.

3. How did you find out about the DDEB(s)?

4. When and why did you decide to join?

5. Did you know any of the other members previous to joining?

 If yes, what was your connection to them?

6. What kind of reactions do you get from people online and IRL when they learn that you are part of fan club devoted to a TV actor?

7. How would you describe your participation in the group? (e.g., occasional, active, very active etc.)

8. Please estimate the percentage of daily postings which deal with:

_____DD/*X-Files* chat

_____personal matters

_____social/political issues

_____other (please specify)

9. Which of these areas do you prefer to discuss on the list?

10. Who else other than DDEB members do you discuss DD and *The X-Files* with on a regular basis?

11. We understand that friendships are an important part of the DDEB lists. How do you compare your friendships with DDEB members and those in IRL friends?

12. Have you met any of the other members IRL?

Part IV: Personal Information

1. What is your nationality?
2. Which age group do you fall in?

 under 18 18-21 22-25 26-30
 31-35 36-40 41-45 over 45

3. Please self-identify as to ethnic and/or racial background.
4. Which language(s) are you fluent in?

 Which language(s) did you learn at home?

5. Are you currently involved with/living with a partner?
6. Do you have children?

 If yes, tell us a bit about them. (age and gender)

7. What was the highest level of education you have completed?
8. Are you currently working on a diploma/degree?
9. Are you a professional working in the field in which you trained?
10. Which income group do you fall into?

 < 10,000 10,001–20,000
 20,001–30,000 30,001–40,000
 40,001–50,000 > 50,000

11. Which of the following statements best describes your level of interest in politics:

_____active in organized political party (have perhaps run for election or have helped others with their campaigns).

_____a card-carrying member of an organized political party.

_____not necessarily affiliated with any party but avidly follow national and global political events.

_____somewhat interested in national and/or global politics.

_____not particularly interested in political issues.

_____find politics really boring and think it's a all a bunch of bullshit anyway.

12. Would you call yourself a feminist? Why or why not?
13. Which of the following statements best describes your position on feminism:

_____Despite all the gains women have made, we still live in a sexist society. Lots of work still required.

_____Women have made many gains in the past twenty years and are generally treated as equals in our society. Some room for improvement.

_____No longer a need for feminist groups, which are just alienating men. Instead women need to work together with men on issues that concern everybody.

_____Sick and tired of hearing feminists rant about being "victims." They should just get on with it and stop complaining.

Due South Slash Fiction Questionnaire
Part I: Contact Information

Name:
Full Mailing Address:
Phone Number (Daytime):
Phone Number (Evening):
Email Address(es):

Part II: Reading Slash

1. When and how did you first hear about slash?
2. Do you primarily access slash online? If yes, please specify (names of websites, lists etc. If no, please go on to Question 4.
3. Where do you access and read slash? At work? At home? If yes to the latter, do you have your own computer and/or space in which to do so?
4. Is there a particular type of DS slash you prefer to read?
5. What other slash, if any, do you read besides DS slash?
6. Do you have a preference for a sub-genre of slash (e.g., h/c or "issue fic")?
7. What are the qualities you look for in a "good" slash story? (Please discuss in order of importance).
8. Do you apply similar standards to slash as you would to non-fan-based fiction (short stories, novels)? Why or why not?
9. Do you have any favourite slash writers?
10. If yes, have you ever contacted any of these writers to offer praise/suggestions?
11. What other types of fan fiction, if any, do you read?

Part III: Writing Slash

Are you also a writer of slash? If your answer is NO, please go on to Part IV. If YES, please answer the questions in this section.

12. When and why did you start writing DS slash?

13. How many stories have you written? 1–10 11–20 21–40 41+
14. What type(s) of DS slash do you write?
15. Where, if at all, do you "publish" your work?
16. Have you entered any competitions and if so have you won any prizes?
17. Have you received praise from readers of your work? If so, please elaborate.
18. Have you been criticized by readers? If so, please elaborate.
19. Do you do any other writing, professional or personal? If so, please elaborate.

Part IV: Community Membership

20. Please list the forums, electronic or RL, in which you communicate with other DS slash readers and writers, and indicate your level of active participation: frequent, regular, occasional, strictly a lurker.
21. Are any of these women-only spaces? If not, are there many men involved?
22. Have you met other slash readers and writers IRL?
23. Have you formed any personal connections or friendships with other female slash readers and writers? If yes, in what ways are they a meaningful and valuable part of your life?
24. In summary, in what ways do you feel like a member of a larger community of like-minded people?
25. How comfortable are you in telling others outside the slash community that you read/write slash?
26. How do people react if you do tell them?
27. Have there been/would there be any repercussions in your personal and professional life as a result of reading/writing slash?
28. If yes, would you describe yourself as being in some ways "closeted" as a reader/writer of slash?

Part V: Identifications: Gender, Sexuality and Feminism

29. What pleasures as a female do you get from reading/writing m/m slash?
30. As a female, how do you identify with the male characters and their relationships?
31. How do you read the sexual orientation of the male characters? Are Fraser and RayK, for example, straight, gay, bisexual?
32. Would you describe the slash you read/write as gay male erotica or pornography on any level?

33. If yes, do you read/have you read other literature that could be classified as gay male erotica or pornography?

34. Do you have any personal or political connections to the gay male community or individual gay men?

35. Would you describe the slash you read/write as a form of romance?

36. Would you describe yourself as a feminist?

37. Do you think that reading/writing slash is a feminist practice?

38. Do you think that the exclusive focus on men could be understood as anti-feminist?

Part VI: Personal Information

My purpose in asking these questions is to get a snapshot of the social identifications of female readers and writers of slash. I have deliberately avoided providing categories to check off as I believe that people should be able to self-identify in their own voice.

39. What is your nationality?

40. What is your age?

41. Do you have children? If yes, please provide their sex and age.

42. Are you currently living with/involved with a partner? If so, are you legally married? If not, are you separated or divorced?

43. How do you self-identify as to ethnic and/or racial background?

44. How do you self-identify as to sexual orientation?

45. What is the highest level of education you have completed? If post-secondary, indicate your major/field of study?

46. Are you currently working on a diploma/degree? Please specify.

47. Are you currently (self) employed? If yes, in what capacity? Full time or part time?

48. If yes to the above, what do you like about your work? What do you dislike?

49. If no to Question 47, what type of job did you last hold? If you are looking for work, please specify the type of job.

✎ References

Anderson, B. (1983). *Imagined communities: Reflections on the origin and spread of nationalism*. New York: Verso.

Andersson, L.-G., & Trudgill, P. (1992). *Bad language*. London; New York: Penguin.

Ang, I. (1989). *Watching Dallas: Soap opera and the melodramatic imagination* (D. Couling, Trans.). New York: Routledge.

Atherton, T. (2003). Retrieved March 2, 2004, from <http://209.47.161.50/articles/OttawaCitizen/citizen030205.htm>

Atwood, M. (1970). *The journals of Susanna Moodie*. Toronto: Oxford University Press.

Atwood, M. (1972). *Survival: A thematic guide to Canadian literature*. Toronto: Anansi.

Austen, I. (1996). *Culture between commericials*. Retrieved March 2, 2004, from <http://www.media-awareness.ca/english/resources/articles/sovereignty_identity/culture_commercial.cfm>

Baker, E. F. (1964). *Technology and woman's work*. New York: Columbia University Press.

Balsamo, A. (1996). *Technologies of the gendered body: Reading cyborg women*. Durham, NC: Duke University Press.

Barker, C. (1999). *Television, globalization and cultural identities*. Philadelphia: Open University Press.

Barnard, M. (1996). *Fashion as communication*. London; New York: Routledge.

Barney, D. (2000). *Prometheus wired: The hope for democracy in the age of network technology*. Vancouver: UBC Press.

Baym, N. (1995). The emergence of community in computer-mediated communication. In S. G. Jones (Ed.), *Cybersociety: Computer-mediated communication and community* (pp. 138–163). Thousand Oaks, CA: Sage Publications.

Baym, N. K. (2000). *Tune in, log on: Soaps, fandom, and online community*. Thousand Oaks, CA: Sage Publications.

Bell, D. (2001). *An introduction to cybercultures*. London; New York, NY: Routledge.

Belsey, C. (1994). *Desire: Love stories in Western culture*. Cambridge, Mass: Blackwell.

Benedikt, M. (Ed.). (1992). *Cyberspace: First Steps*. Cambridge, MA: The MIT Press.

Bourdieu, P. (1977). The economics of linguistic exchanges. *Social Science Information, 16*(6), 645–668.

Boxer, M. J., & Quataert, J. H. (Eds.). (1987). *Connecting spheres: Women in the Western world, 1500 to the present*. New York: Oxford University Press.

Boyd, K. S. (2001). *"One index finger on the mouse scroll bar and the other on my clit": Slash writers' views of pornography, censorship, feminism and risk*. Unpublished MA, Simon Fraser University, Burnaby, B.C.

Brioux, B. (Writer) (2002). Millionaire won TV ratings lottery, and then lost it just as fast: *Toronto Sun*. Available: <http://www.canoe.ca/TelevisionShowsW/whowantstobeamill.html>.

Britzman, D. (1995). Beyond innocent readings: Educational ethnography as a crisis of representation. In W. Pink & G. Noblit (Eds.), *Continuity and contradiction: the futures of the sociology of education.* Cresskill, N.J.: Hampton Press.

Buckingham, D. (1993). *Children talking television: The making of television literacy.* London: The Falmer Press.

Butler, J. (1990). *Gender trouble: Feminism and the subversion of identity.* New York: Routledge.

Butler, J. (1993). *Bodies that matter: On the discursive limits of "sex."* New York: Routledge.

Caddick, A. (1992). Feminist and postmodern: Donna Haraway's cyborg. *Arena, 99/100,* 112–128.

Cameron, D. (1992). *Feminism & Linguistic Theory* (2nd ed.). London: The Macmillan Press.

Cameron, D. (1995). *Verbal Hygiene.* New York: Routledge.

Cameron, D. (1997). Performing gender identity: Young men's talk and the construction of heterosexual masculinity. In S. A. Johnson & U. H. Meinhof (Eds.), *Language and masculinity* (pp. 47–64). Oxford, UK; Cambridge, MA: Blackwell Publishers.

Cameron, D., Frazer, E., Harvey, P., Rampton, M. B. H., & Richardson, K. (1992). *Researching language: Issues of power and method.* London: Routledge.

Camp, J. (1996). We are geeks, and we are not guys: The Systers mailing list. In L. Cherny & E. Reba Weise (Eds.), *wired_women: Gender and new realities in cyberspace* (pp. 114–125). Seattle: Seal Books.

Canadian Radio-television and Telecommunications Commission. (2003). *Broadcasting public notice CRTC 2003–54.* Retrieved November 19,2004, 2004, from <http://www.crtc.gc.ca/archive/ ENG/ Notices/2003/pb2003-54.htm>

Case, S. E. (1996). *The domain-matrix: Performing lesbian at the end of print culture.* Bloomington: Indiana University Press.

Cherny, L. (1999). *Conversation and community: Chat in a virtual world.* Stanford, CA: CSLI Publications.

Cherny, L., & Reba Weise, E. (Eds.). (1996). *wired_women: Gender and new realities in cyberspace.* Seattle: Seal Books.

Cicioni, M. (1998). Male pair-bonds and female desire in fan slash writing. In C. Harris & A. Alexander (Eds.), *Theorizing fandom: Fans, subculture and identity* (pp. 153–177). Cresskill, NJ: Hampton Press, Inc.

Coates, J. (1989). Gossip revisited. In J. Coates & D. Cameron (Eds.), *Women in their speech communities: New perspectives on language and sex* (pp. 94–122). London; New York: Longman Group.

Corrigan, P. R. D., & Sayer, D. (1985). *The great arch: English state formation as cultural revolution.* Oxford: Basil Blackwell.

Curtin, M. E. (2001, April). *The smarm spike: A psychological and critical insight from within the fan community.* Paper presented at the Popular Culture Association, Philadelphia.

Curtin, M. E. (2003, March 17). *Alternative universes: Fanfiction studies.* Retrieved January 2, 2004, 2003, from http://www.alternateuniverses.com/index.html

Davies, B. (1990). The problem of desire. *Social Problems, 37*(4), 501–516.

Davies, B. (1992). Women's subjectivity and feminist stories. In C. Ellis & M. G. Flaherty (Eds.), *Investigating subjectivity: Research on lived experience* (pp. 53–76). Newbury Park, CA: Sage Publications.

de Certeau, M. (1984). *The practice of everyday life* (S. Rendall, Trans.). Los Angeles: University of California Press.

De Lauretis, T. (1987). *Technologies of gender: Essays on theory, film, and fiction.* Bloomington: Indiana University Press.

Department of Canadian Heritage. (2002). *Mission and strategic objectives*. Retrieved March 10, 2004, from <http://www.pch.gc.ca/pc-ch/org/mission/tex_e.cfm>

Dery, M. (1994). Flame wars. In M. Dery (Ed.), *Flame wars: The discourse of cyberculture* (pp. 1–10). Durham, NC: Duke University Press.

Doty, A. (1993). *Making things perfectly queer*. Minneapolis: University of Minnesota Press.

Douglas, S. J. (1994). *Where the girls are: Growing up female with the mass media*. New York; Toronto: Times Books (Random House).

Fairclough, N. (1993). *Discourse and social change*. Cambridge, MA: Polity Press.

Fernback, J. (1999). There is a there there: Notes toward a definition of a cybercommunity. In S. Jones (Ed.), *Doing internet research: Critical issues and methods for examining the Net* (pp. 203–220). Thousand Oaks, CA: Sage Publications.

Fishman, P. (1983). Interaction: The work women do. In N. Henley, C. Kramarae & B. Thorne (Eds.), *Language, gender, and society* (pp. 89–101). Rowley, MA: Newbury House.

Fiske, J. (1987). *Television culture*. New York: Methuen & Co.

Fiske, J. (1989). Moments of television: Neither the text nor the audience. In E. Seiter, H. Borchers, G. Kreutzner & E. M. Warth (Eds.), *Remote control: Television, audiences, and cultural power* (pp. 56–78). New York: Routledge.

Fiske, J. (1990). *Introduction to communication studies* (2nd ed.). New York: Routledge.

Foucault, M. (1972). The discourse on language (A. Sheridan, Trans.). In *The archaeology of knowledge* (pp. 215–237). New York: Dorset Press.

Foucault, M. (1979). *Discipline and punish: The birth of the prison* (A. Sheridan, Trans.). New York: Vintage Books.

Foucault, M. (1980a). Body/power. In C. Gordon (Ed.), *Power/knowledge: Selected interviews and other writings, 1972–1977* (pp. 55–61). New York: Pantheon Books.

Foucault, M. (1980b). Two lectures (C. Gordon, Trans.). In C. Gordon (Ed.), *Power/knowledge: Selected interviews and other writings, 1972–1977* (pp. 78–108). New York: Pantheon Books.

Foucault, M. (1986). Of other spaces. *diacritics, 16*(1), 22–27.

Foucault, M. (1990). *The history of sexuality: An introduction* (R. Hurley, Trans. March 1990 ed. Vol. 1). New York: Vintage Books.

Frankenberg, R. (1993). *White women, race matters: The social construction of whiteness*. Minneapolis: University of Minnesota Press.

Frissen, V. (1995). Gender is calling: Some reflections on past, present and future uses of the telephone. In R. Gill & K. Grint (Eds.), *The gender-technology relation: Contemporary theory and research* (pp. 79–94). London: Taylor & Francis.

Frow, J. (1986). Discourse and power. In *Marxism and literary history*. Cambridge, MA: Harvard University Press.

Full rights expected for same sex couples. (2002). Retrieved June 20, 2004, from <http://www.nnsl.com>.

Fuss, D. (1989). *Essentially speaking: Feminism, nature & difference*. New York: Routledge.

Gal, S. (1989). Between speech and silence: The problematics of research on language and gender. *Papers in Pragmatics, 3*(1), 1–38.

Gee, J. (1990). *Social linguistics and literacies: Ideology in discourses*. New York: The Falmer Press.

Gibson, W. (1984). *Neuromancer*. New York: Ace Books.

Gilbert, P., & Taylor, S. (1991). *Fashioning the feminine: Girls, popular culture, and schooling*. North Sydney, NSW: Allen & Unwin.

Gillespie, M. (1995). *Television, ethnicity and cultural change.* New York: Routledge.

Goodson, I., & Medway, P. (1990). *Bringing English to order: The history and politics of a school subject.* London; New York: Falmer Press.

Green, S., Jenkins, C., & Jenkins, H. (1998). Normal female interest in men bonking: Selections from *The Terra Nostra Underground* and *Strange Bedfellows.* In C. Harris & A. Alexander (Eds.), *Theorizing fandom: Fans, subculture and identity* (pp. 9–38). Cresskill, NJ: Hampton Press, Inc.

Gurak, L. J. (1997). *Persuasion and privacy in cyberspace: The online protests over Lotus MarketPlace and Clipper chip.* New Haven, CT: Yale University Press.

Habermas, J. (1989). *The structural transformation of the public sphere: An inquiry into a category of bourgeois society* (T. Burger, Trans.). Cambridge, MA: Polity Press.

Hacker, D. (2001). *A Canadian writer's reference* (Updated 2nd ed.). Scarborough, Ont.: Nelson Thomson Learning.

Hall, D. E. (2003). *Queer theories.* New York: Palgrave Macmillan.

Hall, S. (1986). On postmodernism and articulation: An interview with Stuart Hall. *Journal of Communication Inquiry, 10,* 45–60.

Haraway, D. (1988). Situated knowledges: the science question in feminism and the privilege of partial perspective. *Feminist Studies, 14*(3), 575–599.

Haraway, D. (1992). *Simians, cyborgs, and women.* New York: Routledge.

Harcourt, W. (1999). *Women@Internet: Creating new cultures in Cyberspace.* London; New York: Zed Books.

Harding, S. (1987). Introduction: Is there a feminist method? In S. Harding (Ed.), *Feminism and methodology* (pp. 1–13). Bloomington: Indiana University Press.

Hartley, J. (1992a). Invisible Fictions. In *Tele-ology* (pp. 101–144). New York: Routledge.

Hartley, J. (1992b). Television and the power of dirt. In *Tele-ology* (pp. 21–42). New York: Routledge.

Heller, M. (1988). *Codeswitching.* Berlin: Mouton de Gruyter.

Herring, S. (Ed.). (1996). *Computer-mediated communication: Linguistic, social, and cross-cultural perspectives.* Philadelphia: J. Benjamins.

Herskowitz, A. S. (1999). ASE-D: Alt.support.eating-disord. A pilot study of an Internet self-help group. *Resources for Feminist Research, 27*(1/2), 49–72.

Hetherington, K. (1997). *The badlands of modernity: Heterotopia and social ordering.* New York: Routledge.

Hine, C. (2000). *Virtual ethnography.* London; Thousand Oaks, CA: Sage Publications.

Holmes, J. (1995). Who speaks here? Interacting politely. In *Women, men, and politeness* (pp. 30–71). Harlow, Essex; New York: Longman.

Howatt, A. P. R. (1984). *A history of English language teaching.* Oxford; New York: Oxford University Press.

Hufton, O., & Tallett, F. (1987). Communities of women, the religious life, and public service in eighteenth-century France. In M. J. Boxer & J. H. Quataert (Eds.), *Connecting spheres: Women in the Western world, 1500 to the present* (pp. 75–85). New York: Oxford University Press.

Hughes, G. (1991). *Swearing: A social history of foul language, oaths, and profanity in English.* Oxford; Cambridge, MA: Blackwell.

Jacobs, J. (1961). *The death and life of great American cities.* New York: Random House.

Jenkins, H. (1992). *Textual poachers: Television fans & participatory culture.* New York: Routledge.

Jones, S. (Ed.). (1999). *Doing Internet research: critical issues and methods for examining the Net.* Thousand Oaks, CA: Sage Publications.

Jones, S. G. (Ed.). (1997). *Virtual culture: Identity & communication in cybersociety.* Thousand Oaks, CA: Sage Publications.

Katz, J. E., & Rice, R. E. (2002). *Social consequences of internet use: Access, involvement, and interaction.* Cambridge, MA: MIT Press.

Kellner, D. (1995). *Media culture: Cultural studies, identity and politics between the modern and the postmodern.* New York: Routledge.

Kendall, L. (1999). Recontextualizing "cyberspace": Methodological considerations for on-line research. In S. Jones (Ed.), *Doing Internet research: critical issues and methods for examining the Net* (pp. 57–74). Thousand Oaks, CA: Sage Publications.

Kendall, L. (2002). *Hanging out in the virtual pub: Masculinities and relationships online.* Berkeley: University of California Press.

Kristeva, J. (1986). Women's time. In T. Moi (Ed.), *The Kristeva reader* (pp. 187–213). London: Basil Blackwell.

Lakoff, R. T. (1975). *Language and woman's place.* New York: Harper & Row.

Lamb, P. F., & Veith, D. L. (1986). Romantic myth, transcendence, and Star Trek zines. In D. Palumbo (Ed.), *Erotic universe: Sexuality and fantastic literature* (pp. 235–255). Westport, CT: Greenwood Press.

Lather, P. A. (1991). *Getting smart: Feminist research and pedagogy with/in the postmodern.* New York: Routledge.

Lock, K. (1996). *Canada's hottest export.* Retrieved November 19, 2004, from <http://www.klockworks.co.uk/bibliography/journalism/duesouth.htm>

Ludlow, P. (Ed.). (1996). *High Noon on the electronic frontier: Conceptual issues in cyberspace.* Cambridge, MA: The MIT Press.

Lull, J. (1990). *Inside family viewing: Ethnographic research on television's audiences.* New York: Routledge.

MacDonald, A. (1998). Uncertain utopia: Science fiction, media fandom and computer-mediated communication. In C. Harris & A. Alexander (Eds.), *Theorizing fandom: Fans, subculture and identity* (pp. 131–152). Cresskill, NJ: Hampton Press, Inc.

Mackey, E. (2002). *The house of difference: Cultural politics and national identity in Canada.* Toronto: University of Toronto Press.

Martin, M. (1997). *Communication and mass media: Culture, domination and opposition.* Scarborough, ON: Prentice Hall Allyn and Bacon Canada.

Marvin, C. (1988). *When old technologies were new: Thinking about electric communication in the late nineteenth century.* New York: Oxford University Press.

Massey, D. B. (1994). *Space, place, and gender.* Cambridge: Polity Press.

McRobbie, A. (2000). *Feminism and youth culture* (2nd ed.). Houndmills, Basingstoke, Hampshire, UK.: Macmillan Press.

Miami Theory Collective (Ed.). (1991). *Community at loose ends.* Minneapolis: University of Minnesota.

Moore, S. (1988). Here's looking at you, kid! In L. Gamman & M. Marshment (Eds.), *The female gaze: Women as viewers of popular culture* (pp. 45-59). London: Women's Press.

Morley, D. (1980). *The 'Nationwide' audience.* London: British Film Institute.

Mulvey, L. (1989). *Visual and other pleasures.* Bloomington: Indiana University Press.

Naficy, H. (1993). *The making of exile cultures: Iranian television in Los Angeles.* Minneapolis: University of Minnesota Press.

Nakamura, L. (2002). *Cybertypes: Race, ethnicity and identity on the Internet.* New York; London: Routledge.

O'Farrell, M. A., & Vallone, L. (1999). *Virtual gender: Fantasies of subjectivity and embodiment.* Ann Arbor: The University of Michigan Press.

Penley, C. (1991). Brownian motion: women, tactics and technology. In C. Penley & A. Ross (Eds.), *Technoculture* (pp. 135–161). Minneapolis: University of Minnesota Press.

Penley, C., & Ross, A. (1991). Interview with Donna Haraway. In C. Penley & A. Ross (Eds.), *Technoculture* (pp. 1–20). Minneapolis: University of Minnesota Press.

Pile, S., & Thrift, N. (Eds.). (1995). *Mapping the subject: Geographies of cultural transformation.* New York: Routledge.

Plant, S. (1997). *Zeros + ones: Digital women + the new technoculture.* Toronto: Doubleday.

Poster, M. (1995). *The second media age.* Cambridge, MA: Polity Press.

Probert, B., & Wilson, B. W. (Eds.). (1993). *Pink collar blues: Work, gender & technology.* Carlton, Vic.: Melbourne University Press.

Probyn, E. (1993). *Sexing the self: Gendered positions in Cultural Studies.* New York; London: Routledge.

Radway, J. (1984). *Reading the romance: Women, patriarchy, and popular literature.* Chapel Hill: The University of North Carolina Press.

Rakow, L. (1992). *Gender on the line: Women, the telephone, and community life.* Urbana: University of Illinois Press.

Rampton, B. (1995). *Crossing: Language and ethnicity among adolescents.* London; New York: Longman Group Limited.

Reid, E. M. (1999). Hierarchy and power: Social control in cyberspace. In M. Smith & P. Kollock (Eds.), *Communities in cyberspace* (pp. 107–118). London; New York: Routledge.

Rheingold, H. (1993a). A slice of life in my virtual community. In L. Harasin (Ed.), *Global networks: Computers and international communication* (pp. 57–80). Cambridge, MA: MIT Press.

Rheingold, H. (1993b). *The virtual community: Homesteading on the electronic frontier.* Reading, MA: Addison-Wesley Publishing Co.

Rodman, G. B., Kolko, B. E., & Nakamura, L. (2000). *Race in cyberspace.* New York: Routledge.

Russ, J. (1985). *Magic mommas, trembling sisters, puritans & perverts: Feminist essays.* Trumansburg, NY: Crossing Press.

Saco, D. (2002). *Cybering democracy: Public space and the Internet.* Minneapolis: University of Minnesota Press.

Sedgwick, E. Kosofsky (1993a). Axiomatic. In T. W. Adorno & S. During (Eds.), *The Cultural studies reader* (pp. 243–268). New York: Routledge.

Sedgwick, E. Kosofsky (1993b). Epistemology of the closet. In H. Abelove, M. A. Barale & D. M. Halperin (Eds.), *The lesbian and gay studies reader* (pp. 45–61). New York: Routledge.

Sharf, B. F. (1999). Beyond netiquette: The ethics of doing naturalistic discourse research on the internet. In S. Jones (Ed.), *Doing Internet research: Critical issues and methods for examining the Net* (pp. 243–256). Thousand Oaks, CA: Sage Publications.

Shea, V. (1994). *Netiquette.* San Fransisco: Albion Books.

Simpson, J. (2003). Television's cultural colony. *The Globe and Mail.* Retrieved March 2, 2004, from <http://209.47.161.50/articles/globeandmail/globe030530.htm>

Singer, L. (1991). Recalling a community at loose ends. In Miami Theory Collective (Ed.), *Community at loose ends* (pp. 121–133). Minneapolis: University of Minnesota Press.

Smith, M., & Kollock, P. (Eds.). (1999). *Communities in cyberspace.* London; New York: Routledge.

Spain, D. (1992). *Gendered spaces.* Chapel Hill: University of North Carolina Press.

Spender, D. (1985). *Man made language* (2nd ed.). London; Boston: Routledge & Kegan Paul.

Spender, D. (1996). *Nattering on the net: Women, power and cyberspace.* Toronto: Garamond Press.

Srole, C. (1987). "A blessing to mankind and especially to womankind": The typewriter and the feminization of clerical work, Boston, 1860–1920. In B. Drygulski Wright, M. M. Ferree, G. O. Mellow, L. H. Lewis, M.-L. Daza Samper, R. Asher & K. Claspell (Eds.), *Women, work, and technology: Transformations* (pp. 84–100). Ann Arbor: University of Michigan Press.

Stacey, J. (1994). *Star gazing: Hollywood cinema and female spectatorship.* London; New York: Routledge.

Sterling, B. (1993, 2002). *Short History of the Internet.* Retrieved April 16, 2003, from http://w3.aces.uiuc.edu/AIM/scale/nethistory. html

Sterne, J. (1999). Thinking the Internet: Cultural Studies versus the millennium. In S. Jones (Ed.), *Doing Internet research: Critical issues and methods for examining the Net* (pp. 257–287). Thousand Oaks, CA: Sage Publications.

Stone, A. R. (1992). Will the real body please stand up? Boundary stories about virtual cultures. In M. Benedikt (Ed.), *Cyberspace: First steps* (pp. 81-117). Cambridge, MA: MIT Press.

Stone, A. R. (1995). *The war of desire and technology at the close of the mechanical age.* Cambridge, MA: The MIT Press.

Sutton, L. A. (1996). Cocktails and thumbtacks in the Old West: What would Emily Post say? In L. Cherny & E. Reba Weise (Eds.), *wired_women: Gender and new realities in cyberspace* (pp. 169–187). Seattle: Seal Books.

Tannen, D. (1990). *You just don't understand: Women and men in conversation* (1st ed.). New York: Morrow.

Thurston, C. (1987). *The romance revolution: Erotic novels for women and the quest for a new sexual identity.* Urbana: University of Illinois Press.

Turkle, S. (1995). *Life on the screen: Identity in the age of the Internet.* New York: Simon & Schuster.

Van Dijk, J. (1999). *The network society: Social aspects of new media* (L. Spoorenberg, Trans.). Thousand Oaks, CA: Sage Publications.

Walkerdine, V. (1990). *Schoolgirl fictions.* New York: Verso.

Webster, J. (1993). Women's skills and word processors: Gender issues in the development of the automated office. In B. Probert & B. W. Wilson (Eds.), *Pink collar blues: Work, gender & technology* (Vol. Melbourne University Press, pp. 41–59). Carlton, Vic.: Melbourne University Press.

Weedon, C. (1987). *Feminist practice and poststructuralist theory.* Oxford; New York: Basil Blackwell.

Weir, A. (1996). *Sacrificial logics: Feminist theory and the critique of identity.* New York; London: Routledge.

Wiesner, M. E. (1987). Women's work in the changing city economy, 1500–1650. In M. J. Boxer & J. H. Quataert (Eds.), *Connecting spheres: Women in the Western world, 1500 to the present* (pp. 64–74). New York: Oxford University Press.

Wolff, J. (1990). *Feminine sentences: Essays on women and culture.* Berkeley: University of California Press.

Wolmark, J. (1999). *Cybersexualities: A reader on feminist theory, cyborgs and cyberspace.* Edinburgh: Edinburgh University Press.

Woolf, V. (1977). *A room of one's own.* London: Grafton Books.

Young, I. M. (1990). The ideal of community and the politics of difference. In L. J. Nicholson (Ed.), *Feminism/Postmodernism* (pp. 300–323). New York: Routledge.

Zerbisias, A. (2003). *Too many cooks, too little drama.* Retrieved March 4, 2004, from <http://www.friends.ca/News/Friends_News/archives/articles12210301.asp>

⚅ Index

General Editor: Steve Jones

Digital Formations is an essential source for critical, high-quality books on digital technologies and modern life. Volumes in the series break new ground by emphasizing multiple methodological and theoretical approaches to deeply probe the formation and reformation of lived experience as it is refracted through digital interaction. **Digital Formations** pushes forward our understanding of the intersections—and corresponding implications—between the digital technologies and everyday life. The series emphasizes critical studies in the context of emergent and existing digital technologies.

Other recent titles include:

To order other books in this series please contact our Customer Service Department:

(800) 770-LANG (within the US)
(212) 647-7706 (outside the US)
(212) 647-7707 FAX

To find out more about the series or browse a full list of titles, please visit our website:

WWW.PETERLANGUSA.COM